The Beauty of Black & White

Photos by

MARCIAL S. VALENZUELA

Annotations by

ART G. VALENZUELA

The contents of this book are non-fiction.

The Beauty of Black & White

Philippine Copyright
2017 by
ART G. VALENZUELA
Registration No. A 2017-342

United States Publisher
KAIBIGAN BOOKS
PERCIVAL CAMPOAMOR CRUZ
Lebec, California 93243
percivalcruz@yahoo.com

ISBN-13: 978-1544820033

ISBN-10: 1544820038

Without limiting the rights of the author under copyright as printed above, no part of this book may be reproduced, stored in or introduced into retrieval system, or transmitted, in any form or by any means (electronic, mechanical, photocopying, recording or otherwise), without the prior written permission of the copyright owner and his heirs.

The scanning, uploading and distribution of this article via the Internet or via any other means without the permission of the author is punishable under all applicable international laws. Please purchase from authorized electronic edition and do not participate in or encourage piracy of copyrighted materials. Your support of the rights of the authors and their heirs and the publishers and their heirs is appreciated.

THE BEAUTY OF BLACK & WHITE

Dedication & Acknowledgement

My wife, Norma, joins me in dedicating this book to the memories of
one of the very first photojournalists
of the Philippines---my father, Marcial S. Valenzuela,
and as a remembrance of my mother, Segunda.
I also dedicate this book to all professional and amateur photographers
who take photography as a vehicle of artistic expression and
an endeavor worth pursuing.

Always remember that there is no such thing as
"the perfect picture." Keep on improving because photography is
a journey with no end; a passion with endless feelings.

Always bring your digital camera around
simply because an opportunity could present itself at
any moment
Keep on clicking.

I wish to thank my publisher, Percy Campoamor Cruz of California, USA, for the technical assistance in the making of the international edition of this book. Percy and my younger brother, Carlito, were classmates in high school in the Philippines. It is a pleasure working with you on this project, Percy. I am looking forward to writing more books in the future.

THE BEAUTY OF BLACK & WHITE

FOREWORD

By
JOSE C. DE VENECIA, JR.
Five-time Speaker of the House of Representatives
Republic of the Philippines
Writer, statesman and diplomat

I feel honored to write this preface to a fine labor of love and a work of art. The efforts dedicated by the author in paying a tribute to his father, through this book, are worth emulating

The book honors the pioneering efforts made by the country's very first recorded news photographers---photojournalists as we call them today---circa 1920s, in an era in our history when the whole wide world were seeing pictures of events and faces of their icons and favorite personalities being photographed and printed on the pages of their morning newspapers. It was something new to many people at that time; it caught their fancy. In like manner, we were mesmerized when CNN pioneered in the use of hologram (a digital form of photo or image projection in 3-dimension) in covering the US presidential elections starting in 2008. We said: "How did they do that?"

This book opens our eyes to the many picturesque and dramatic photos taken by Marcial S. Valenzuela---native of the province of Pangasinan in the Philippines where my family also traces its roots---and his personal passion for photography; but most importantly, his contributions to Philippine photography and photojournalism. Back then, in the 1920s, photography was the new-born medium that was taking the whole world by storm.

In like manner, the name Marcial Valenzuela was starting to become the talk of the town, mostly among major newspaper editors in Manila like THE PHILIPPINES FREE PRESS, THE MANILA TIMES, TALIBA and LA VANGUARDIA. Professionals in the printed news were starting to take notice of his bravado and skills in covering breaking news events of that time.

THE BEAUTY OF BLACK & WHITE

The author, a personal friend, showed me old pictures taken by his father, Marcial. At first sight, I would be lying if I would not say that I was amazed and taken back in time, to that era that defined Marcial as really a very fine photojournalist. And to use an old cliché---a photojournalist par excellence.

Here then, are the works of one of the very first photojournalists of the Philippines as preserved and presented in this book in black and white. His photographs had made history, he was a witness to it. He had a front row seat to it. Refresh yourself and turn back the pages of time.

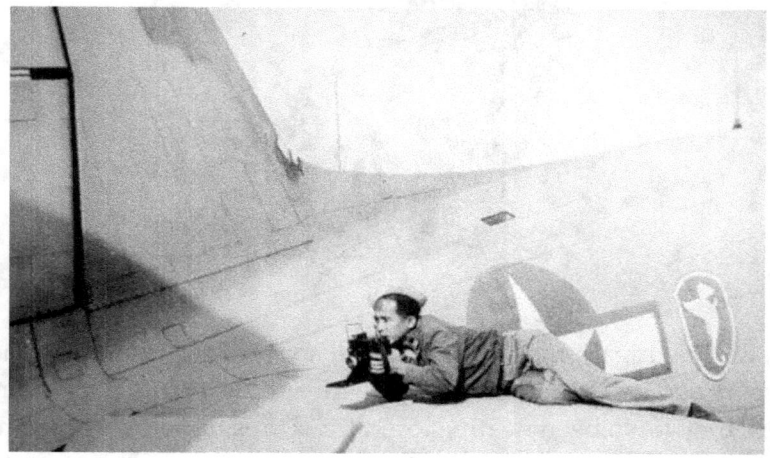

THE BEAUTY OF BLACK & WHITE

INTRODUCTION
By Art G. Valenzuela

I was reproducing, for posting on my social account, some of the great old black and white pictures taken 70 years ago by my father when the idea to write this book struck me. From the big boxes, where they have been neatly stored for scores of years, I brought the old well-preserved pictures and negatives out (some of them in big 5R format), dusted them off gingerly with a soft and dry camel hair brush and looked at each one against the light with a new perspective. I said to myself that I should not let these beautiful black and white pictures go unnoticed and wasted.

I glossed, yet again, at both the journalistic and artistic skills with which my father, Marcial S. Valenzuela, captured with his camera the great moments in Philippine history as well as the country's beautiful people and exciting views which the country's foremost newspapers and magazines printed between 1927 until he retired on January 2, 1968, a span of forty one years--- perhaps unequalled in Philippine photojournalism.

He covered every president of the Philippines during his career, from the pioneering President Manuel L. Quezon during the American Commonwealth government in 1935, to the pre-Martial Law years of President Ferdinand E. Marcos in 1965.

Marcial S. Valenzuela, was really first among his peers, or perhaps a cut above the rest. He started taking pictures in the late 1920s, at the dawning of the Age of Aquarius for most Filipinos, when admiration for the American Commonwealth regime and the American way of life were in full flower; when the presence of Americans on Philippine soil was akin to realizing one's aspirations for a better life with limitless opportunities for those who work hard.

THE BEAUTY OF BLACK & WHITE

At that time, Henry Ford and the Wright Brothers had just revolutionized the way people would travel and live. Conversely, Marcial was opening a new window for reporting visual news and human struggles on Page One, dramatic and with full impact------always a picture that spoke a thousand words. At that time, it was equally prestigious for both the cameraman (photographer, as they were called) and the subjects to have their photos published by the news dailies albeit in black and white.

Marcial added depth into black and white photography.

Whenever there was breaking news, he would always be there with his camera to freeze historic moments for the country's No. 1 newspaper, THE MANILA TIMES to print, and for the whole nation to read. He had the eyes of both a photojournalist and an artist. He was very good at it that, in 1934, he was commissioned by the American government to shoot a picture for the cover of the school textbook "Health through Knowledge," that became the standard reference book in elementary schools in the Philippines until mid-1950s. And his model for it was my brother Fortunato who was about four months old at that time.

Marcial pioneered and inspired his fellow photojournalists to blaze the trail at the way printed news photos could be brought to the reading public; it was the time when audacity was the word. It was the time the brand name Kodak was almost synonymous to the name Marcial wherever he went. In those days, the generic reference for photograph was Kodak in the same manner as people were inclined to say Ford for car, Frigidaire for refrigerator, Colgate for toothpaste. And Marcial for photography.

Marcial had the pulse of the Filipino readers at his fingertips. He was the link between the readers and the newsmakers. He viewed and recorded news events and Philippine landscapes the way people would want to view them-----bursting with drama of human interest, cropped and framed at almost perfect angles, the hallmark of his trade for the rest of his career.

His skill was his ticket to fame. Here then, are some of his handiworks, perhaps some of the best, and definitely still lovely to look at. In our digital age, there is still a lot of beauty in good old black and white photography.

The Author

The author, Arturo Gamueda Valenzuela is the seventh of the nine siblings of the couple Marcial S. Valenzuela and Segunda Moreno Gamueda. He is a big fan of his father's and an admirer of his mother's great Ilocano cultural practices --- hardworking and frugal.

"The first time Tatay Marcial handed me a camera was in 1949. It was a small "Brownie" box camera which viewfinder was on top of the cam, a tiny glass window measuring one inch by one inch on the leftforward edge. I still remember the shutter button was on the right side which produced a very soft 'click' when you push it down.

"My grandfather was visiting with us at our apartment in Manila. He had come from his home province where my father was born about 180 kilometers away. At that time he was already 90 years old and I was a budding child of seven years. I thought he would make a good subject, wrinkles and all. My father noticed me gazing at my grandpa and so he handed me the "Brownie" and I took one or two shots of my grandpa but my father never told me what happened to those shots. Little did I think then that my first handle on that cam was my own ticket to creative photography."

Art was only three years of age when WW II ended in the Philippines in 1945. It was also the year when his father moved the whole family of ten from the province back to Manila for *Tatay Marcial* to resume his work with THE MANILA TIMES. Art attended post-war elementary schooling at the Padre Gomez Elementary School and secondary schooling at Arellano High School, both of which were American-influenced public schools, in Manila. He took up architecture at Asia's oldest university in Sampaloc District in Manila, the University of Sto. Tomas. But as fate would have it, his studies were cut short by a new calling – radio Disc Jockey which took him out from Manila to his father's home province, Pangasinan.

Between the years 1978 to 2001, and with provincial Dagupan City as his home base, Art was into serious and professional production of audiovisual documentaries for Philippine regional and national clients which required a lot of photographic works. Two of such photographic documentaries were shown in Berlin in 1986 and 1987 for the Philippine national government's request for renewal of funding for the "Philippine-German Seed Potato Project" in Benguet, an upland province in the Philippines.

"Within a span of 23 years (1978-2001), I must have shot no less than 15,300 slides (Kodak Ektachrome transparencies) or about 425 rolls of 36 shots per roll until digital photography outclassed the conventional cameras in 2001. Today, romancing my digital cams has become a new past time for me."

When he is not busy with his cameras, and during political season in the Philippines, which come every three years when elections are held, Art is consulted by local and national politicians as a pollster, a mainstream job which he started in 1970. This job had taken him to different parts of the country and at each opportunity he is always seen tagging along his favorite digital cameras. *(Follow his photos on Facebook.)*

THE BEAUTY OF BLACK & WHITE

Art was the in-house pollster of the then Lakas-CMD Party, a dominant political party in the Philippines between 1992 to 2001. He was also Campaign Manager for Research in the bid for presidency by former Philippine House Speaker Jose de Venecia, Jr. between 1995 and 1998. De Venecia lost to former Pres. Joseph E. Estrada in the 1998 elections but Estrada *"was ousted from office in 2001 during a popular uprising in Metro Manila after an aborted impeachment trial in which he was charged with plunder and perjury."* (WIKIPEDIA)

As a private pollster, Art must have written about 300 technical polling reports most of which were reviewed (and upon which very important decisions were made) by former Philippine Presidents Fidel V. Ramos (1992-1998) and Gloria Macapagal Arroyo (2001-2007), De Venecia himself and scores of other clients. Today De Venecia and the author remain as close friends.

When he is not busy with meetings in Metro Manila, Art finds comfort in his home in Dagupan City and at the farm in his father's hometown in Mangatarem town in Pangasinan.

Art is married to the former Norma Villaruz of Baguio City whom she met in Dagupan City in 1961 while she was teaching at the University of Pangasinan while Art was a budding disc jockey. They have four children: The eldest Arthur Norman, manager of a fast food chain, is an Australian citizen married to Abigail Balingit both of whom are residing in Sydney with their three children and two grandchildren. The other one is Rosanna, a banker, married to Eric Bonn Miguel, a computer engineer, both of whom are residing in Melbourne with their two children. In Dagupan City, Philippines are: Rosario Valenzuela-Pitargue, MD, a foremost oncologist in northern Philippines married to Arthur R. Pitargue, MD, a cardiologist and a camera buff himself. They have three children. And the youngest of Art and Norma's children is Mana Vita Valenzuela-Yu, married to Chinese businessman Abrahan Yu both of whom are residing in Dagupan City with their two children.

In an interview with the very popular Philippine newspaper columnist and TV host of the 1950s Jose "JQ" Quirino that was printed on the pages of the popular afternoon newspaper, THE DAILY MIRROR on October 10, 1955, the author's father was quoted as saying: *"No, I don't like my children to follow in my footsteps,"* he said when asked if he would like his boys to be professional cameramen. *"It is too strenuous,"* he added with a twinkle in his eyes."

Three of Marcial's grandsons are big-time camera buffs themselves: Nestor L. Valenzuela, a professional photographer based in Metro Manila; Carl S. Valenzuela, another professional photographer based in Hong Kong; and Eddxer DV. Valenzuela, a photo hobbyist based in Manila. A grandson-in-law, Arthur R. Pitargue, MD is an avid photo hobbyist and so is the author.

The Beauty of Black & White

Photos by
MARCIAL S. VALENZUELA
(1907-1976)

Annotations by Art G. Valenzuela

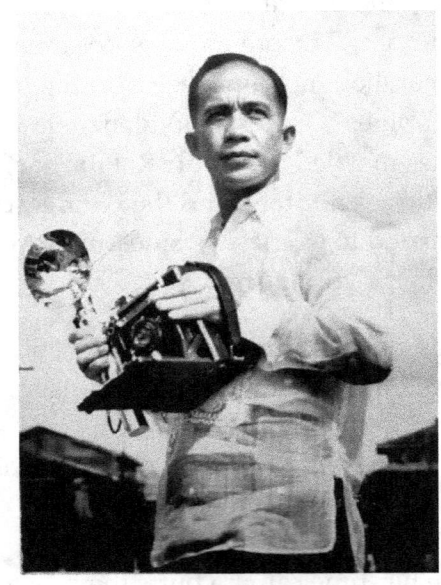

"Valenzuela was a master of black and white photography using available light and manual adjustments.

Here are some of the best photos taken by one of the Philippines' first and finest photojournalists.
Each picture speaks a thousand words"

THE BEAUTY OF BLACK & WHITE

Romancing the Camera (1927-1968)

Each photo that Marcial took was a canvass of his artistic skill.

Aside from dramatic news photos, the pictures he shot also highlighted the lighter side of life. Some of them won plum awards in annual photo contests. Whenever an opportunity presented itself, he was always quick with his camera. He sees things in detail which only his creative imagination could see. The result is always stunningly beautiful as those presented in the next pages taken mostly at the time when his country was just getting out of the ashes of WWII.

Marcial was part of that "manual adjustment" era when sharpness of judgment and experience will tell you which aperture (opening) to adjust in your camera lens in relation to the light that is available; and with what speed you should capture the moment, unlike in today's digital and hybrid cameras and lenses which give both the amateur and professional photographers a wide menu of automatic adjustments--- making picture-taking a walk in the park.

The captions in the photos are based on my best recollections as I am a living witness to some of the works of my father. It must not go unnoticed that I had many conversations with my father about places he had visited as I would almost always show him a picture that he took and ask a few questions out of curiosity --- places that I would also visit later in my adult life.

THE BEAUTY OF BLACK & WHITE

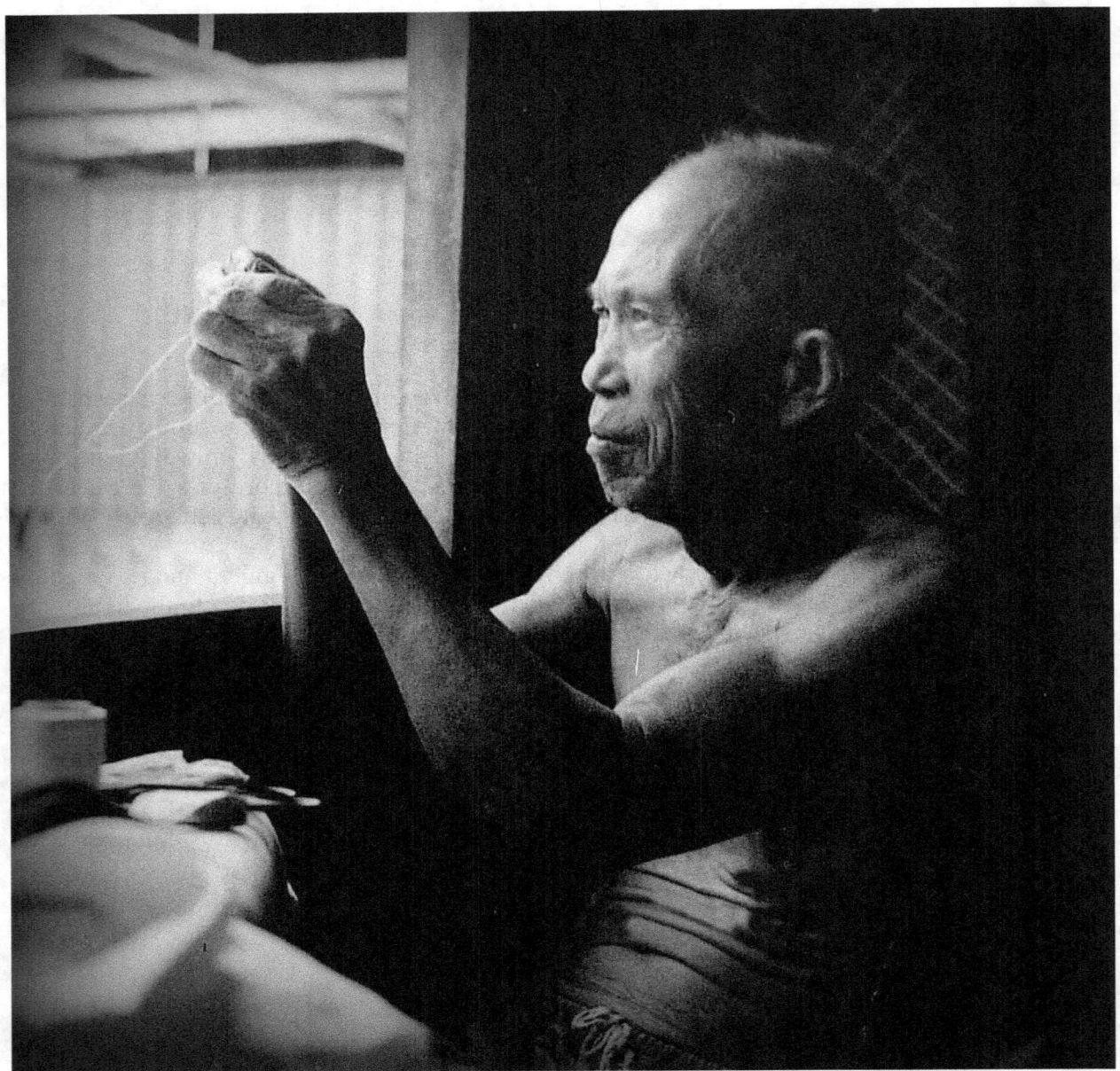

THE NAKED EYE The subject in this photo is no less than Marcial's father-in-law, my grandpa Fausto Gamueda shown here threading a needle with his naked eye. This photo was taken during one of our summer vacations in the town of Santa Lucia in Ilocos Sur in northern Philippines. Marcial would almost always take a break from his work in Metro Manila and consume his annual vacation leave in Ilocos Sur, my mother's home province or in his hometown of Mangatarem (in Pangasinan province).

THE BEAUTY OF BLACK & WHITE

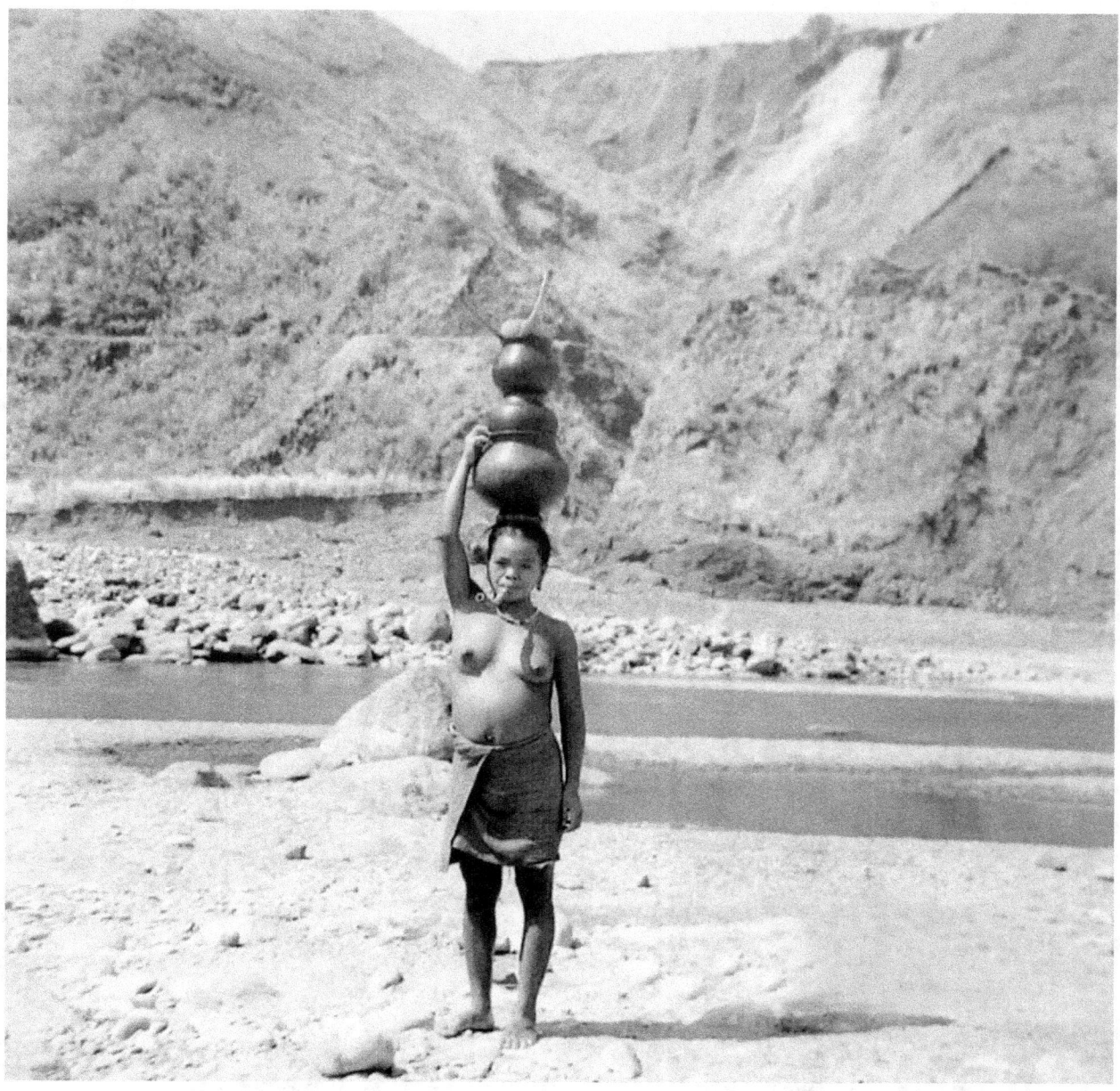

"THE BAREFOOT COUNTESS" A half-naked native is shown balancing three tiers of pots on her head while smoking a long local cigar. Nowadays, they still smoke, but smaller cigarettes; and they (natives) don't strut around like this anymore. This is a gem of a picture indeed. According to my father, he chanced upon this subject somewhere along the Abra River in northwest Philippines.

THE BEAUTY OF BLACK & WHITE

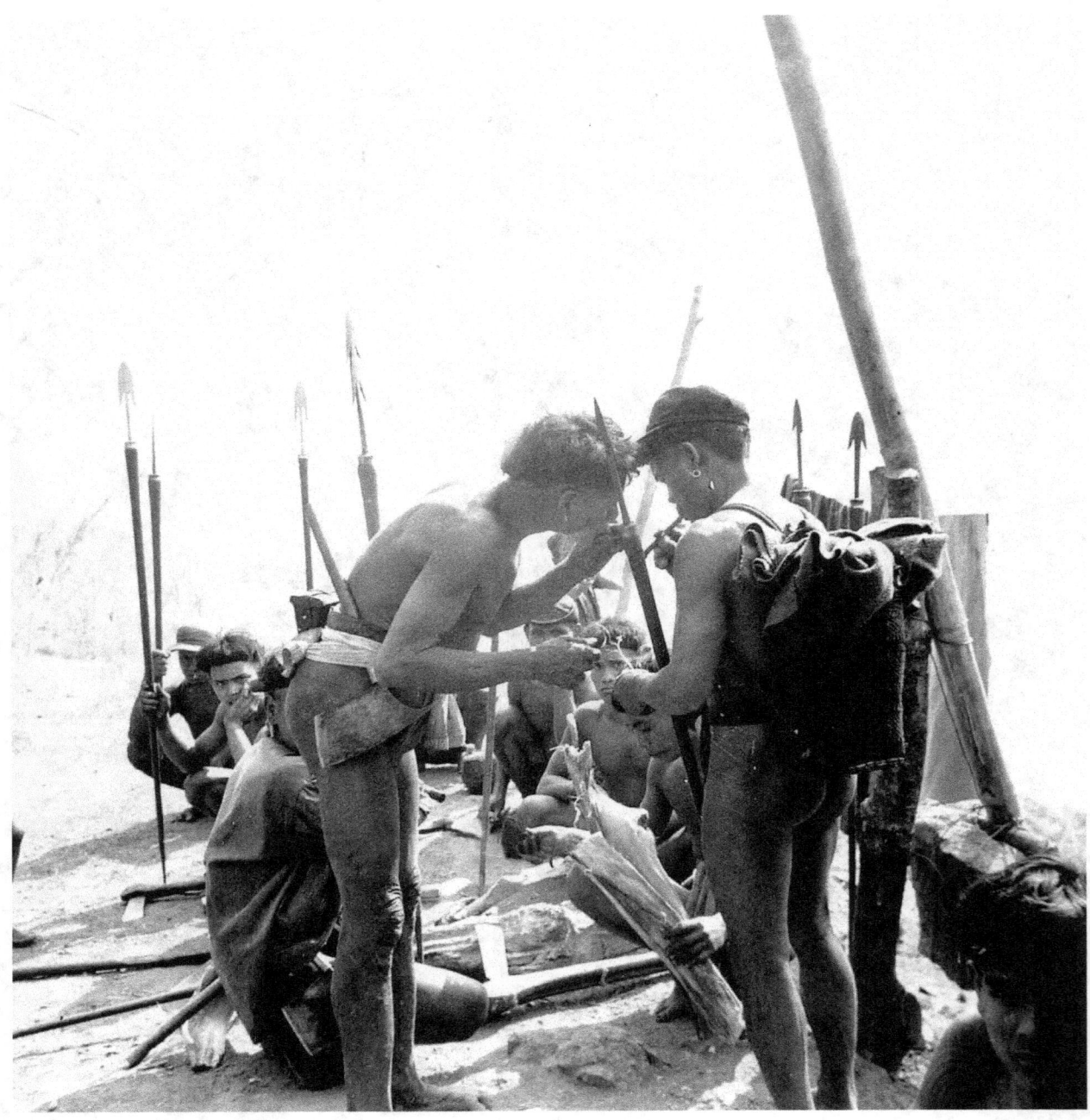

LIGHTING AND SMOKING THE "PEACE PIPES" Two warring tribal chieftains light up the "peace pipes" while their followers gingerly wait in the background during a break in the *"Budong"* (Peace Talks) in the late 1940s that ended decades of beheadings in the upland provinces of the Philippines. Today, the whole upland region is a top national and international tourist destination due to its cool weather. It is host to the country's scenic rice terraces (see Page 109) at Banaue in Ifugao province and Baguio City, the country's summer resort nestled some 5,000 feet above sea level.

THE BEAUTY OF BLACK & WHITE

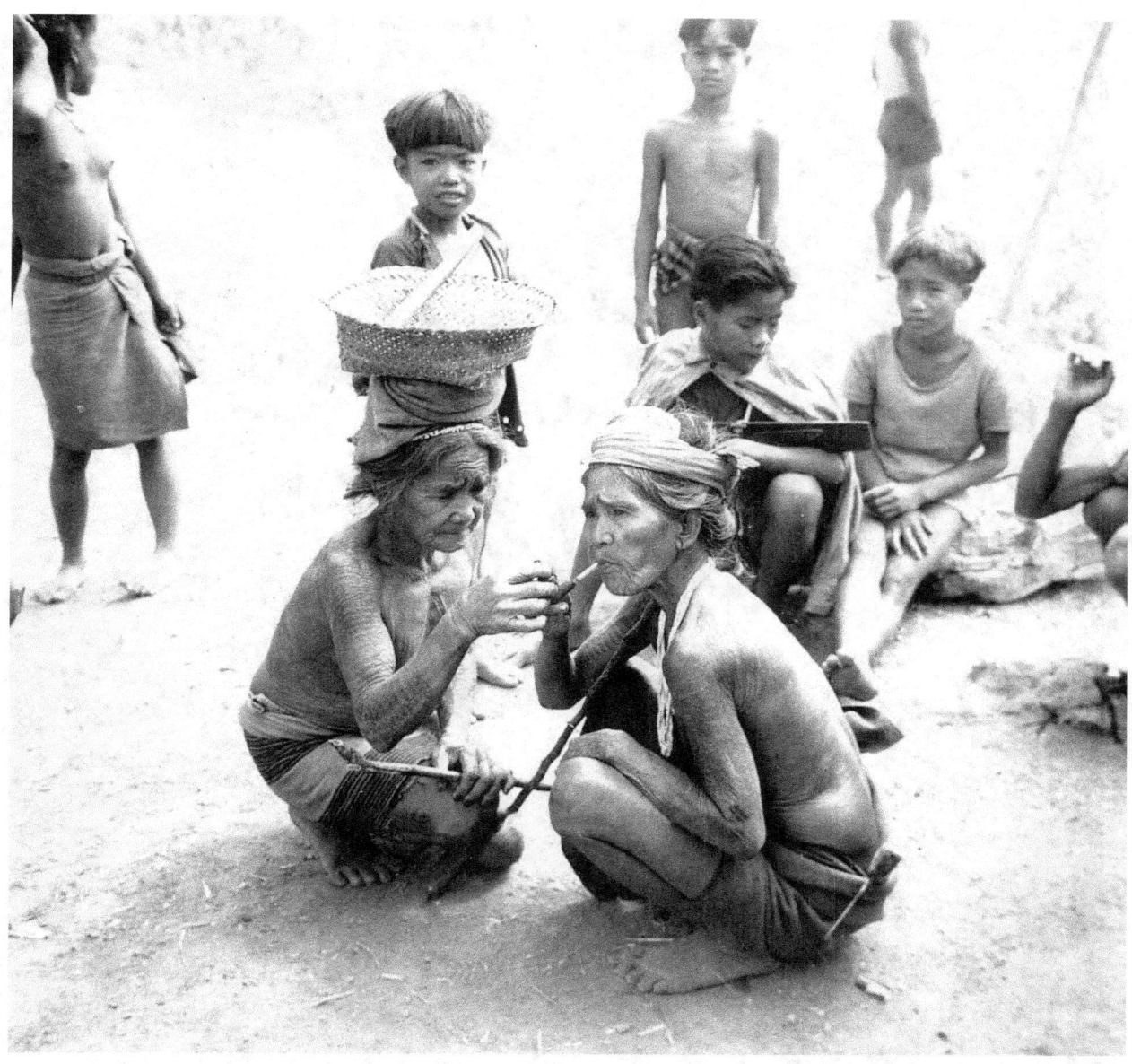

TATTOOED AND HALF NAKED Two elderly women in Bontoc town in the Mountain Province (northern Philippines) while the time away smoking thin cigars. Wearing tattoo marks was traditional then as they symbolized social status. This photo was taken in the late 1940s.

THE BEAUTY OF BLACK & WHITE

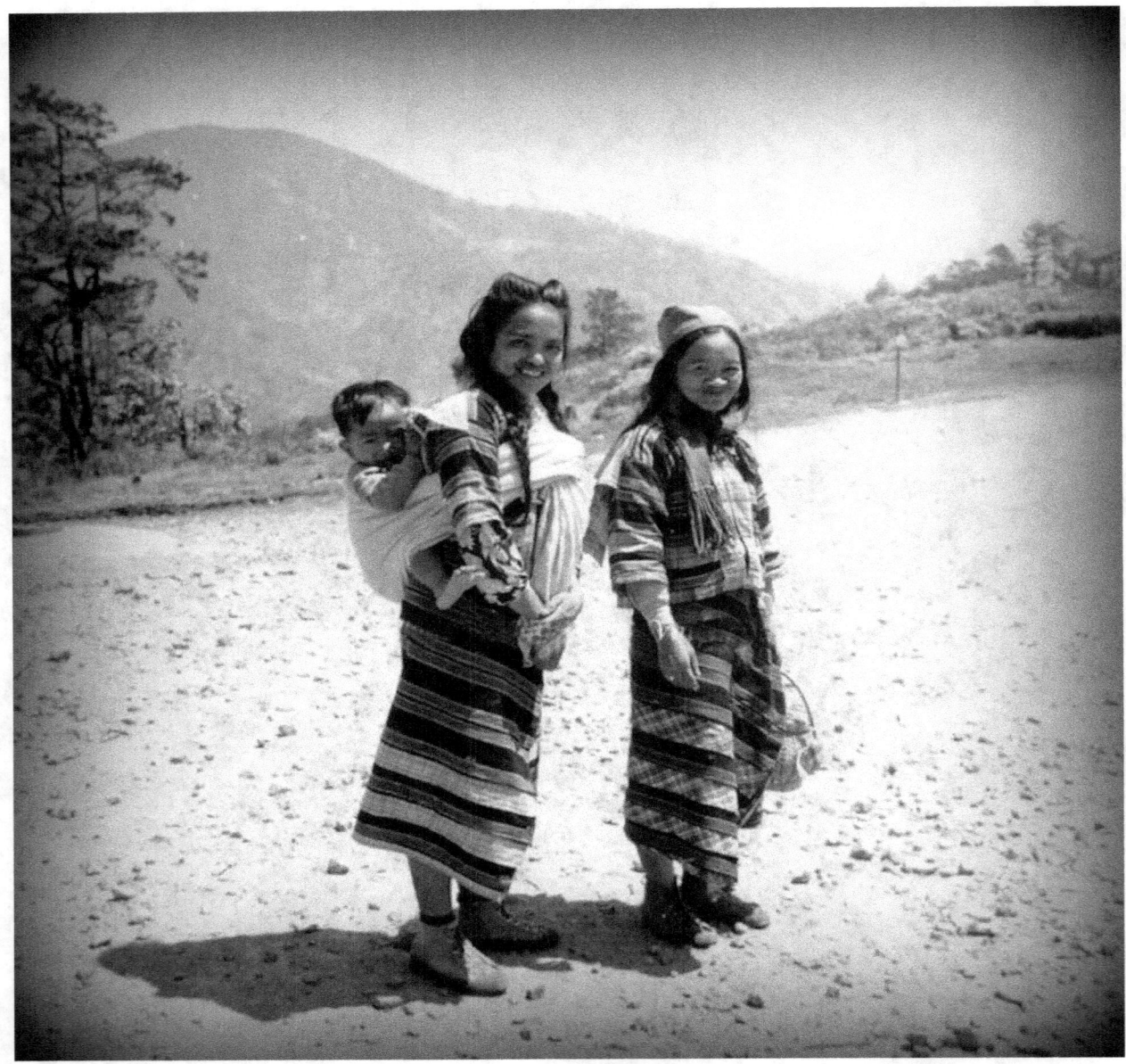

PIGGY-BACK RIDE A tot seemingly enjoys the ride at the back of his mother along the Halsema Highway in Benguet Province in northern Philippines. Today, this everyday attire is worn only during ceremonial activities. Benguet province rose to become the country's top producer of colorful flowers and upland vegetables which are sold as far as Manila, the country's capital, and elsewhere in the country.

THE BEAUTY OF BLACK & WHITE

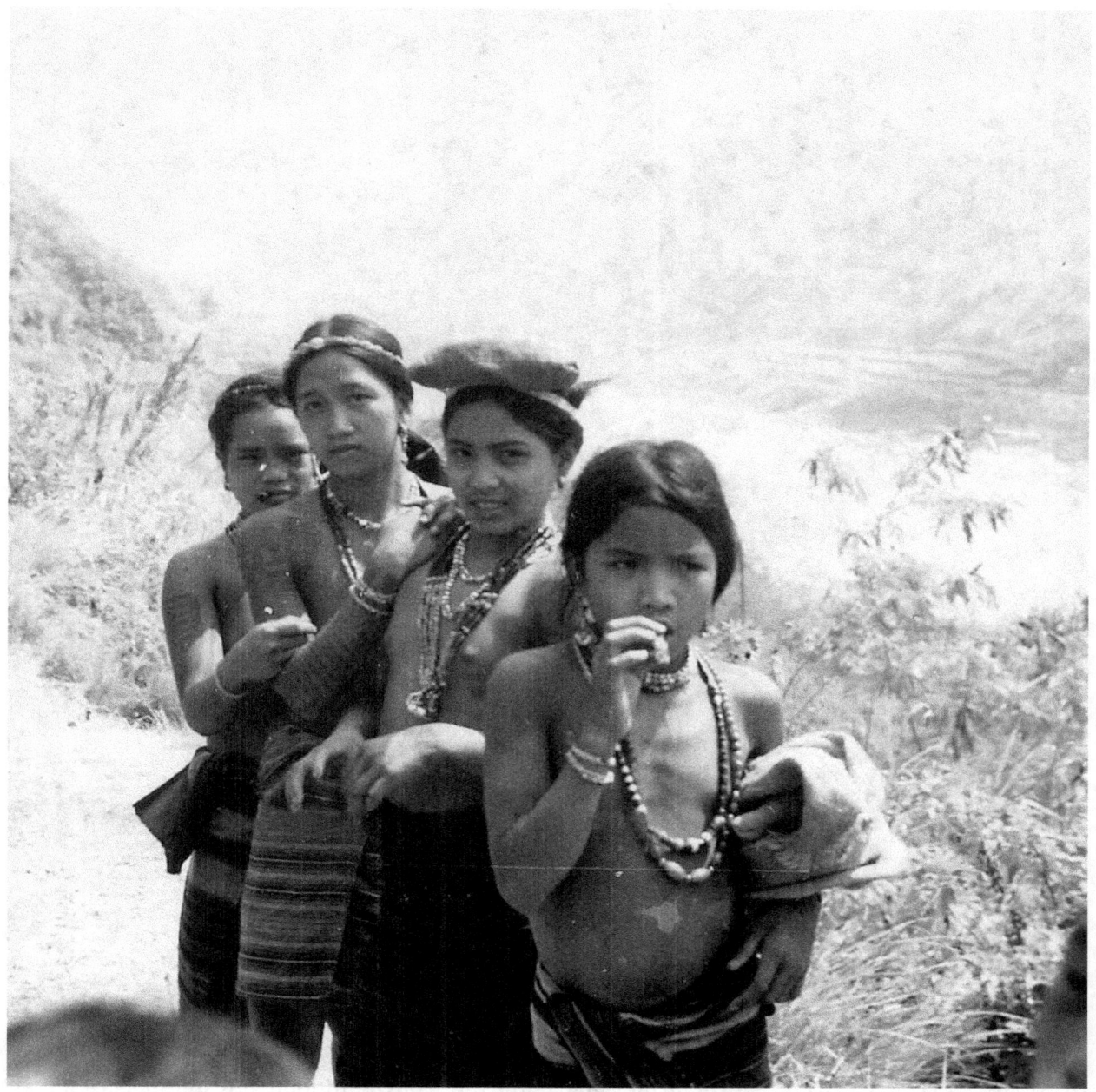

BUDDING MAIDENS A bevy of young native lasses, timidly pose for this picture which was shot in the upland town of Bontoc, Mountain Province (Philippines) at a time when the region was coming out of the cocoon of traditional practices into a "new world." Today, this upland part of the Philippines, which is known for its cool weather, is a favorite tourist destination. Not far from here, along the Halsema Highway, is Buguias town, well-known for cultivating upland vegetables which are transported to as far as Metro Manila and other parts of the Philippines. Further down here is Baguio City. This photo must have been taken at summer time, late 1940s.

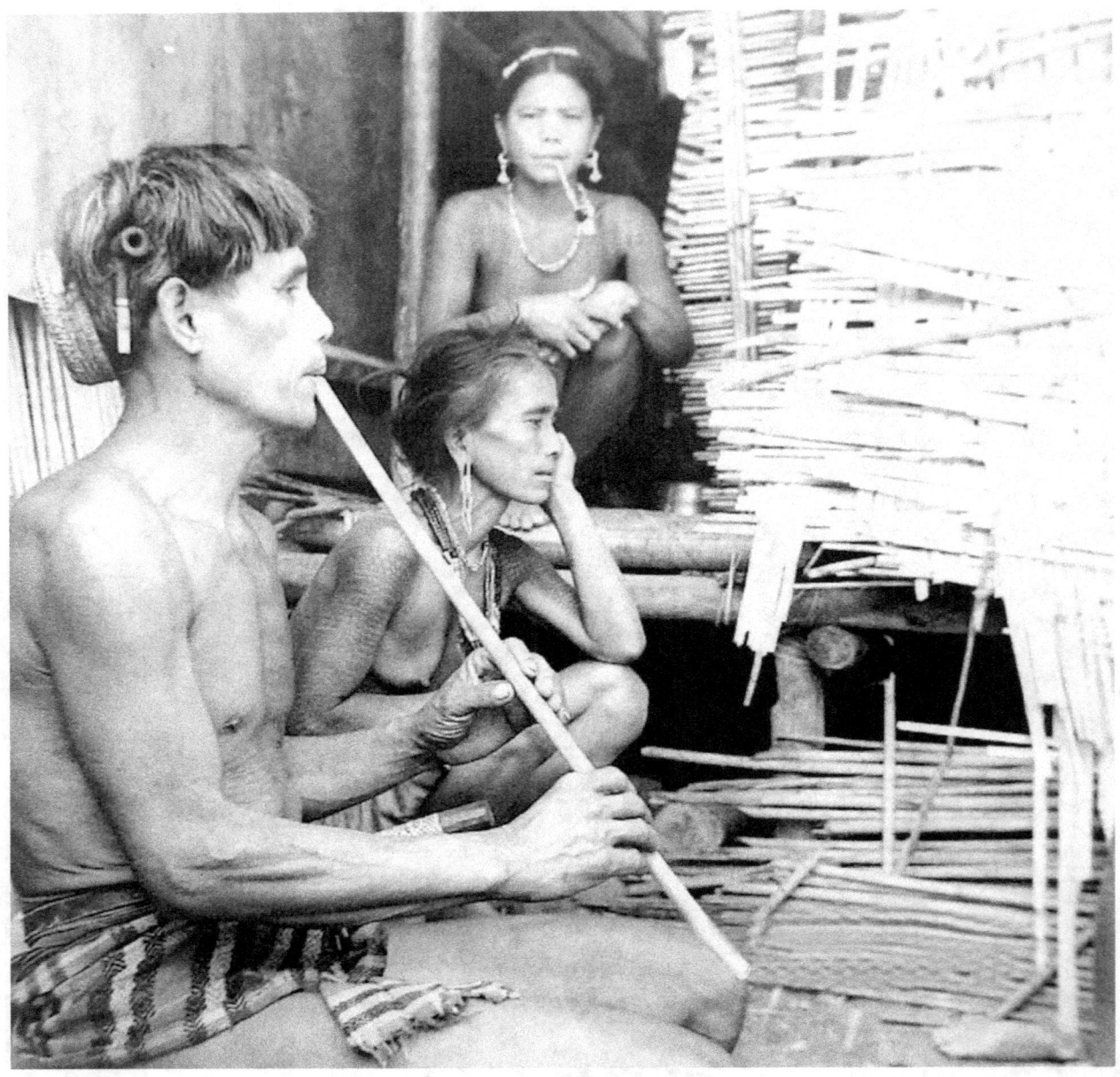

SERENADE TO MY LADY A local farmer takes time out from a mundane life and plays a native paean for her lady. Upland people in the "cordillera" are known to be adept at playing either the pipe flute or pan flute. To this day, one can buy locally made pipe flutes at the local markets in the towns of Bontoc and Sagada or at the metropolitan Baguio City. Notice the cap and a pipe on the man's head, symbols of "manhood and social status."

THE BEAUTY OF BLACK & WHITE

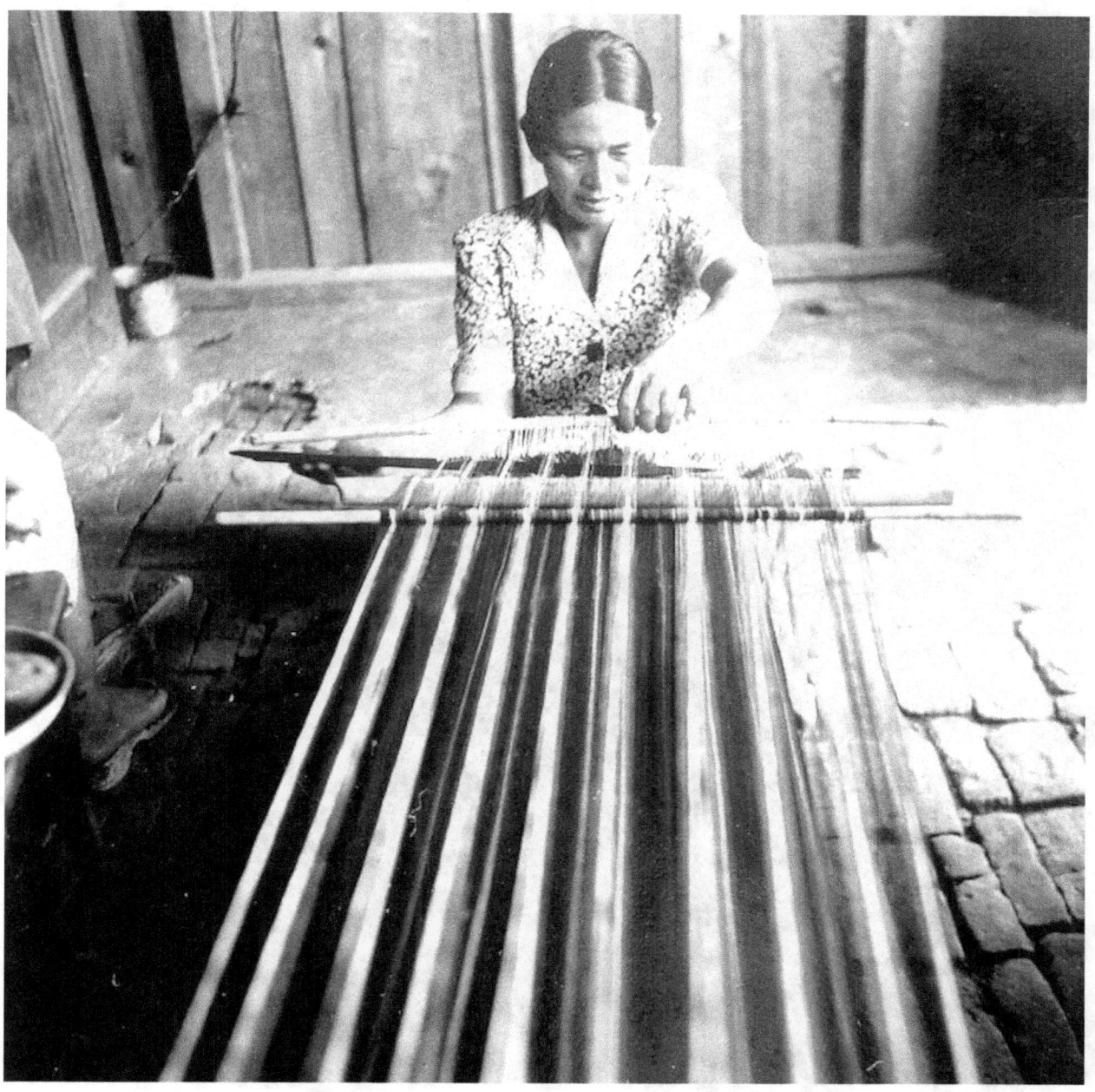

WEAVING THE TRADITIONAL TRIBAL CLOTH An upland woman is shown weaving the traditional tribal cloth worn locally. One could tell which tribe a person belongs to by the texture and design in the weave of the cloth one wears, very similar to the old practices of the native American Indians.

THE BEAUTY OF BLACK & WHITE

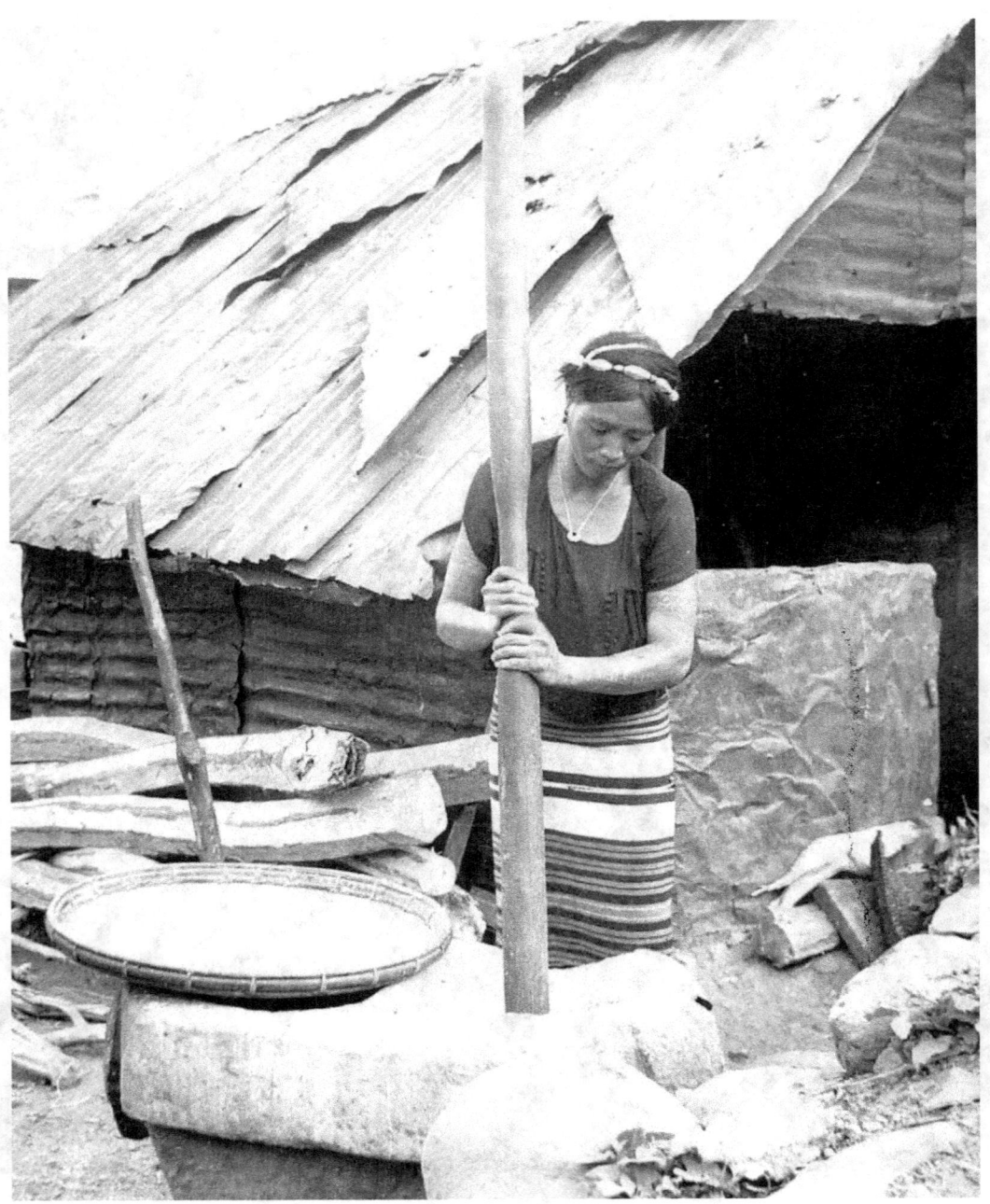

POUNDING RICE An upland Bontoc woman of the "cordillera" (mountain) region in northern Philippines uses an extra long pestle to pound rice in an equally large mortar. Notice the length of the pestle which makes pounding a lot easier when compared to the shorter ones used in the old days in the lowland areas of the Philippines. (See next picture.)

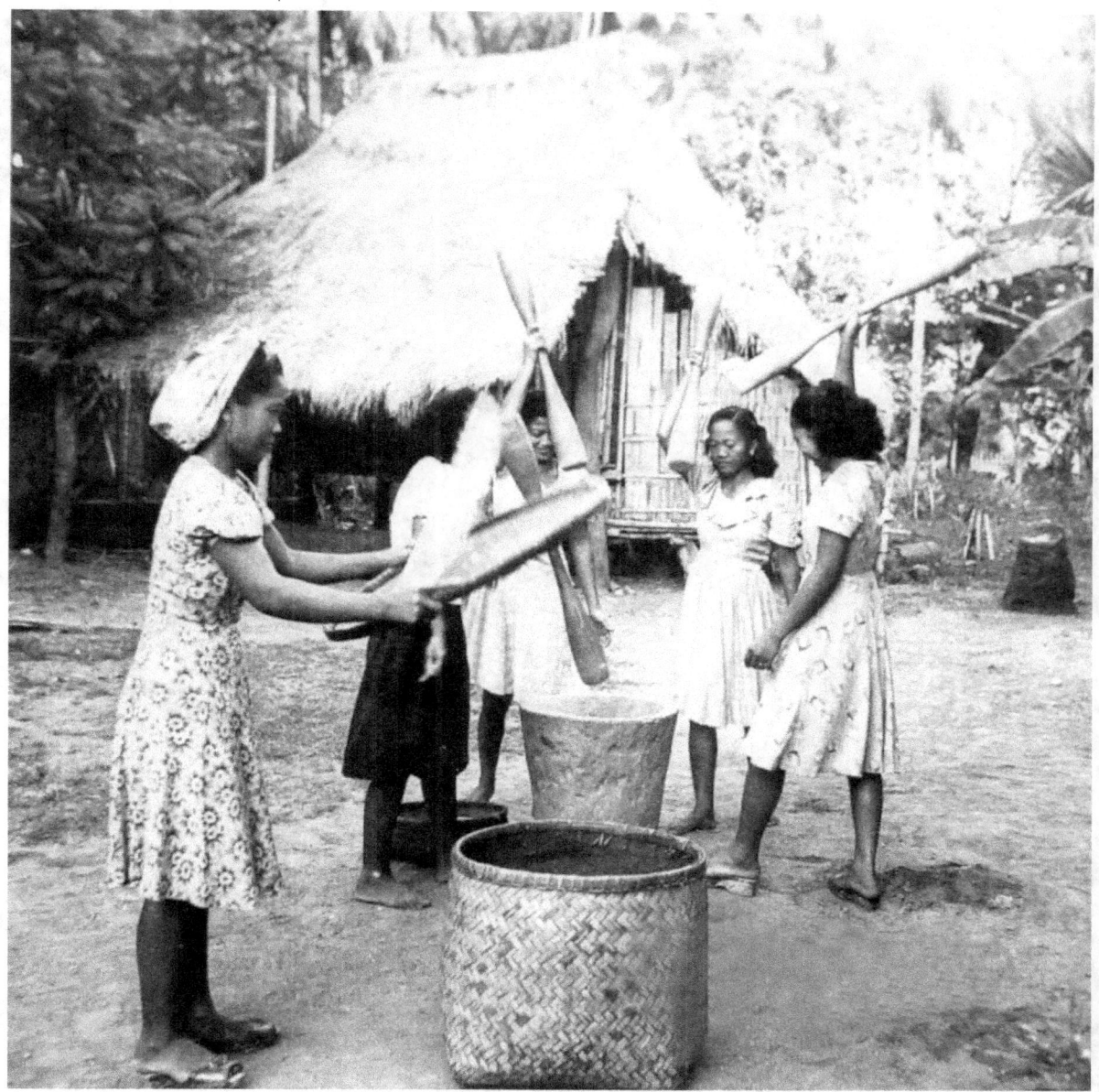

SEPARATING THE GRAIN THE OLD HARD WAY (Early 1940s) Four women take turns pounding *palay* (local grain) to separate rice from the husks while another winnows. The rhythmic sonorous thuds of the poundings were almost incessant and they could be heard from a half kilometer away. In the background is the rice storage barn which, today, is the site of the so-called "White House," a one-bedroom private cottage that I erected in 2001 at this family farm in my father's hometown.

THE BEAUTY OF BLACK & WHITE

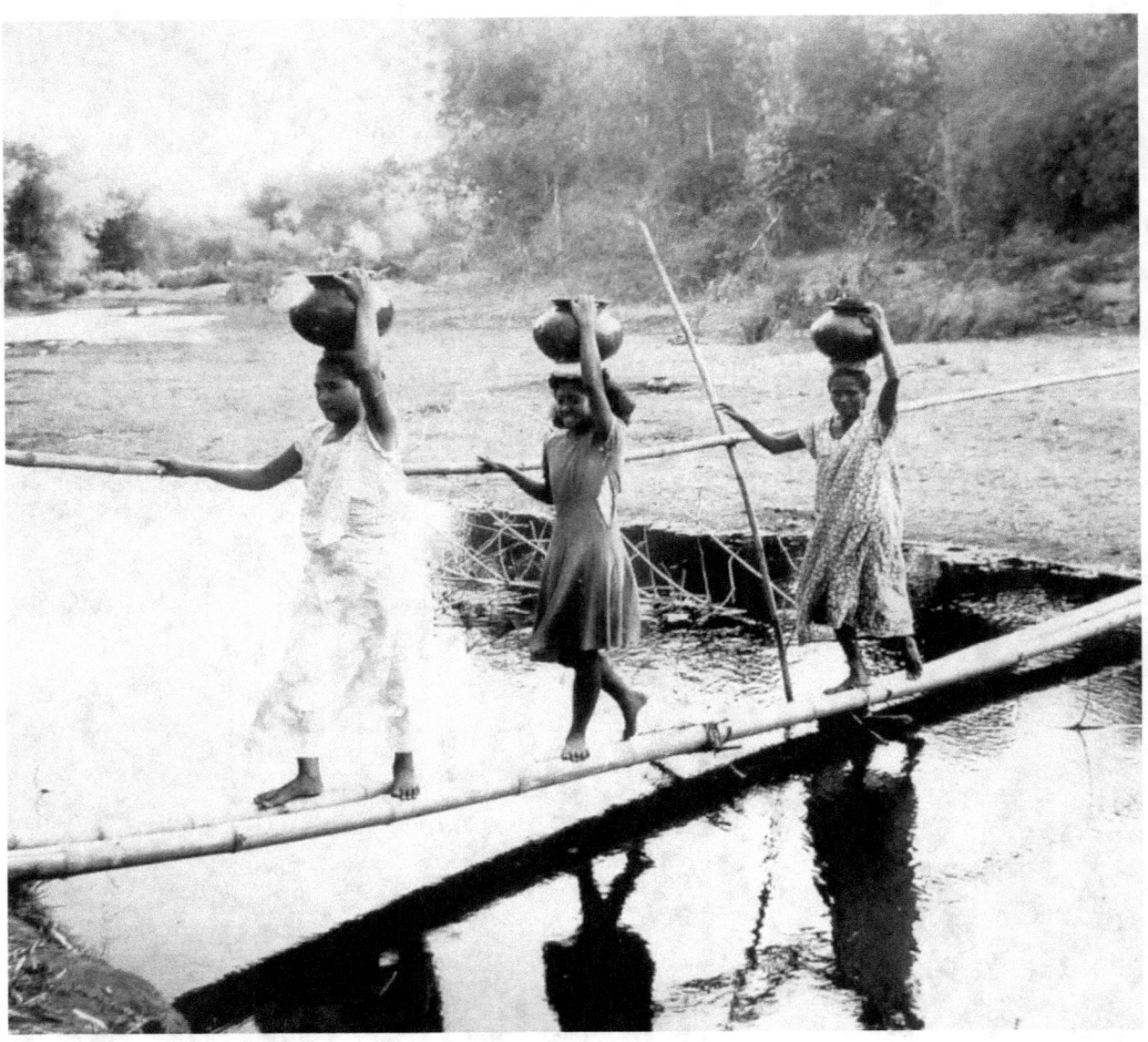

FRESH AND CLEAN DRINKING WATER These women cross a makeshift bamboo bridge each of them balancing a pot on her head filled with drinking water drawn from a river bank source called *bubon* (dug-out well) as shown in the background in the middle of the photo. Back then (late 1940s), surface water was unpolluted and free from residues of pesticides from nearby rice fields.

THE BEAUTY OF BLACK & WHITE

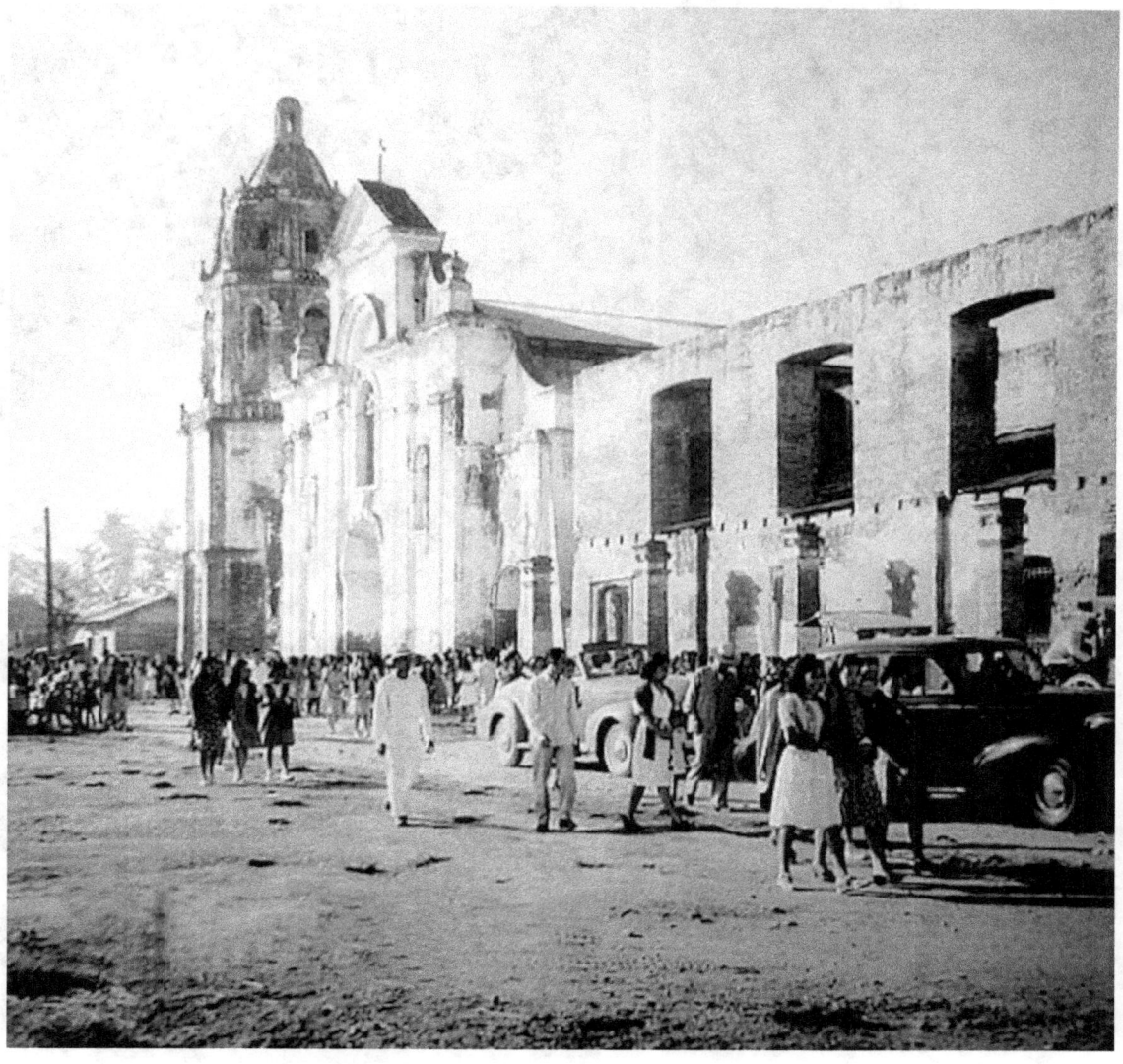

SUNDAY MASS AFTER WORLD WAR II Folks stream out of the Dagupan City cathedral after hearing Sunday Mass in this photo taken by my father on the day the city was chartered in 1947. A few hours later, my father would document for THE MANILA TIMES the inauguration and oathtaking of the newly elected city officials in ceremonies fronting the city hall. Notice the bombed out convent at right where Japanese soldiers camped. Not far from here, and three years earlier, Gen. Douglas MacArthur made his historic beach landing at Lingayen Gulf to liberate the rest of the Philippines.

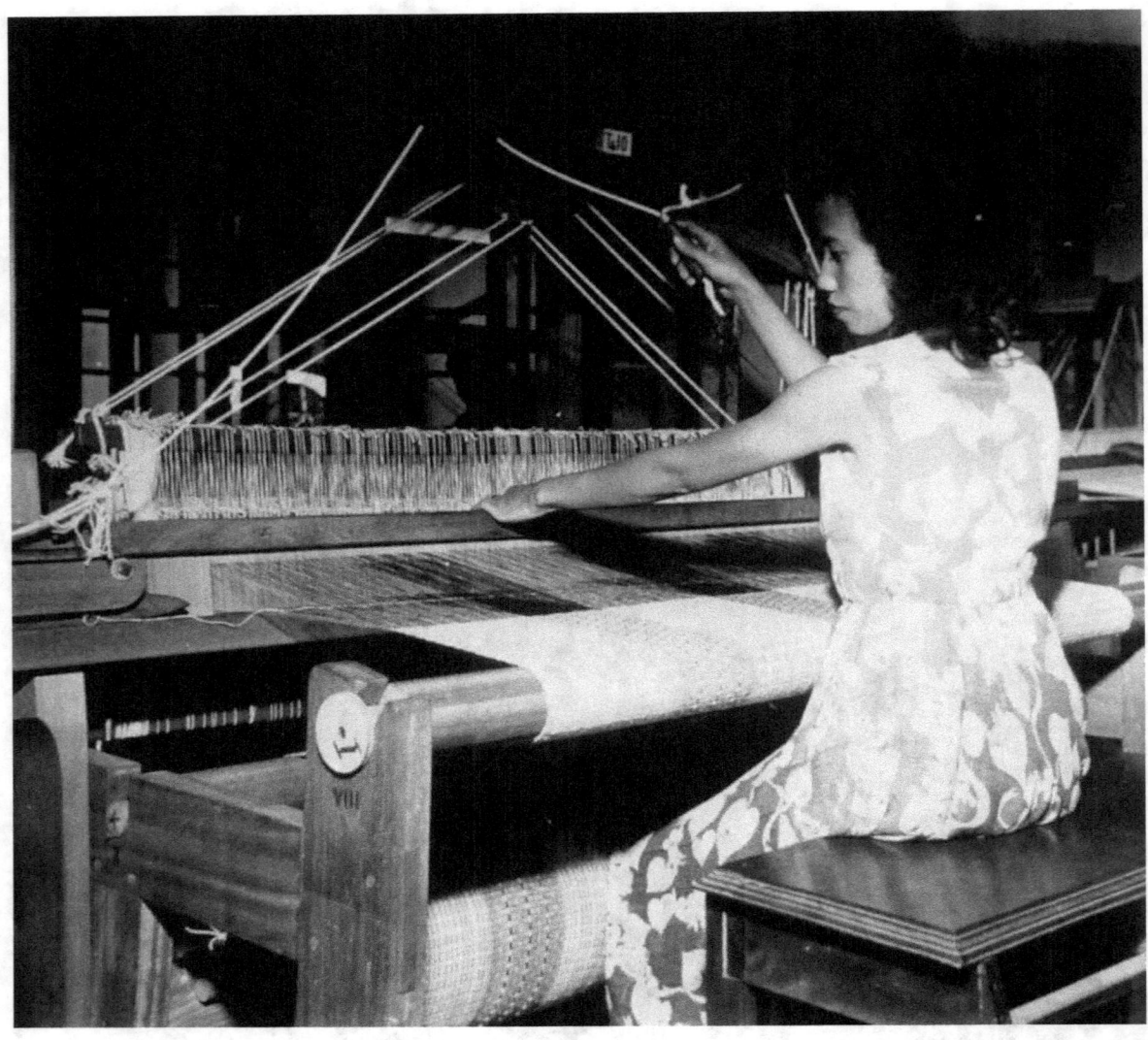

DOING IT THE HARD WAY A young lady weaves a local cloth using an old wooden looming machine. My father had a close friend, also a photojournalist assigned at the photo department of the old THE MANILA TIMES named Marcelo Ablaza who owned a dress shop in the outskirts of Metro Manila that used this kind of machines. Knowing my old man, this photo must have been shot in that shop where one of my cousins was employed. To this day, wooden looming machines are still used in my country for weaving delicately patterned and expensive cloth called "jusi" which are used for clothing materials that are exported abroad.

THE BEAUTY OF BLACK & WHITE

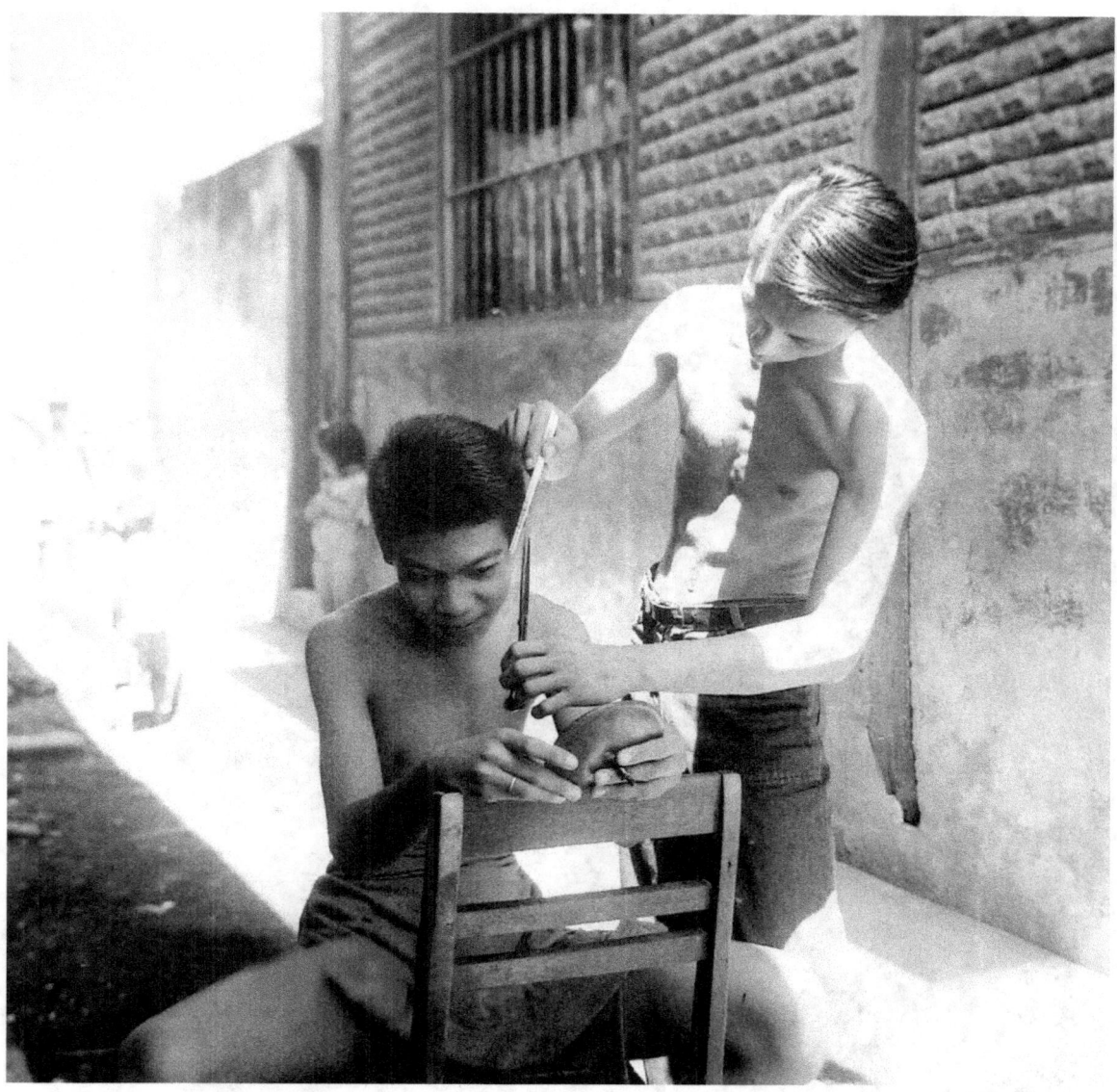

STREET BARBER Our neighbor, Meto, gives a haircut to my brother Fernando in a street alley near our apartment in Santa Cruz District in Manila. Meto usually gives out free hair cut in exchange for a stick of cigarette as token. When one neighbor asks for a free hair cut, other young men would come out of their houses and line up for a free hair cut, too. This usually happens on a Saturday weekend.

THE BEAUTY OF BLACK & WHITE

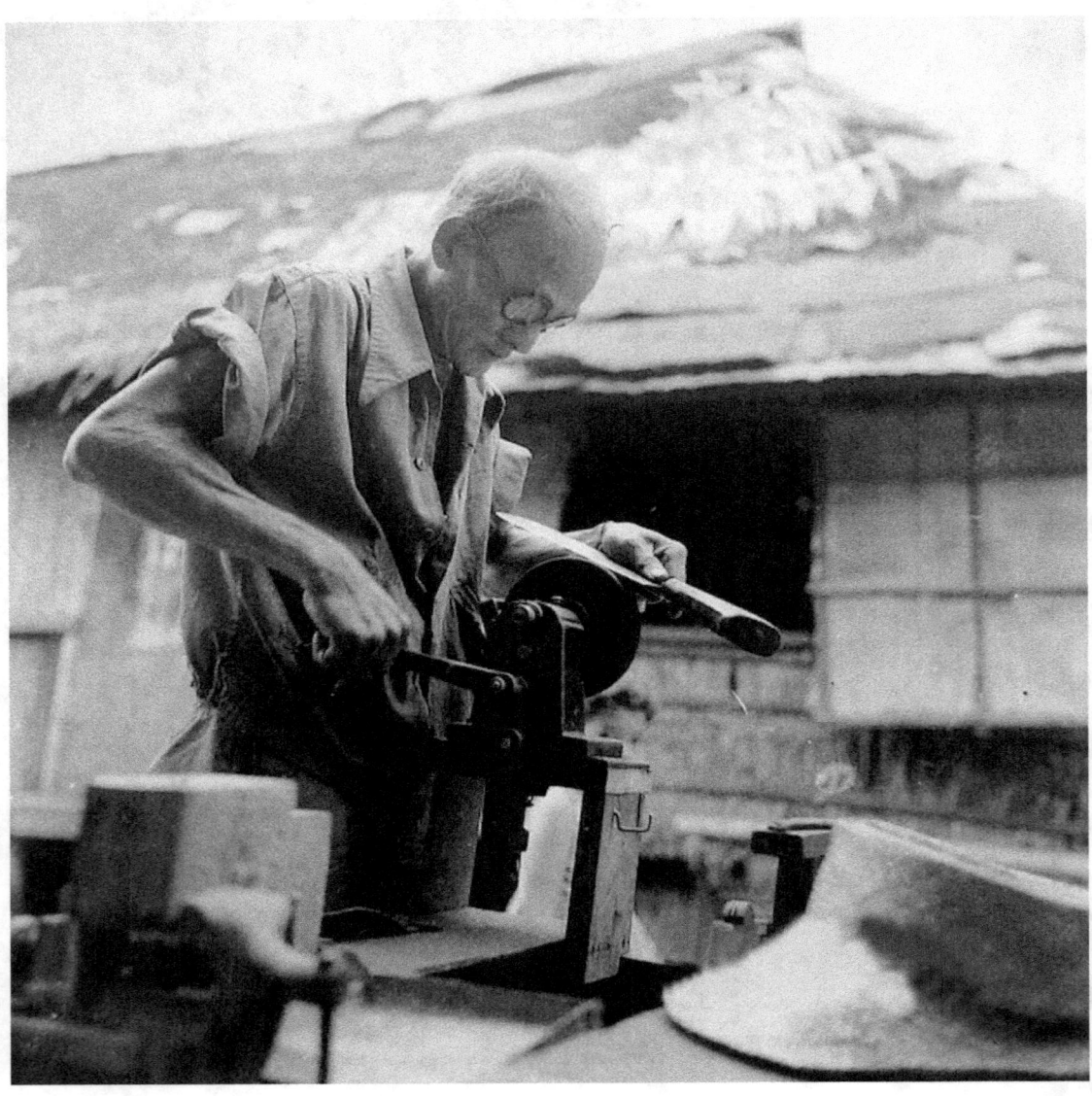

AMBULANT KNIFE SHARPENING My father catches this man doing grinding services and sharpening of kitchen knives in a neighborhood in old Manila. The belt-driven grinding contraption is operated by foot using an old sawing machine to run it. Notice the man is wearing protective goggles. Notice, too the few sparks under the knife. In the old days (1940s and 1950s), ambulant vendors and services roamed the streets of Manila. Today, almost all of them are on the sidewalks and pedestrian overpasses of the metropolis.

THE BEAUTY OF BLACK & WHITE

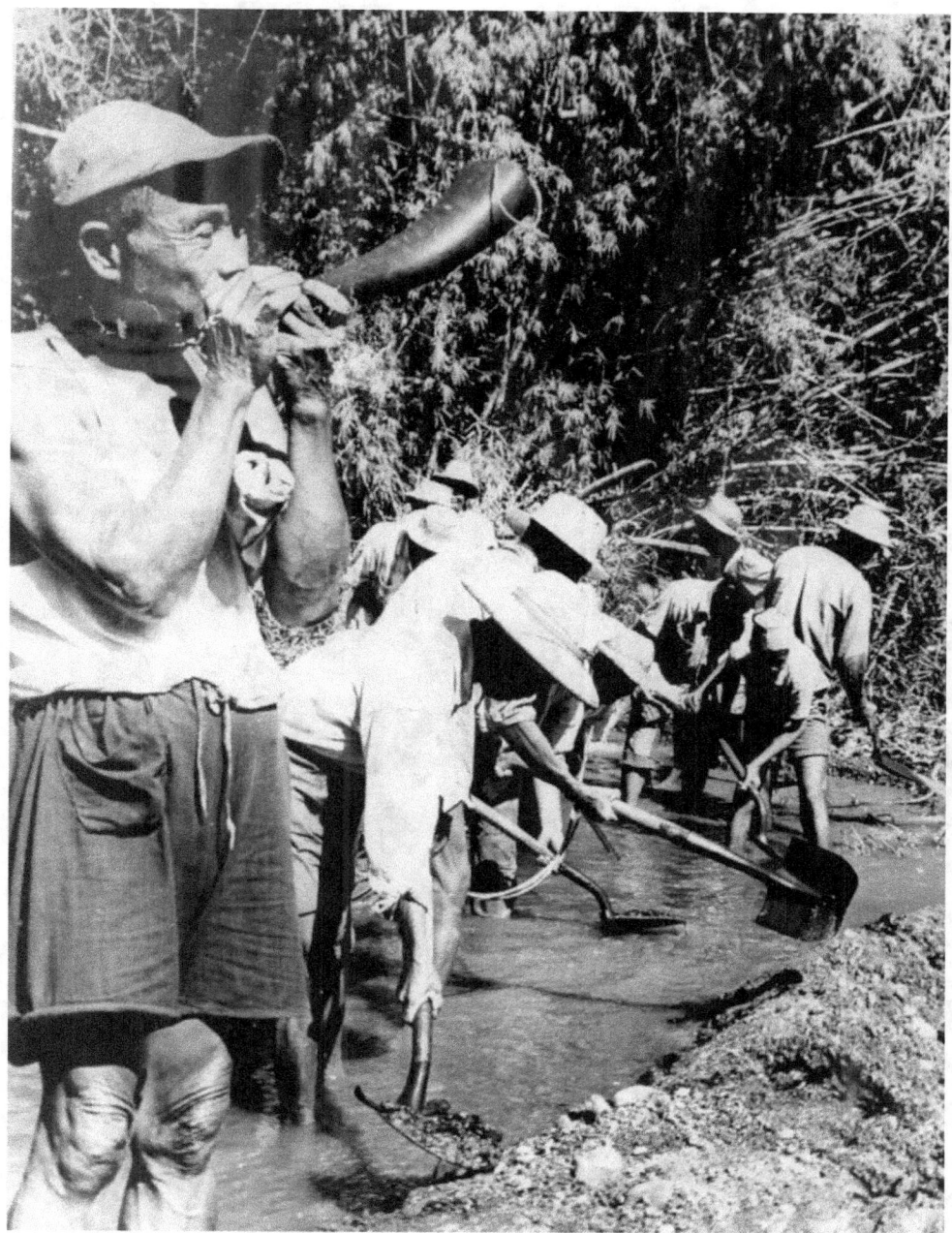

CALL TO WORK In the old days animal horn was in popular use as in this case where an old man is shown blowing his horn and calling for more volunteers to render work at a communal dam in a village. The horn has long been replaced by cell phones in reaching out to the neighborhood.

THE BEAUTY OF BLACK & WHITE

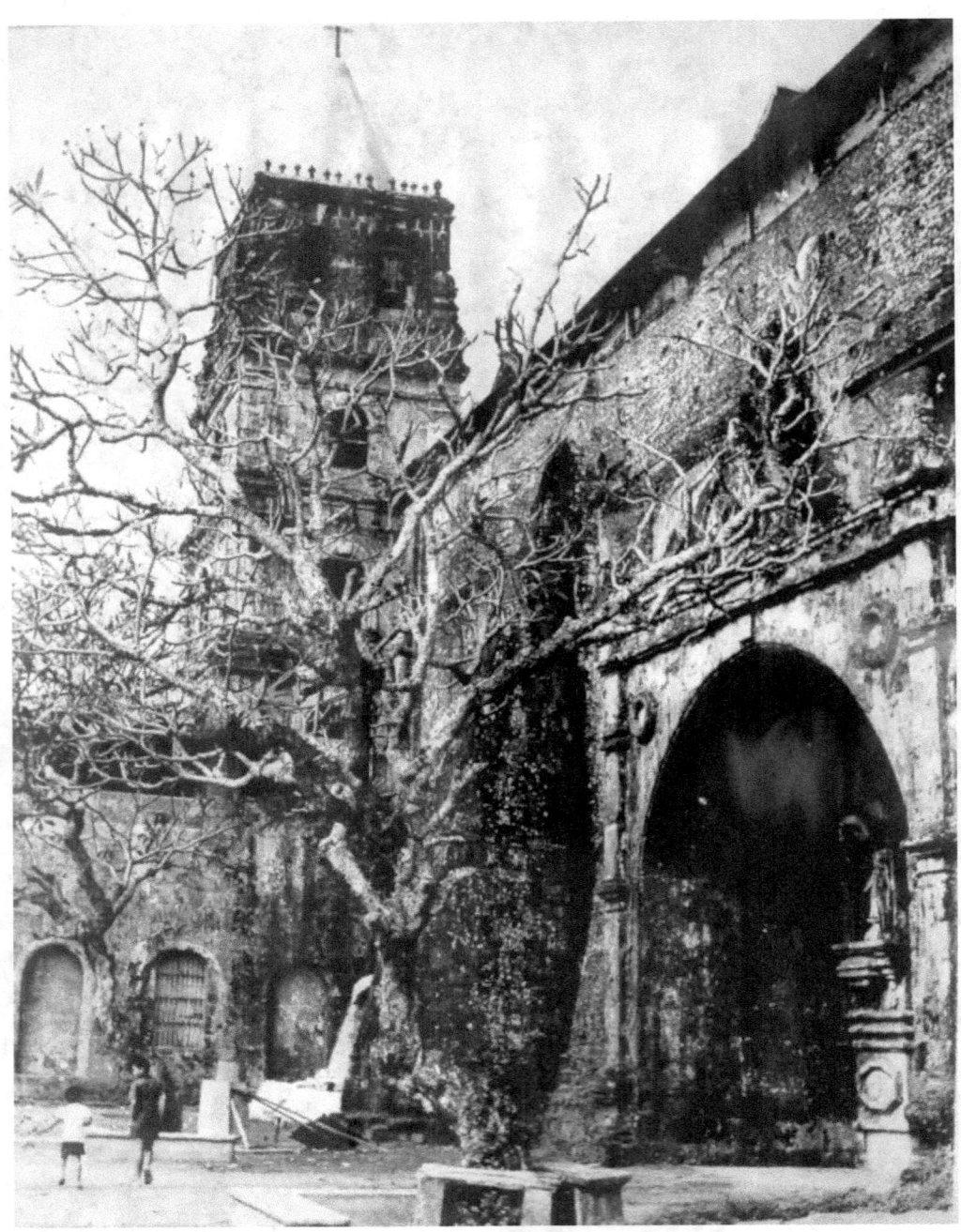

A LEAFLESS TREE AND AN OLD CHRISTIAN CHURCH At first glance, one is attracted by the old structure which is a very old church somewhere south of Metro Manila. But on second glance, one will notice the leafless "kalachuchi" tree in the foreground and two young boys apparently jogging along in the lower left part of this photo. Such is the way my father would compose his shots. He often told me to "frame" your shot in your mind before you even peep thru the viewfinder.

THE BEAUTY OF BLACK & WHITE

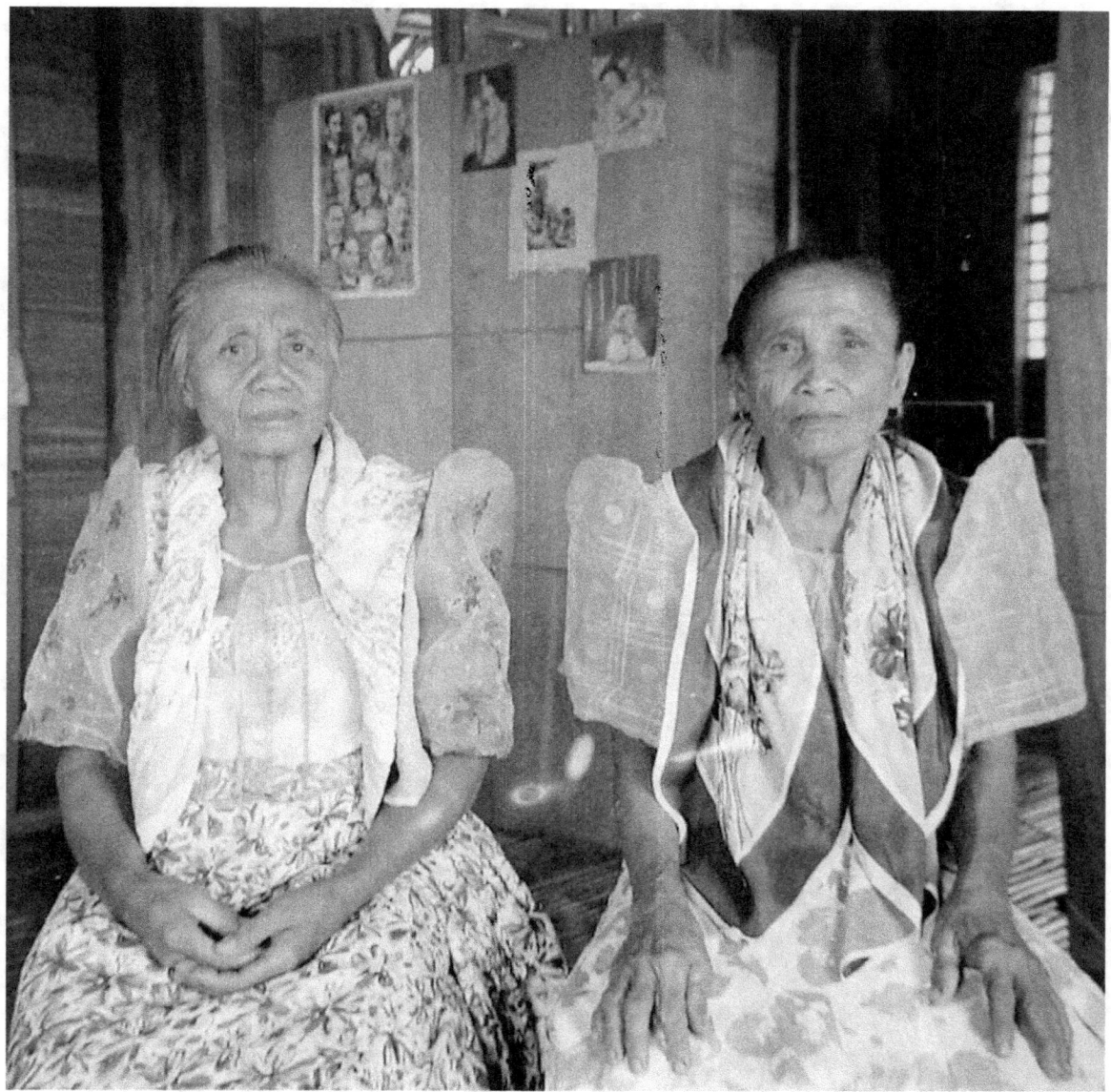

CRYING LADIES It used to be that during funeral wakes in the highly traditional Ilocos provinces of my country--where both my father and mother were born and raised—the services of "crying ladies" were indispensable among rich families. They were hired to do the crying for members of the family, reciting in emotional incantations the good deeds and memories of the dead. You will notice that the ladies in this photo are completely and formally attired for the work. This beautiful practice was very popular between the 1800s up to the late 1950s and faded out with the demise of ladies such as these ones shown in the photo taken by my father.

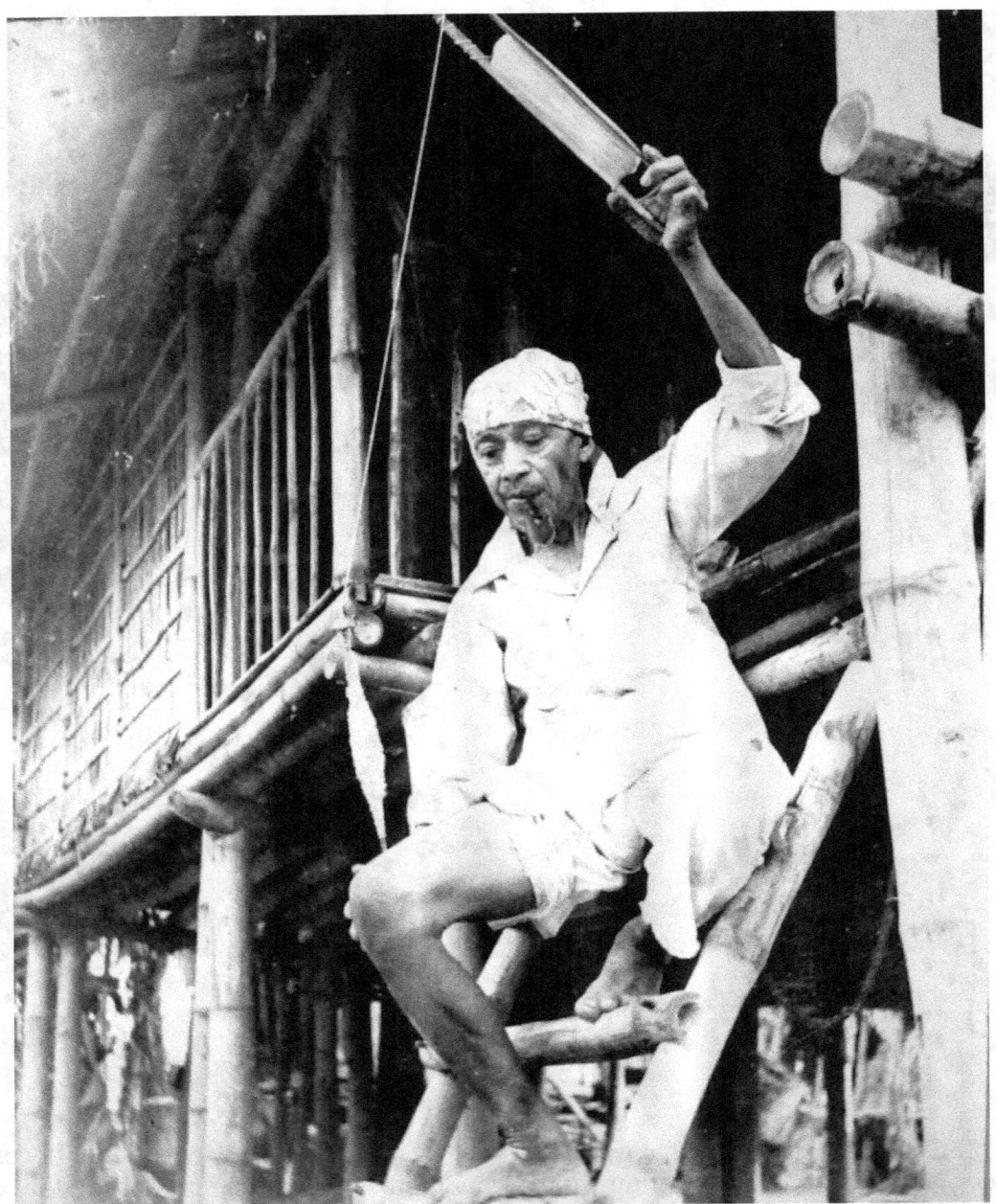

MY GRANDFATHER This photo reveals my father's humble beginnings for it shows my grandfather, Vicente, weaving a long fishing line for his net. From Paoay town in the northernmost part of the Philippines, grandpa migrated some 300 kilometers south, to the province of Pangasinan where he applied for a homestead to raise his own family. In 2001, I converted two hectares of what was left of that homestead into a private farm and built a cottage right in this place where this photo was taken. In December of 2015 I dedicated a marker in his honor. The following year, I dedicated a marker in honor of my father. Grandpa died in 1959 at age 100. He must have been in his late 80s when my father shot this photo.

THE BEAUTY OF BLACK & WHITE

THE DRINK THAT REFRESHES A worker takes a breather from work and takes a cupful of fresh water from an earthen jar using a shaven coconut husk for a cup. The man, the jar and the cup are long gone but this photo will endure the passing of time as a masterpiece in black & white photography and in the use of available light. My father shot this frame against the light and the silhouette is almost perfect.

THE BEAUTY OF BLACK & WHITE

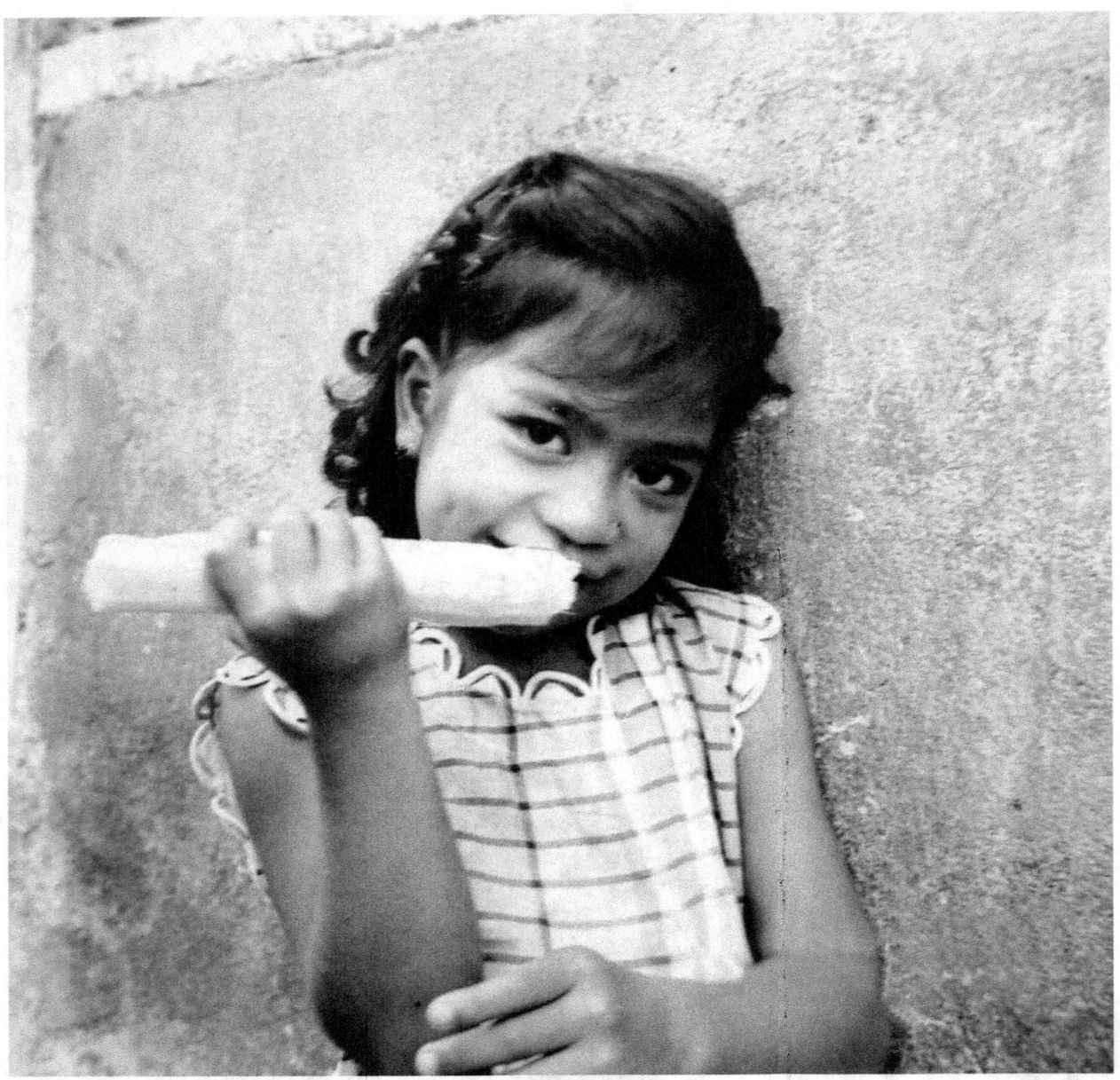

SUGAR CANE GIRL My younger sister, Aurora, bites a piece from a peeled sugar cane stalk and chews the sweet fresh juice out of it. This practice was not only very refreshing but was also a good dental practice as the cane pulps clean the teeth. (Manila early 1950s)

THE BEAUTY OF BLACK & WHITE

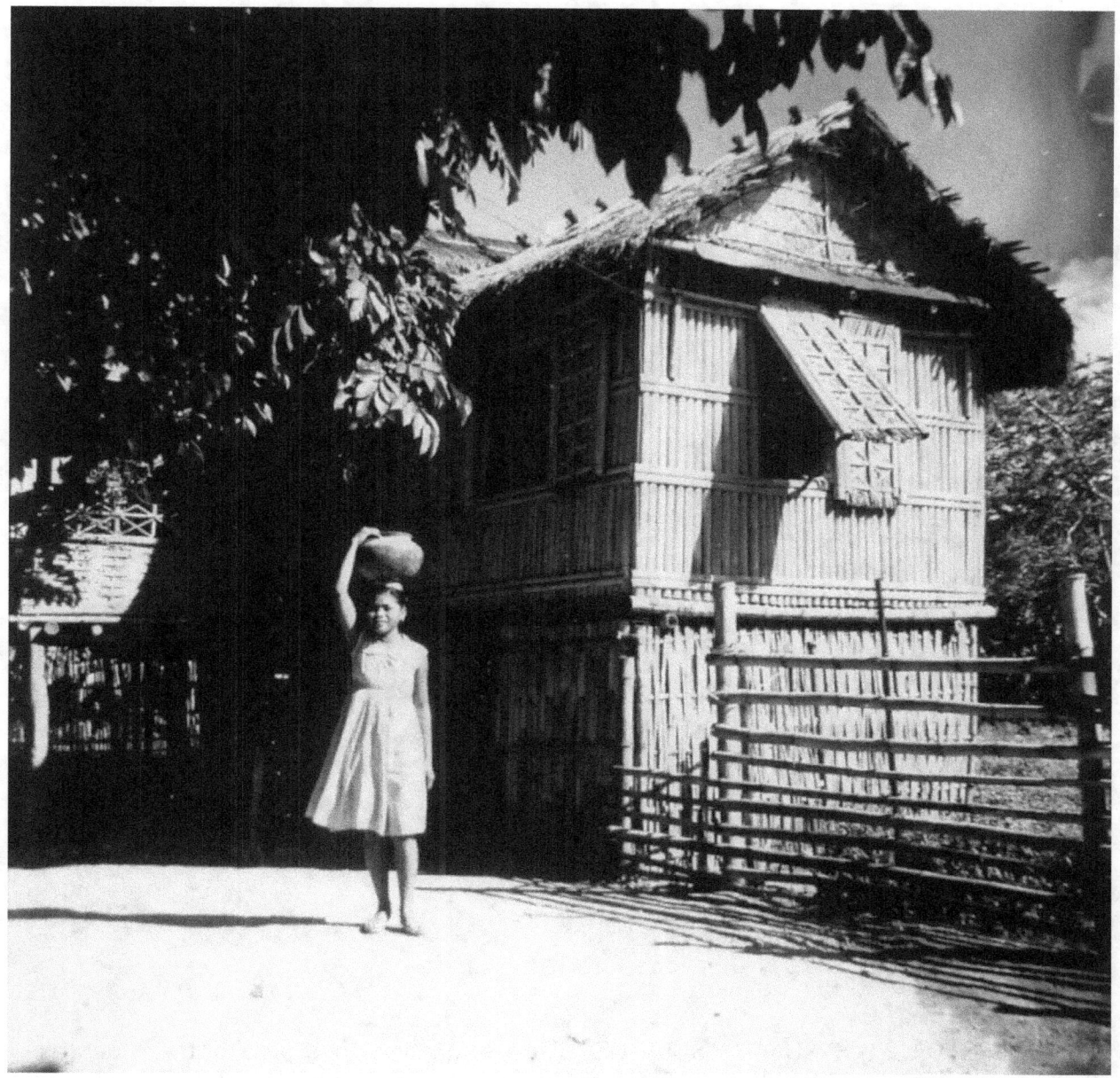

WATER JAR A young lady balances drinking water on her head as she passes by a neighbor's house in rural Philippines. Notice the house and the fence are all made of light materials called bamboo which could last for a lifetime when the house is properly maintained. Today, water are sourced from deep wells, pumped by electric power while most houses are made of concrete materials.

THE BEAUTY OF BLACK & WHITE

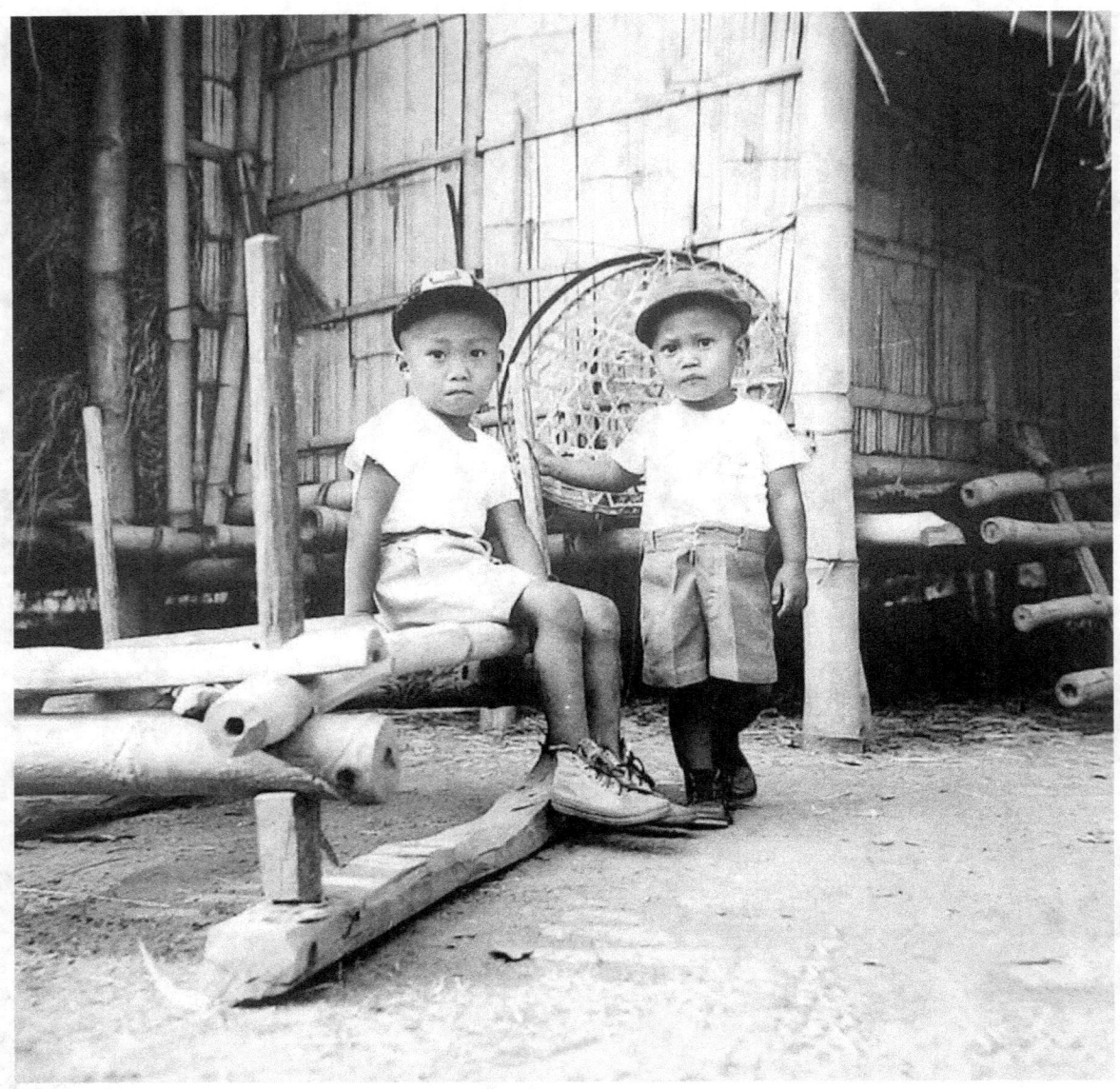

ALL DRESSED UP FOR SUNDAY SERVICE These young boys shyly pose for the camera as they prepare to go to town riding a sled pulled by a water buffalo called "carabao." (See Page 119) Then, and now, people from the far flung areas flock to the town center once every Sunday, and on designated days, to hear mass, do the once-a-week marketing, and take in the views of the day at the town plaza.

THE BEAUTY OF BLACK & WHITE

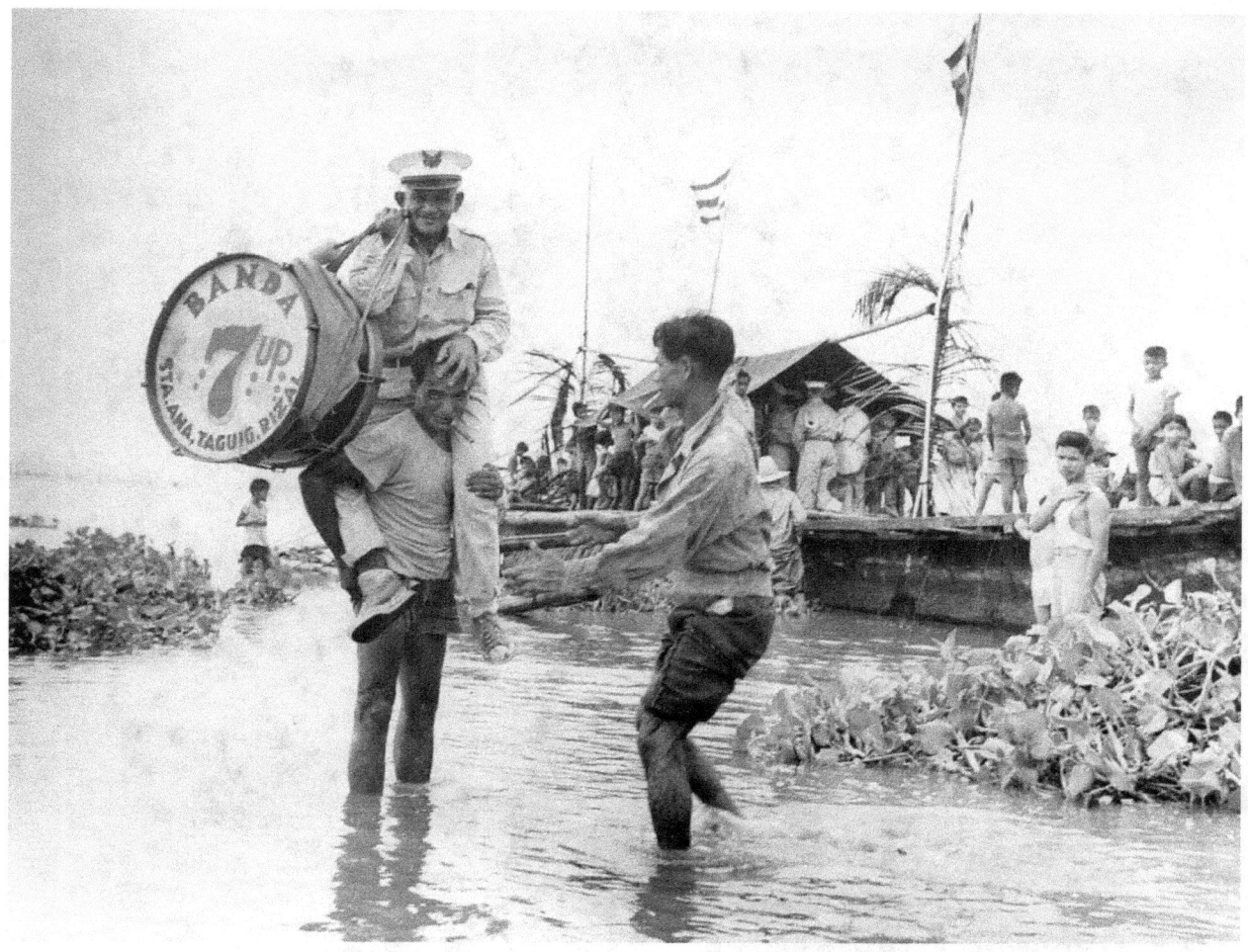

TAKE ME TO THE FESTIVAL ON TIME A bass drum band player from old Taguig town south of Manila is given a gingerly ride on the shoulder of a boatman, with the heavy drum on his shoulder, as the former tries to catch up with the rest of the band in this scene along the Laguna de Bay. Another boatman tries to lend a helping hand. Most likely, he would be playing in a town festival.

THE BEAUTY OF BLACK & WHITE

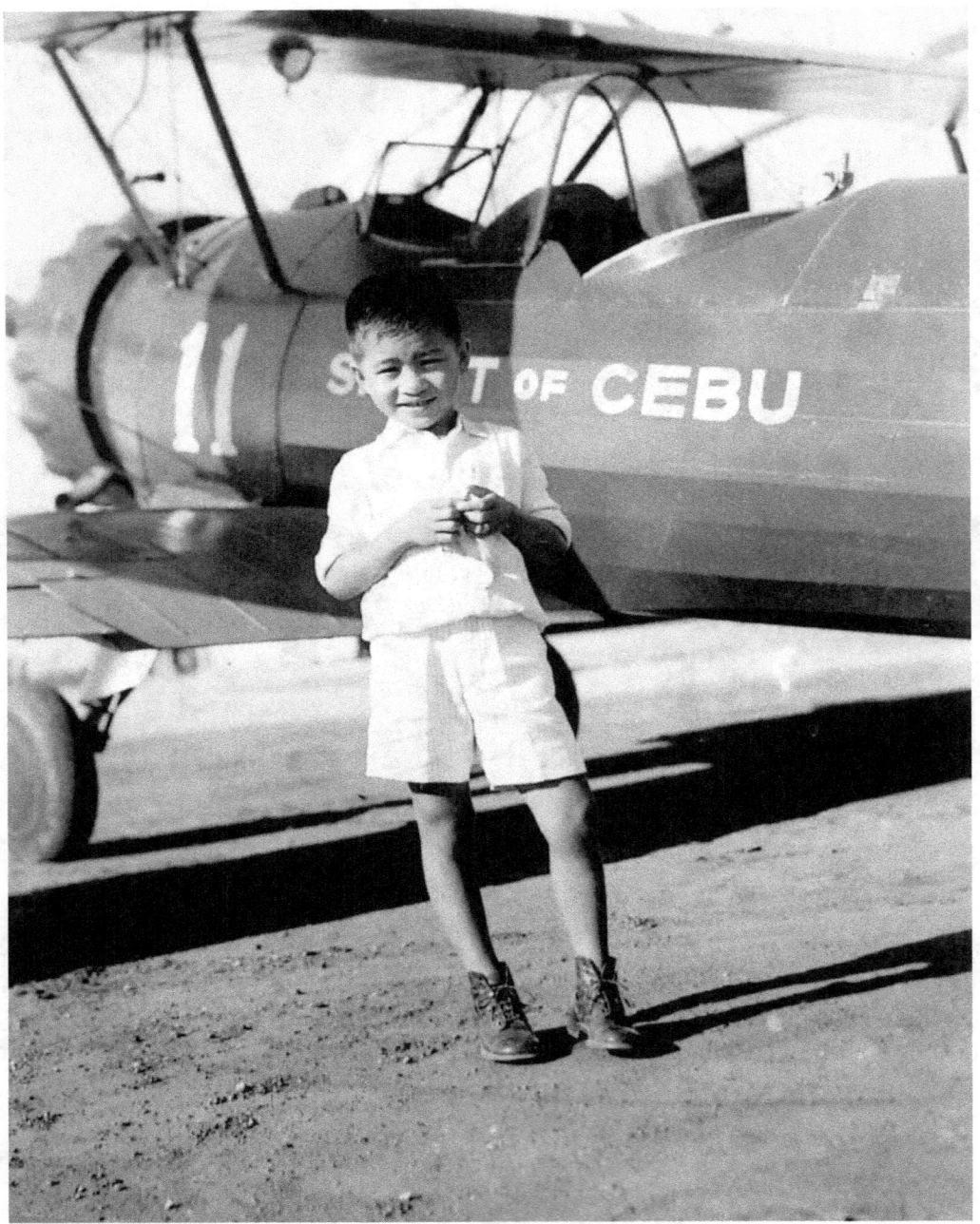

THE SPIRIT OF CEBU That's my eldest brother, Dominador, probably at age eleven, posing before one of the country's very first private planes that was about to fly out from the Manila airport to Cebu City, a historic place in the middle part of the Philippines. Dominador would have been in his late 80s today (2017) if he were still around.

THE BEAUTY OF BLACK & WHITE

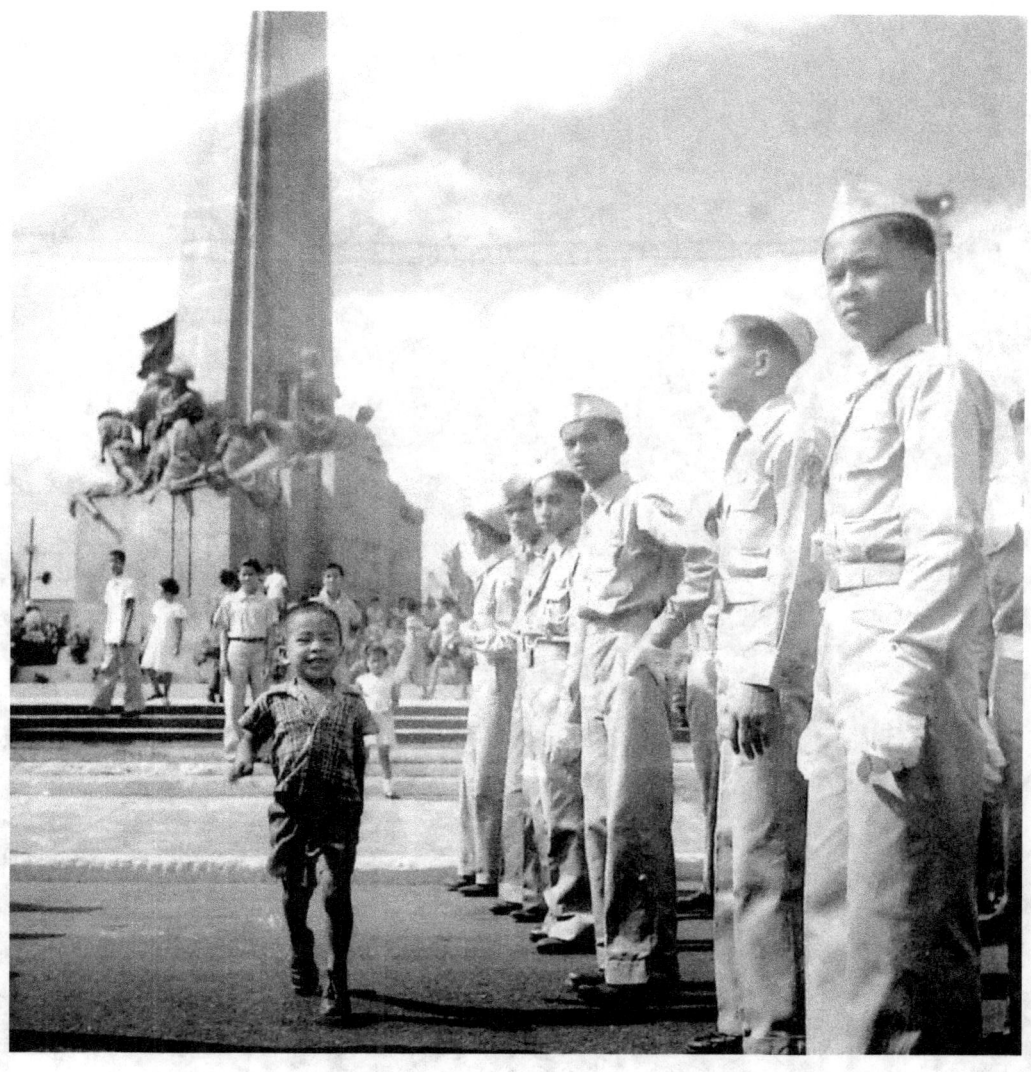

TROOPING THE LINE This young boy mocks trooping the line as ROTC cadets prepare to stand at attention in this photo taken at the monument of our national hero Andres Bonifacio, one of the founders of the *Katipunan* (association), a Philippine revolutionary society of the 1890s that ignited the bloody rebellion against colonial Spain. Bonifacio's birth anniversary is observed annually on November 30, a national holiday in my country.

"The *Katipunan* (usually abbreviated to KKK) was a Philippine revolutionary society founded by antiSpanish Filipinos in Manila in 1892, whose primary aim was to gain independence from Spain through revolution. Based on recently found contemporary documents, the society has been organized as early as January of 1892 but may have not became active until July 7 of the same year on the night when Filipino writer (and national hero – Author) José Rizal was to be banished to Dapitan earlier in the day. Founded by Filipino patriots Andrés Bonifacio, Teodoro Plata, Ladislao Diwa and others, initially, the Katipunan was a secret organization until its discovery in 1896 that led to the outbreak of the Philippine Revolution."

https://en.wikipedia.org/wiki/Katipunan

THE BEAUTY OF BLACK & WHITE

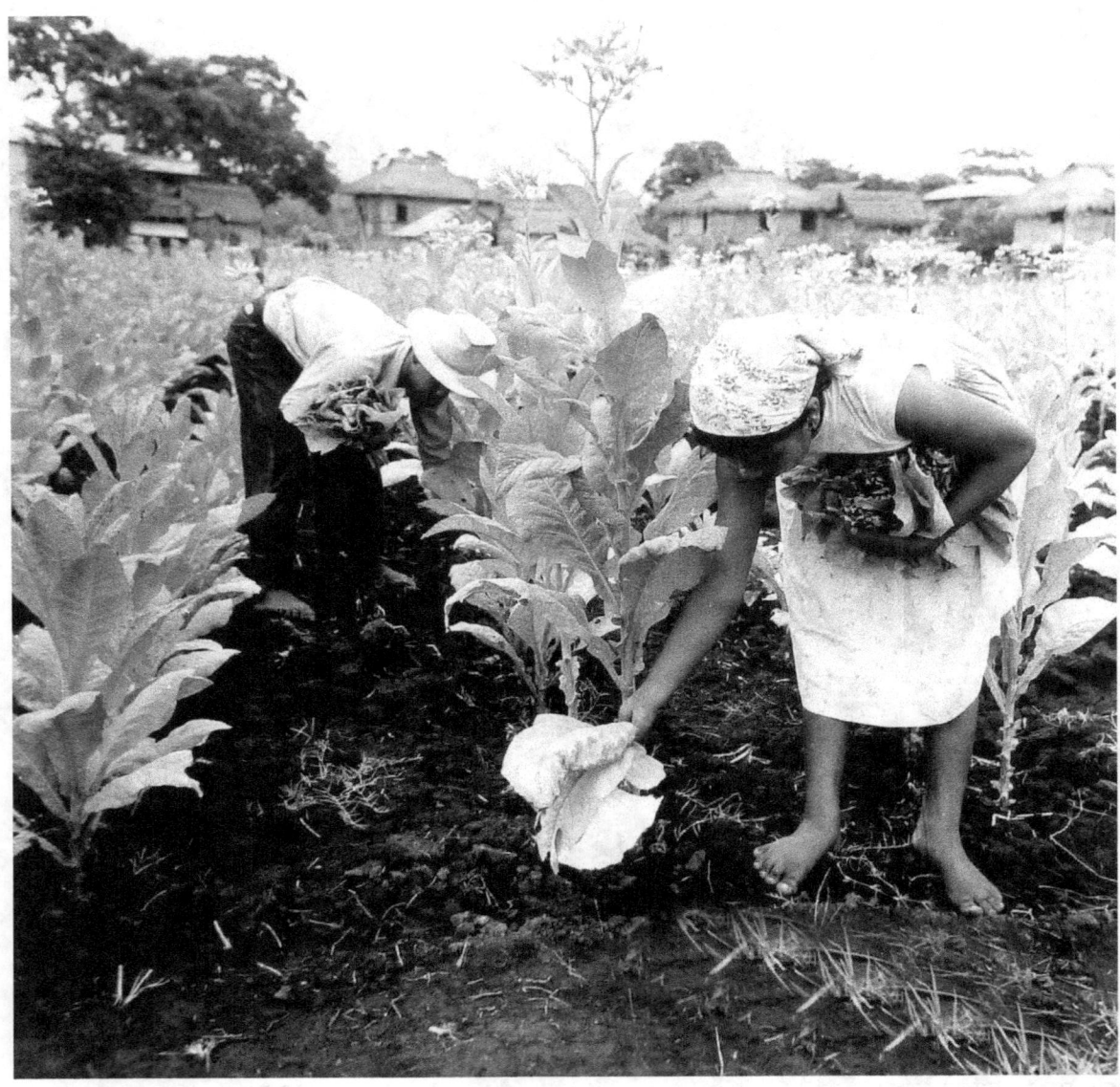

HARVEST TIME Two helpers pick "Virginia" tobacco leaves from a family plot somewhere in the town of Santa Lucia in the province of Ilocos Sur in northern Philippines, one of the few provinces in the region where tobacco used to be cultivated and planted extensively as a major crop. Many farmers had become affluent from tobacco trading.

The Spaniards introduced to the Ilocanos the first tobacco seeds in the last quarter of the 16th century (http://nta.da.gov.ph/about_tobacco.html). Today, almost 400 years later, the tobacco industry in the Philippines is not as active as it used to be, owing to international campaign on the hazards of smoking and many Ilocanos have shifted to other hybrid crops for cultivation.

THE BEAUTY OF BLACK & WHITE

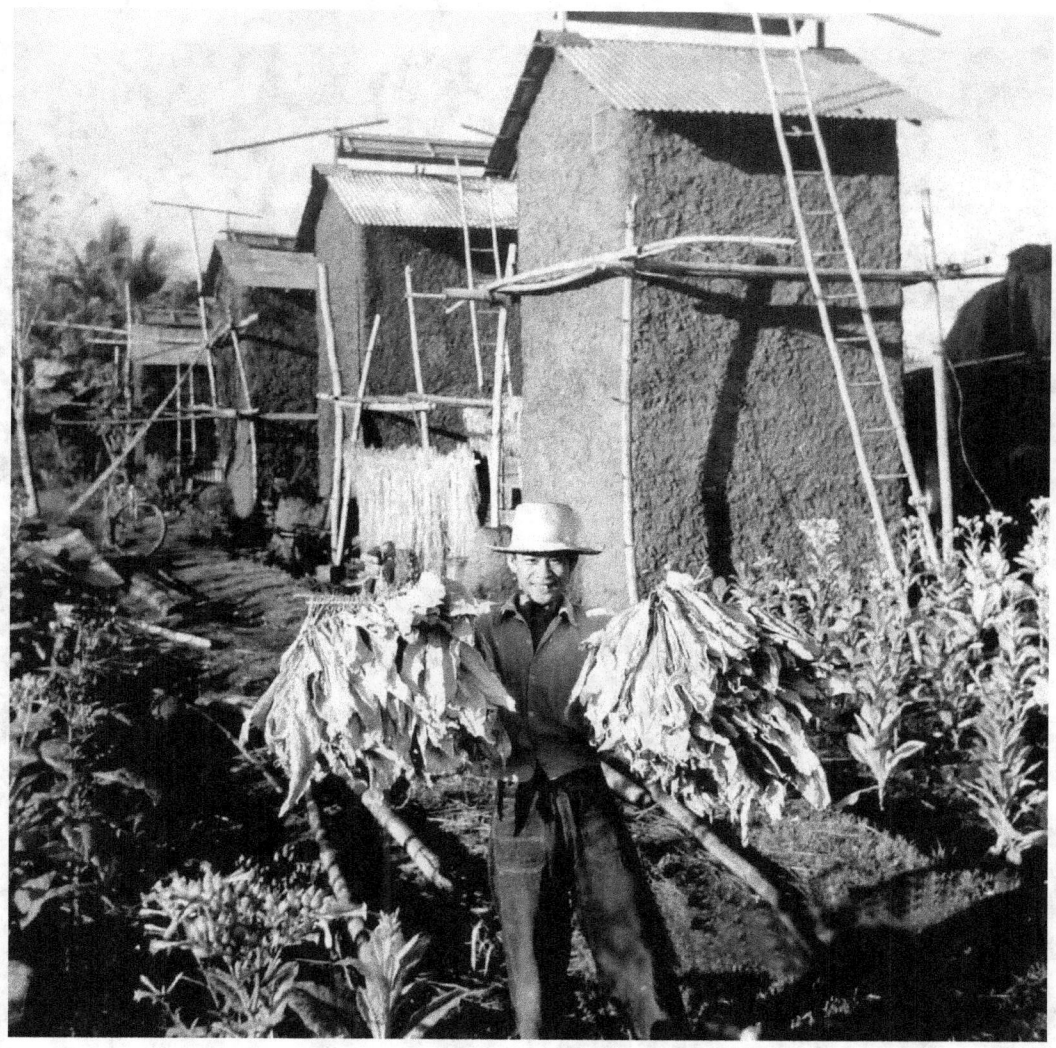

TOBACCO LEAVES READY FOR CURING My elder brother, Fortunato (on vacation from Manila when this photo was shot by my father), displays harvested tobacco leaves that are ready for curing in one of the barns owned by the family of my mother as shown in the background.

An autistic, Fortunato (Spanish word for "fortunate.)" was so patient in taking over all the collections of photographs and negatives that my father had left behind when he (my father) died in 1976. Fortunato diligently arranged and kept them in albums and boxes at our house in Caloocan City in Metro Manila. A year before he died at age 75, and with his eyes failing, Fortunato sentimentally handed over to me all the precious collections of photographs since we were the only siblings living in the country at that time (2001). Later on, it dawned on me that it must have been my mother who had instructed Fortunato to take care of my father's collections of historic negatives and photographs some of which are now featured in this book.

THE BEAUTY OF BLACK & WHITE

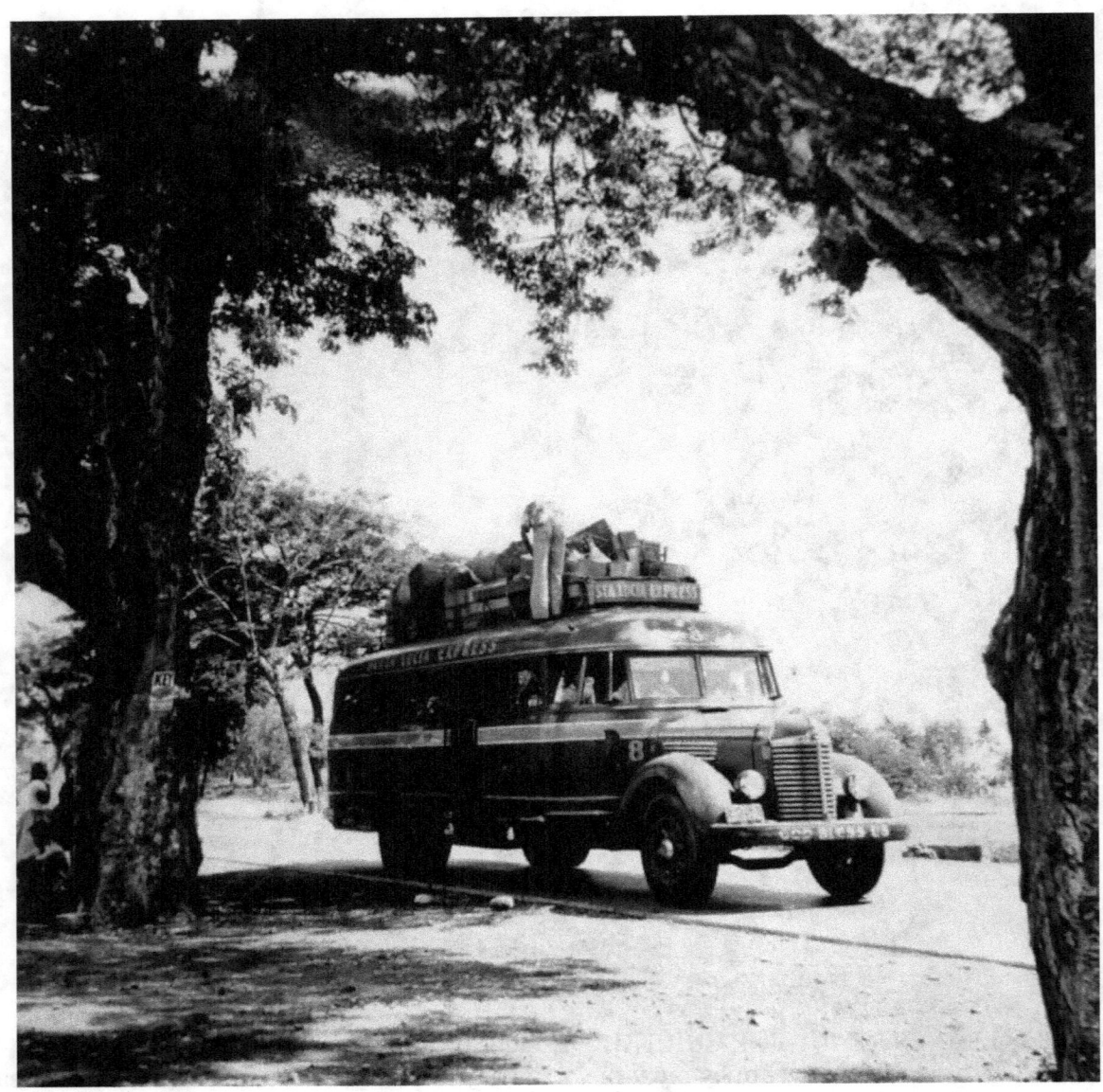

GOOD OLD NO. 8 This is how old "provincial buses" looked. This one used to travel between Ilocos Sur to Manila and back to Ilocos, a distance of about 400 kilometers. I still remember the quaint old terminal in Manila of the Santa Lucia buses that we would take in going to Ilocos Sur leaving at four o'clock in the morning (early 1950s). It was a back-breaking 10 hours travel. Notice the bus conductor on top of the bus. In the old days, it was customary for passengers' luggage to occupy the top-load area of a bus. Sometimes, things could fall off if they are not well secured.

THE BEAUTY OF BLACK & WHITE

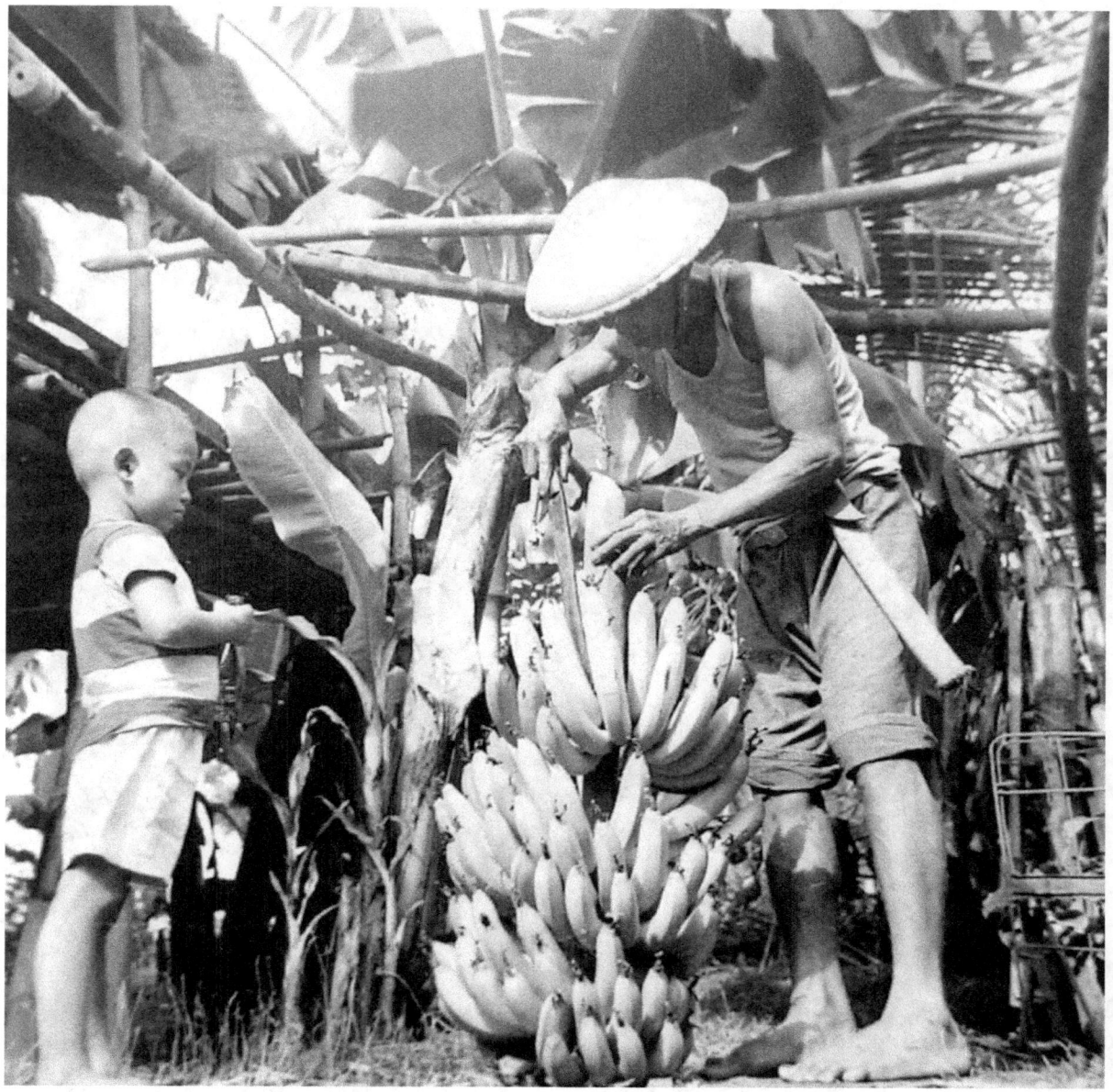

"GIVE ME SOME, GRANDPA" My youngest brother, Carlito, waits in anticipation as grandpa Fausto cuts some Cavendish banana from a large stalk. Notice my grandpa's large feet which are accustomed to walking bare. My father took a shot of the whole length of the stalk with the banana plant in the background.

THE BEAUTY OF BLACK & WHITE

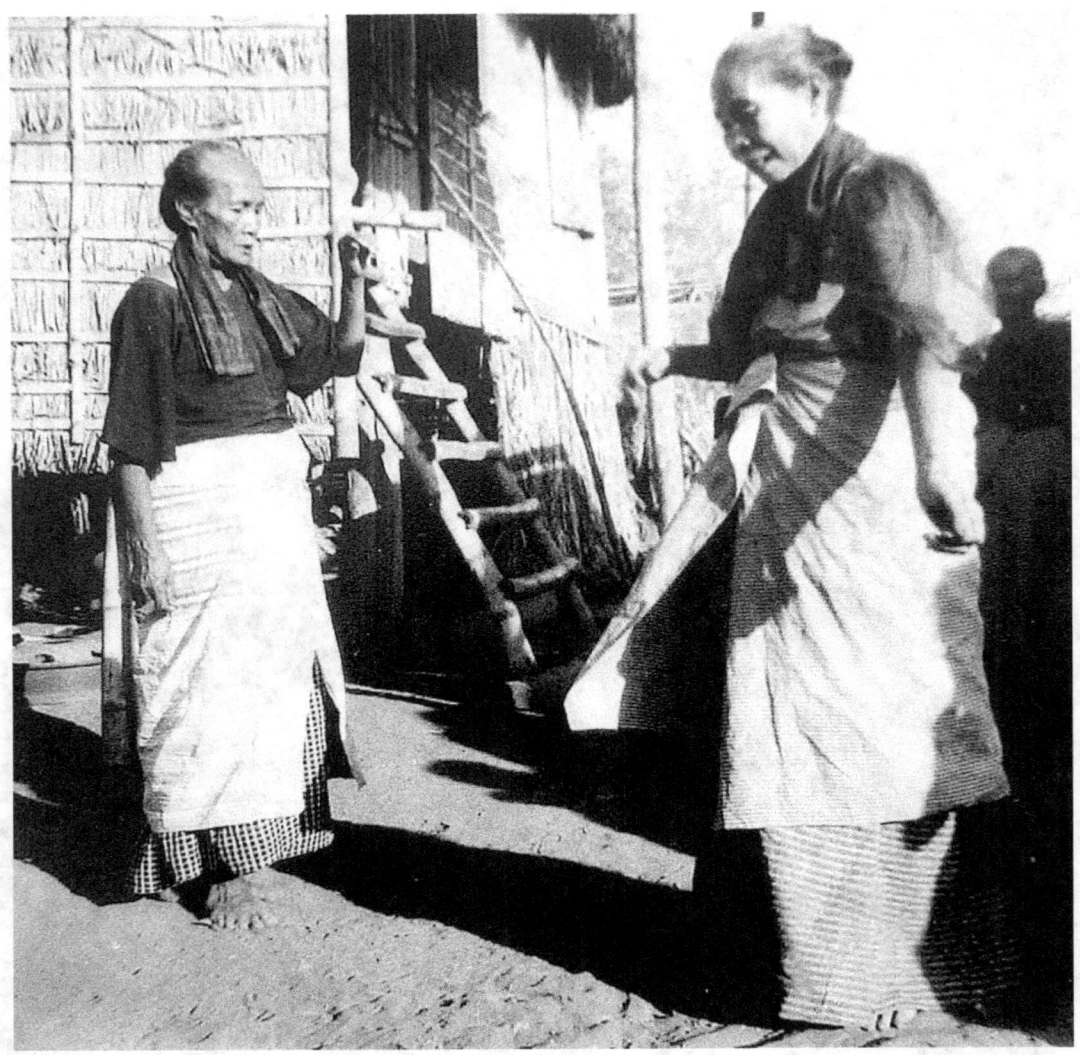

MOURNING DANCE The provinces in northern Philippines are steeped in tradition and old cultural practices, some of which are no longer observed today. One of the old practices was to hire "funeral dancers" who would dance a slow crude ballet, simulating a soul's flight into heaven. The dance is performed as the coffin is brought out and is usually characterized by graceful hand movements using scarf amidst the somewhat disconcerted shrills of singing voices by old ladies called "cantores." In this photo, my father caught for posterity the actual ritual (but minus the coffin).

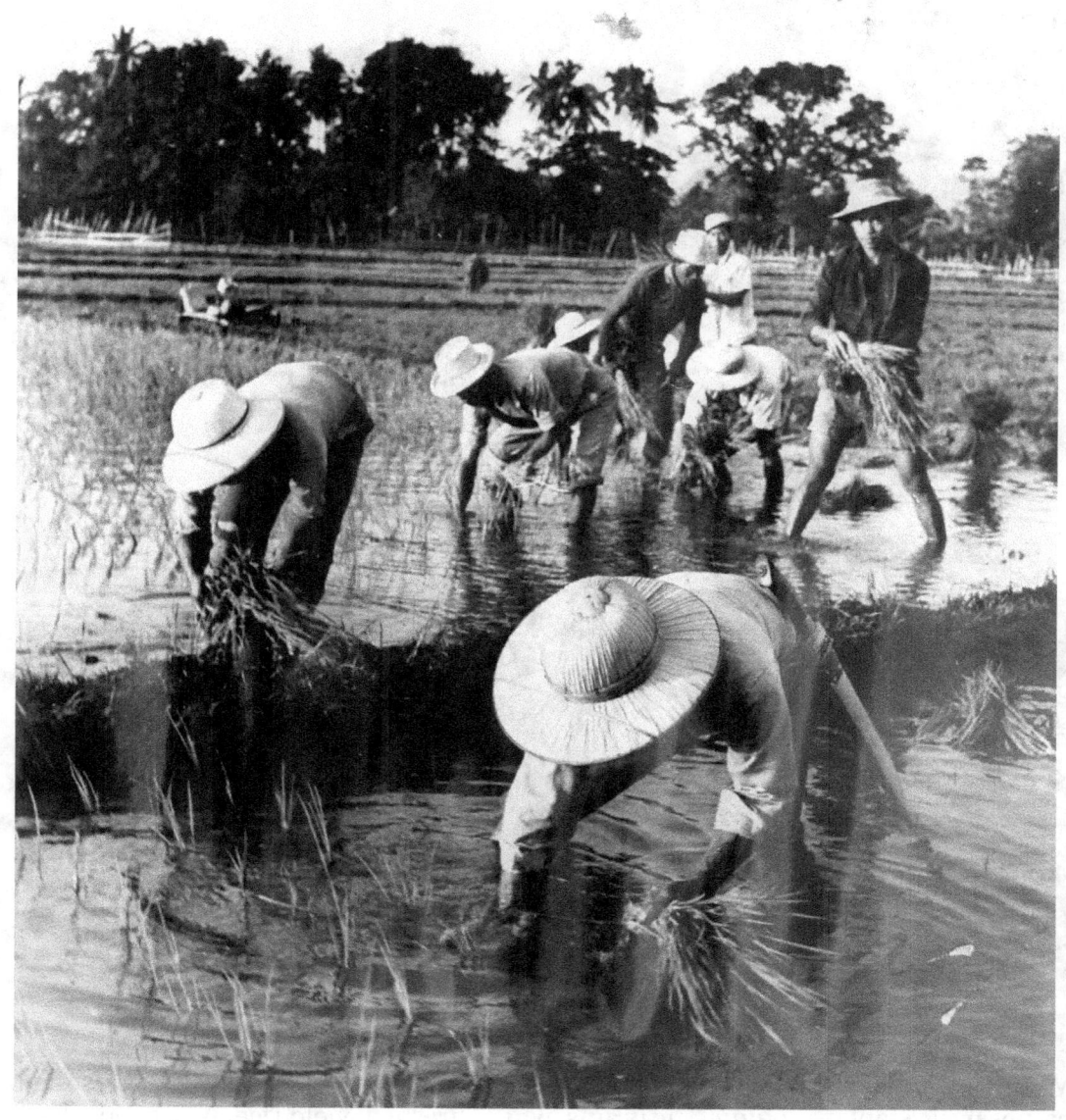

PLANTING RICE An old traditional song that was introduced by the Americans when they colonized the Philippines in the early 1900s is titled: "Planting Rice." The opening lyrics go this way: "Planting rice is never fun; bent from morn till the set of sun." Indeed, it is a back-breaking manual work as practiced then and now. Notice the straight line with which the rice seedlings are planted. This is the "Margate System" introduced in th early 1950s. My father snapped this picture in his hometown of Mangatarem in Pangasinan province north of the Philippines.

THE BEAUTY OF BLACK & WHITE

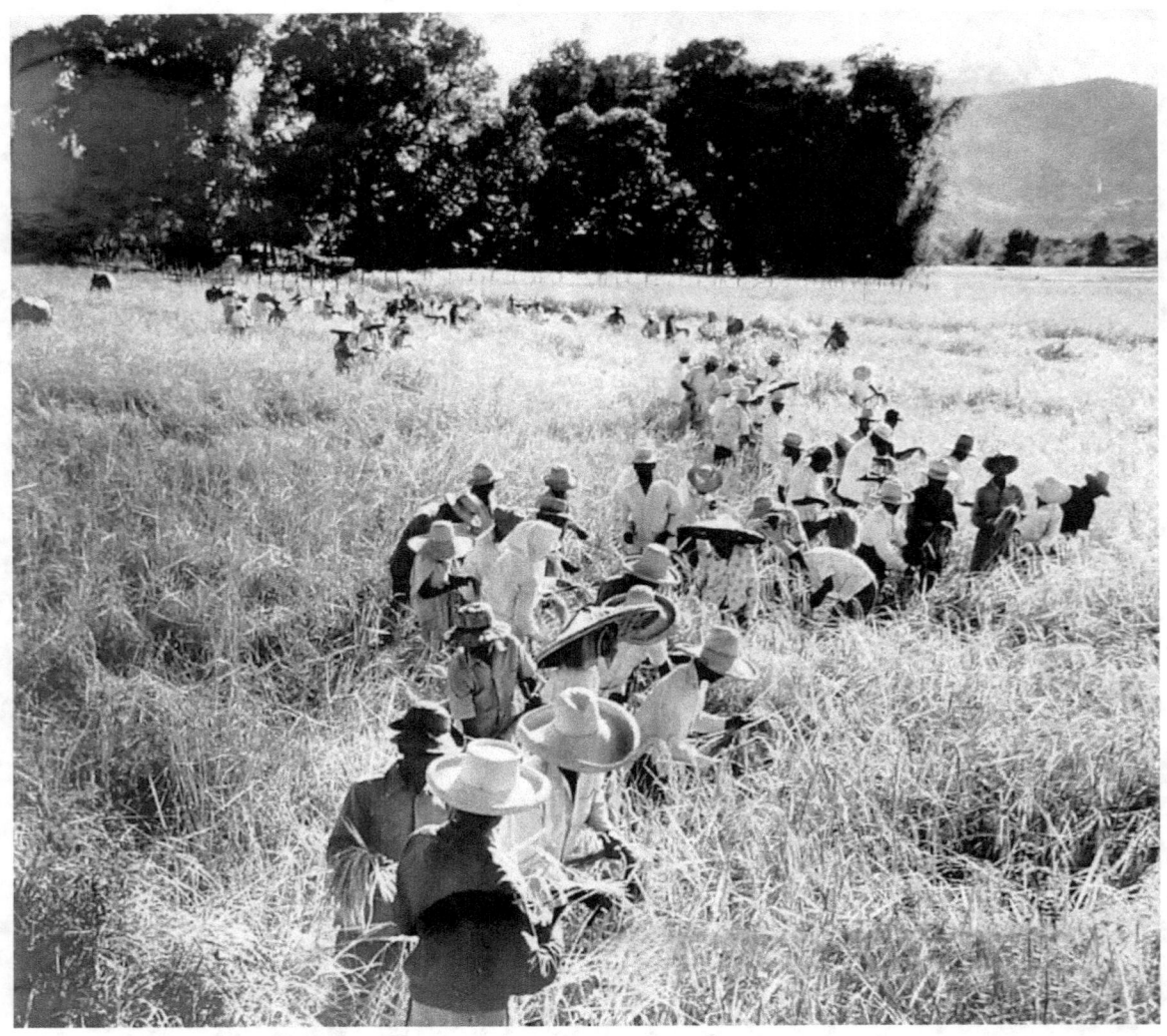

HARVEST TIME A whole lot of hands are on deck as they busy themselves harvesting the Philippines basic staple --- *palay*. The grains, when threshed, yield rice, Asia's most basic staple. Harvest time almost always draws a lot of people for the excitement of seeing the fruit of one's labor. In the old days, in scenes like this, farmers would give free labor to fellow farmers who are expected to return the favor in like manner when needed. The native term for this is called *bayanihan*. Today, laborers are paid to do the work.

THE BEAUTY OF BLACK & WHITE

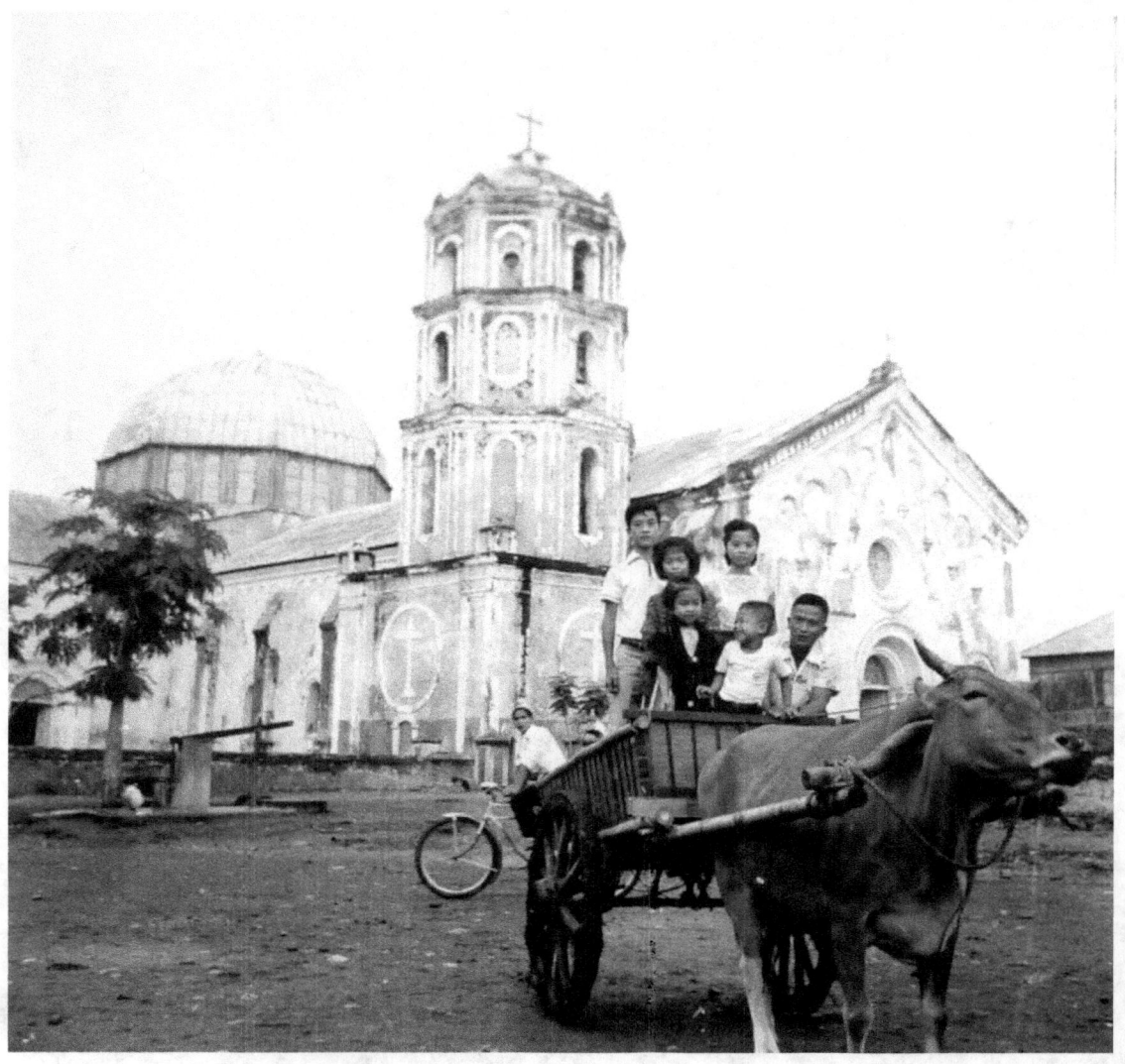

A BULLCART RIDE My mother's younger brother, Geronimo (seated at right) reins in a Brahman bull while my father hurriedly snaps this picture in front of the old Santa Lucia Church in the same town in Ilocos Sur. I am that frail-looking lad of 12 years standing at left on top of the bull cart. With me are cousins Nena, Vicky, Josephine and Boy in one of our summer vacations from Manila.

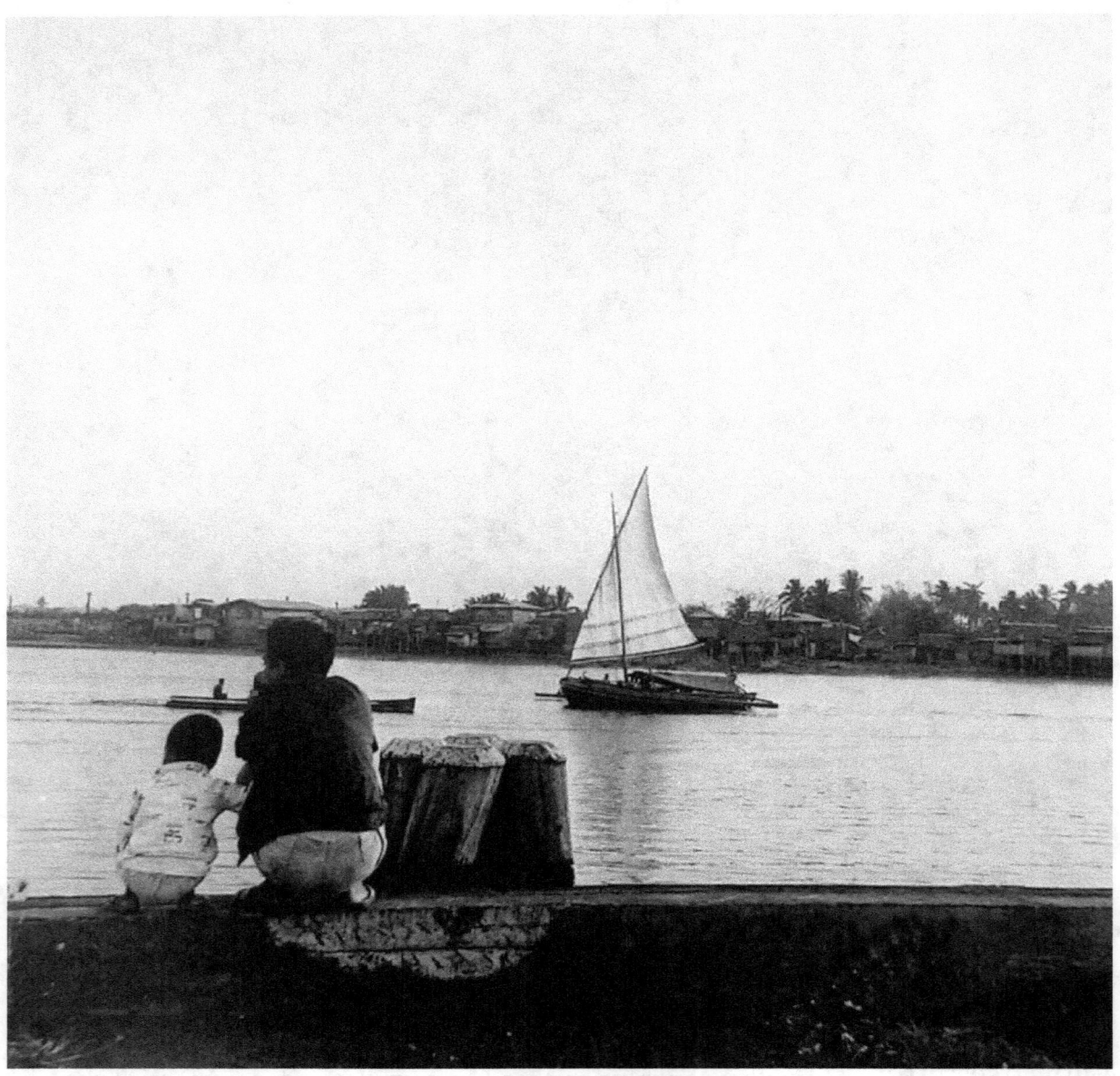

FIFTY YEARS AGO OVERLOOKING CALMAY VILLAGE IN DAGUPAN CITY A "paraw" (small sailboat) loaded with salt from western Pangasinan makes its way to a small port in Dagupan City with the village of Calmay shown in the background. Today (2017) the river is heavily silted and there is still no bridge that would connect the island villages of the growing city to the central business district.

THE BEAUTY OF BLACK & WHITE

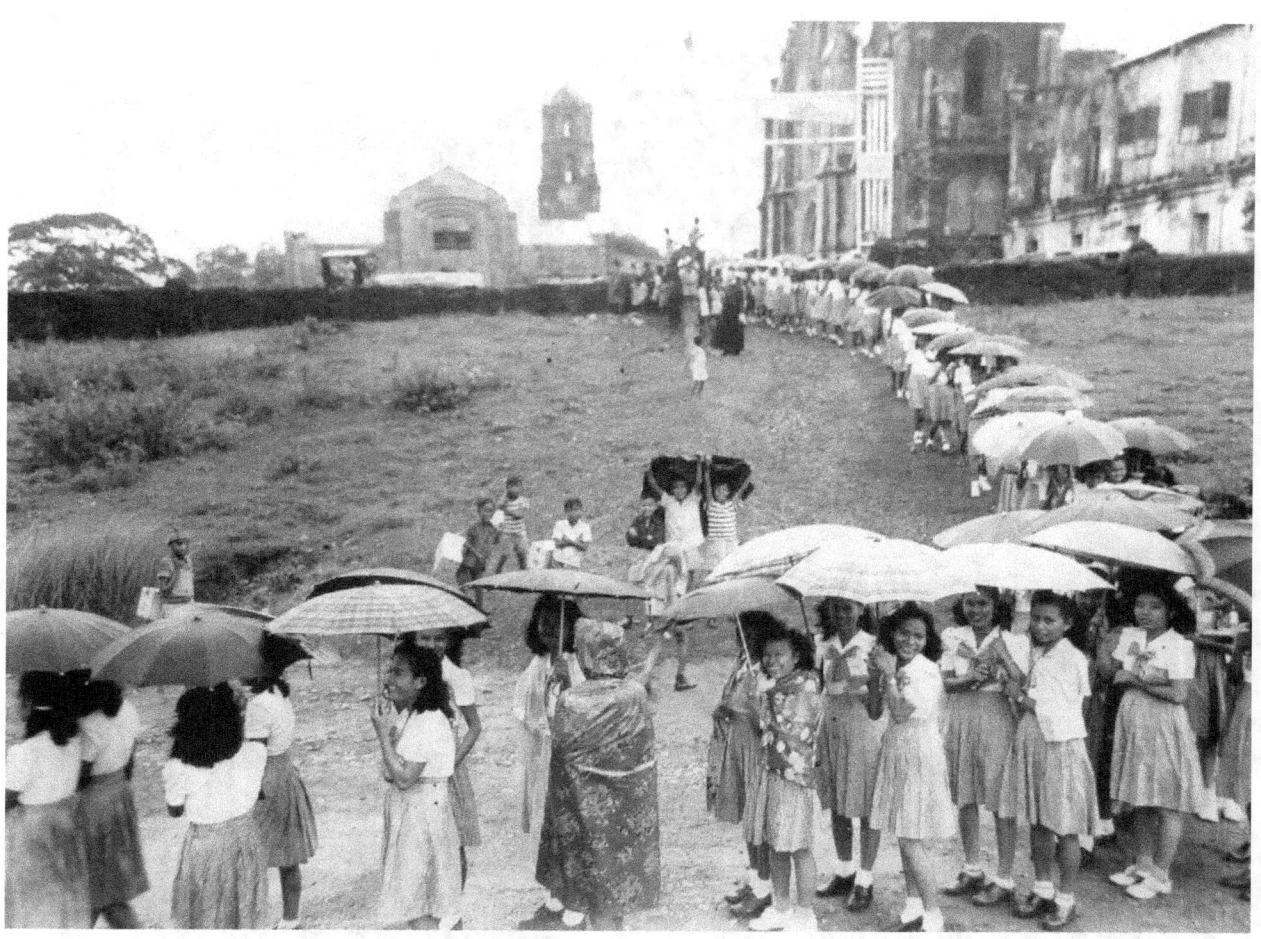

THE LONG GIRLS LINE These young college girls stand under a drizzle in rows of two waiting for the procession to stream out of the church. The traditional procession of patron saints are still practiced the biggest of which are held in Manila (*Nazareno, The Black Nazarene*) and Cebu (*Santo Niño, Child Jesus*).

THE BEAUTY OF BLACK & WHITE

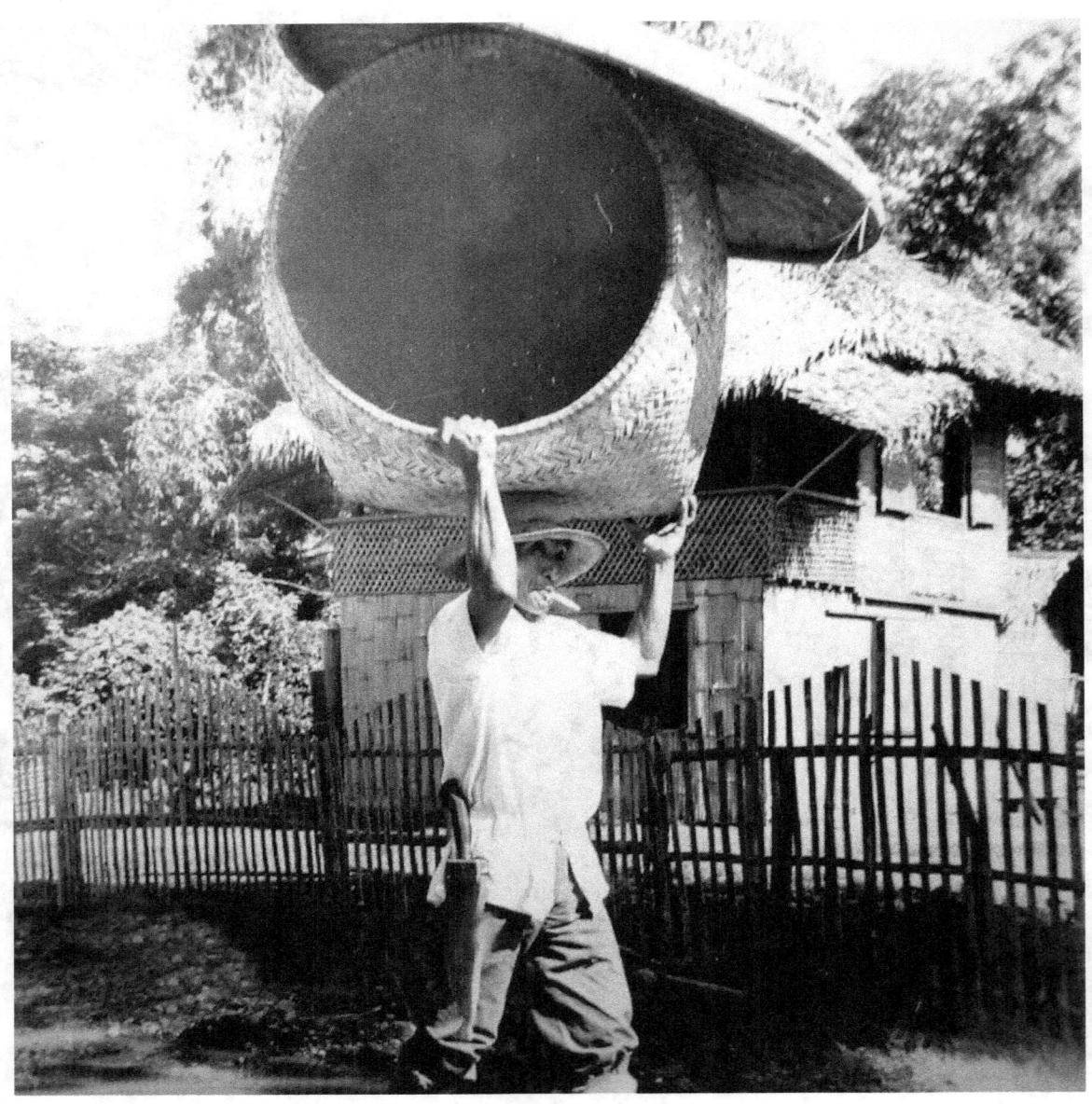

AS BIG AS IT CAN GET A farmer carries a large container of palay grain on top of his head while a cigarette is stuck between his lips and a machete dangles on his side.

THE BEAUTY OF BLACK & WHITE

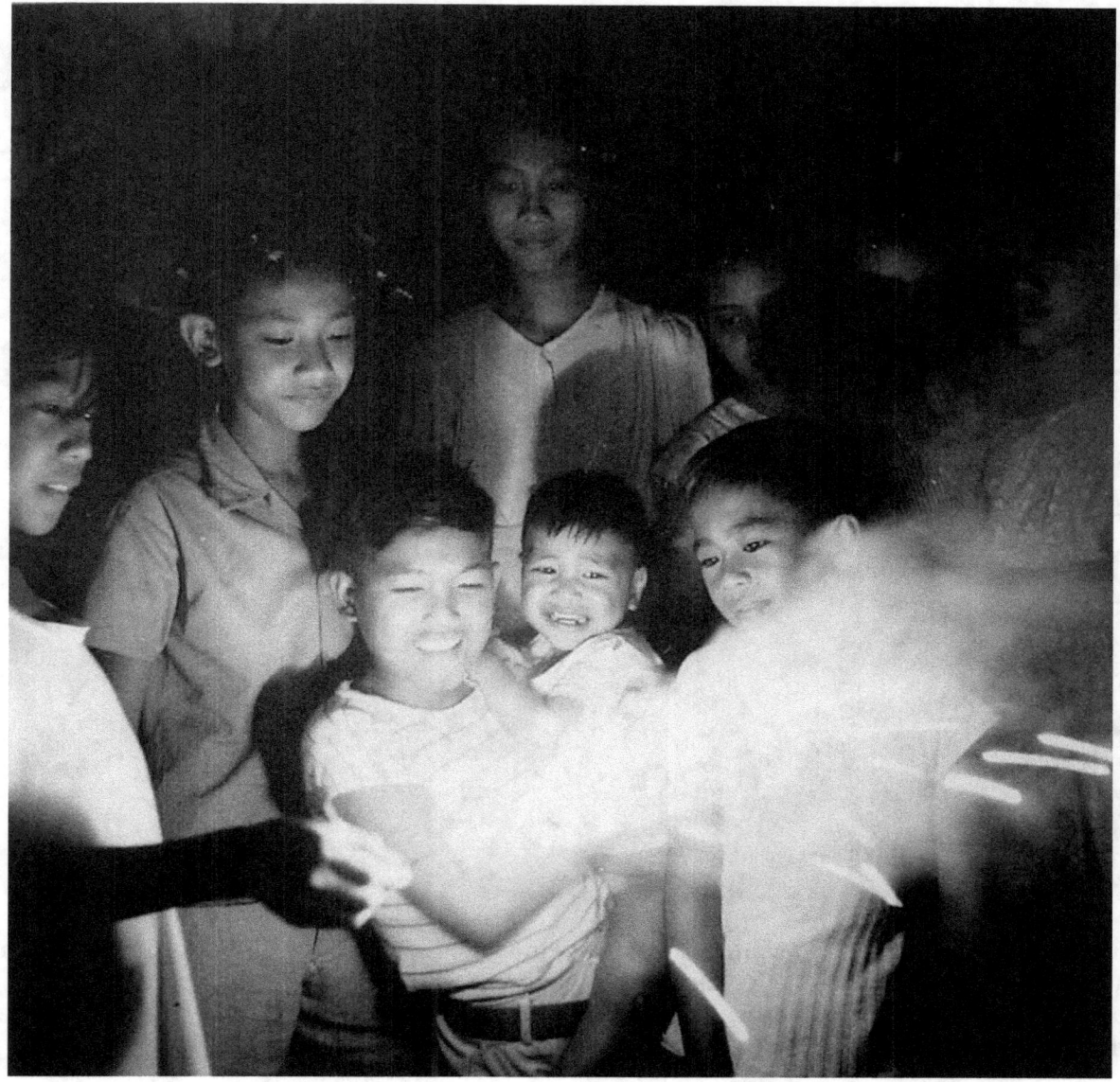

WELCOME THE NEW YEAR Almost the entire neighborhood watches as a sparkle consumes itself in this scene from out of New Year's eve somewhere in Santa Cruz district in the northern part of Manila which was still getting out of the ashes of the World War II. It used to be that this part of Manila was the "enclave" of the working middle class while the southern part of the big city was the domain of the rich capitalists. Toward the end of WW II, battalions of the Japanese Imperial Army retreated southward of Manila and slaughtered many rich people along the way in street-to-street fights against invading US troopers.

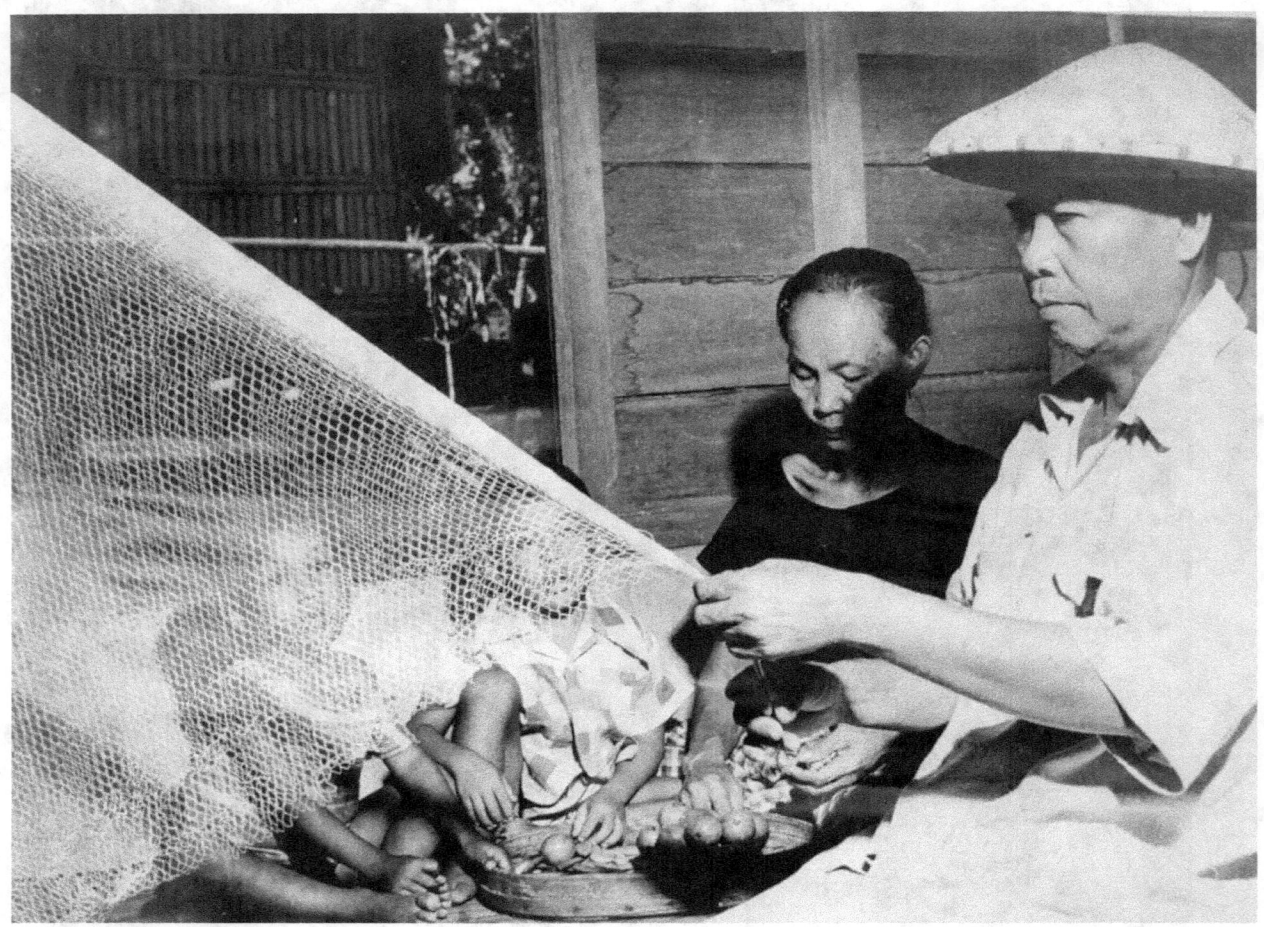

NO FISHING TODAY Two young boys gape at their "old man" fixing his fishing net while their mother peels some local fruits for them. The shadows cast by the subjects indicate that the source of available light is overhead most likely from a lighted Coleman lamp fueled by alcohol which was the most popular source of evening light in the 1940s up to the early 1960s.

THE BEAUTY OF BLACK & WHITE

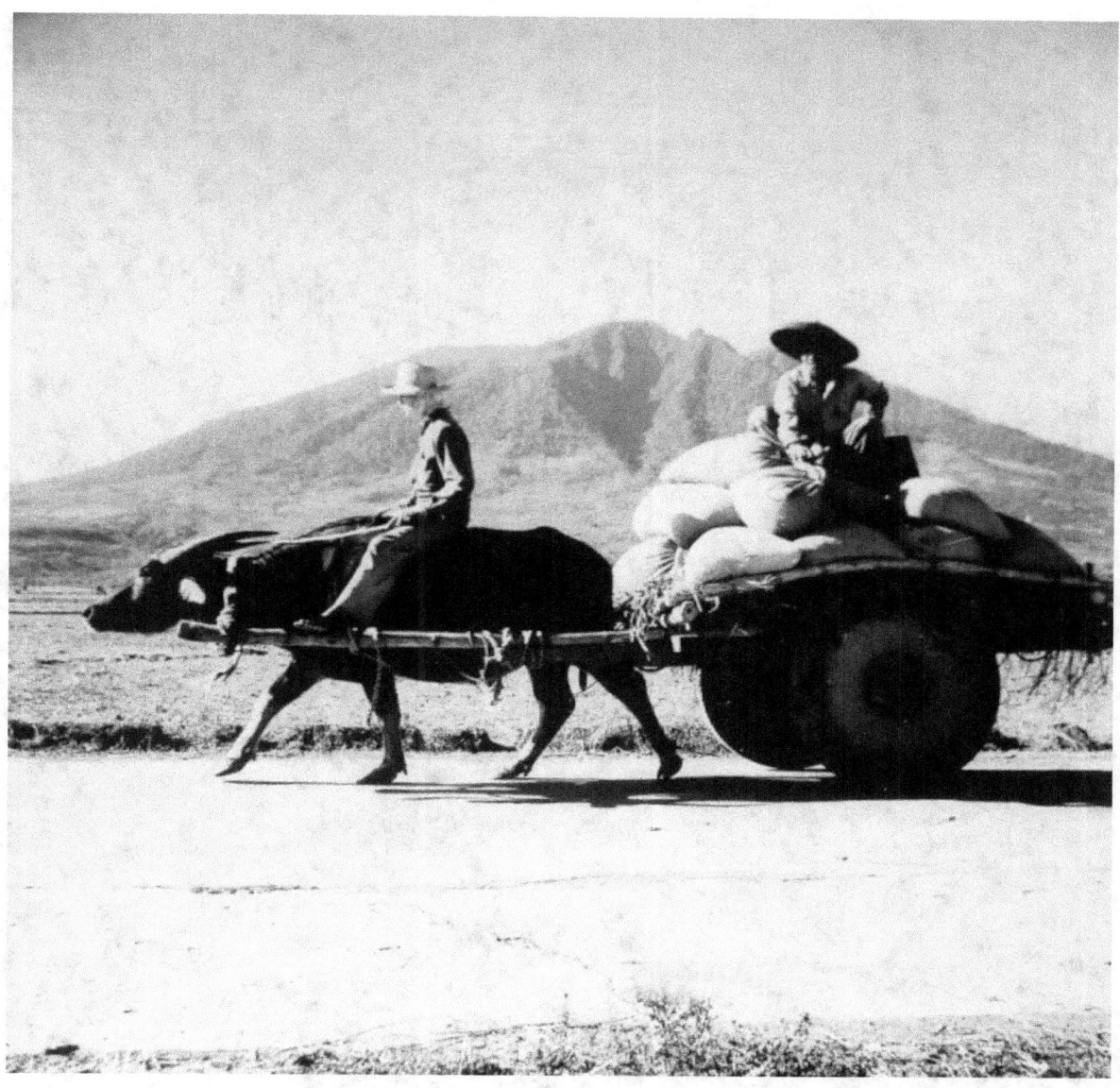

MT. ARAYAT, AN EXTINCT VOLCANO My father clicked his camera shutter in perfect timing as this animal-driven bull cart slowly moves along the main highway somewhere in Central Luzon in the Philippines main island. In the background could be seen Mt. Arayat, an extinct volcano in which a large group of communist rebels sought refuge for many years as they fought a losing battle with government troopers in the early 1950s. Marcial was embedded with the government troopers as he covered the campaign for THE MANILA TIMES. (See next part of this book, *"I Saw History Unfold."*)

THE BEAUTY OF BLACK & WHITE

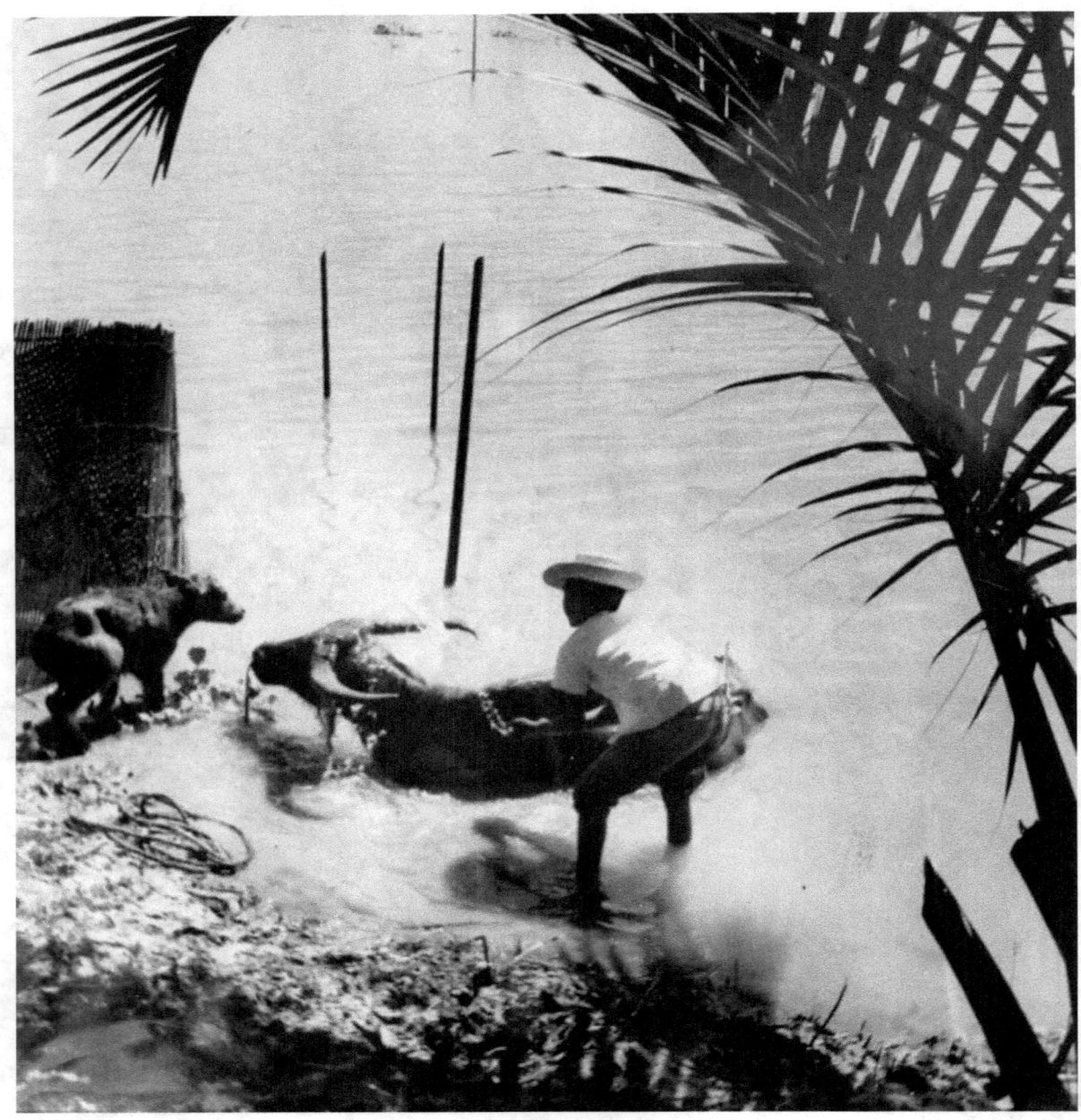

SHHHOOO. GO, TAKE A BATH A farmer gives his working animal a bath. These are water buffaloes called locally as *carabaos* which are "beasts of burden" used to plow rice fields, pull carts and sleds, and are even slaughtered for food. Philippine lawmakers passed a law in the 1950s banning the slaughter of *carabao* for food consumption. In 1992, the Carabao Center of the Philippines (https://en.wikipedia.org/wiki/Philippine Carabao Center) was created in the province of Nueva Ecija in northwest Philippines.

THE BEAUTY OF BLACK & WHITE

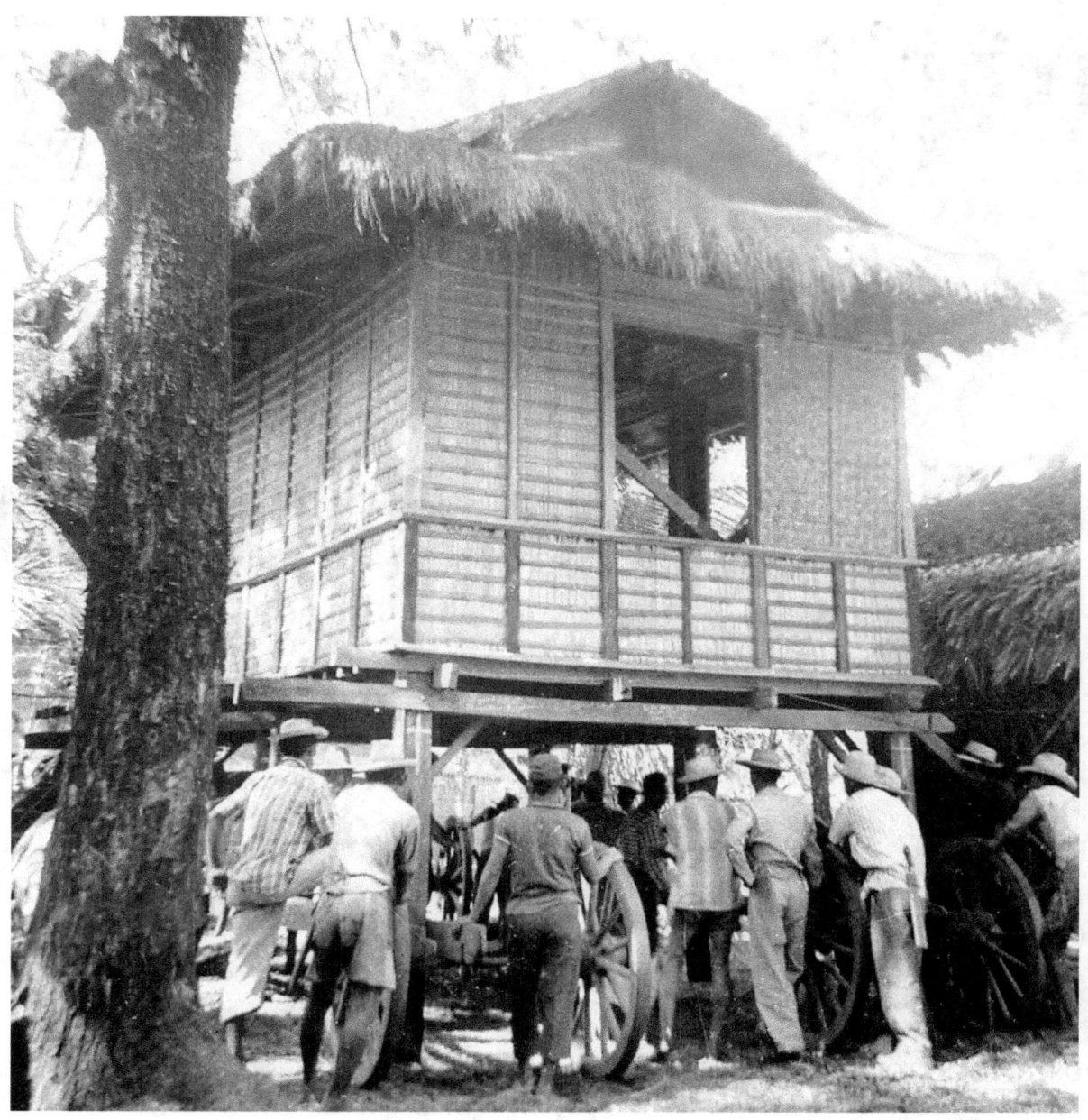

MOVING OUT A WHOLE HOUSE These men prepare to mount a whole house on four sets of cart wheels and move it down the road to a new location. In the old days, most houses were built on elevated posts to ward off entry of wild animals. Doing so also ensures that the house is not easily engulfed by floodwater which was a frequent occurrence in most part of the Philippines then, and more so now.

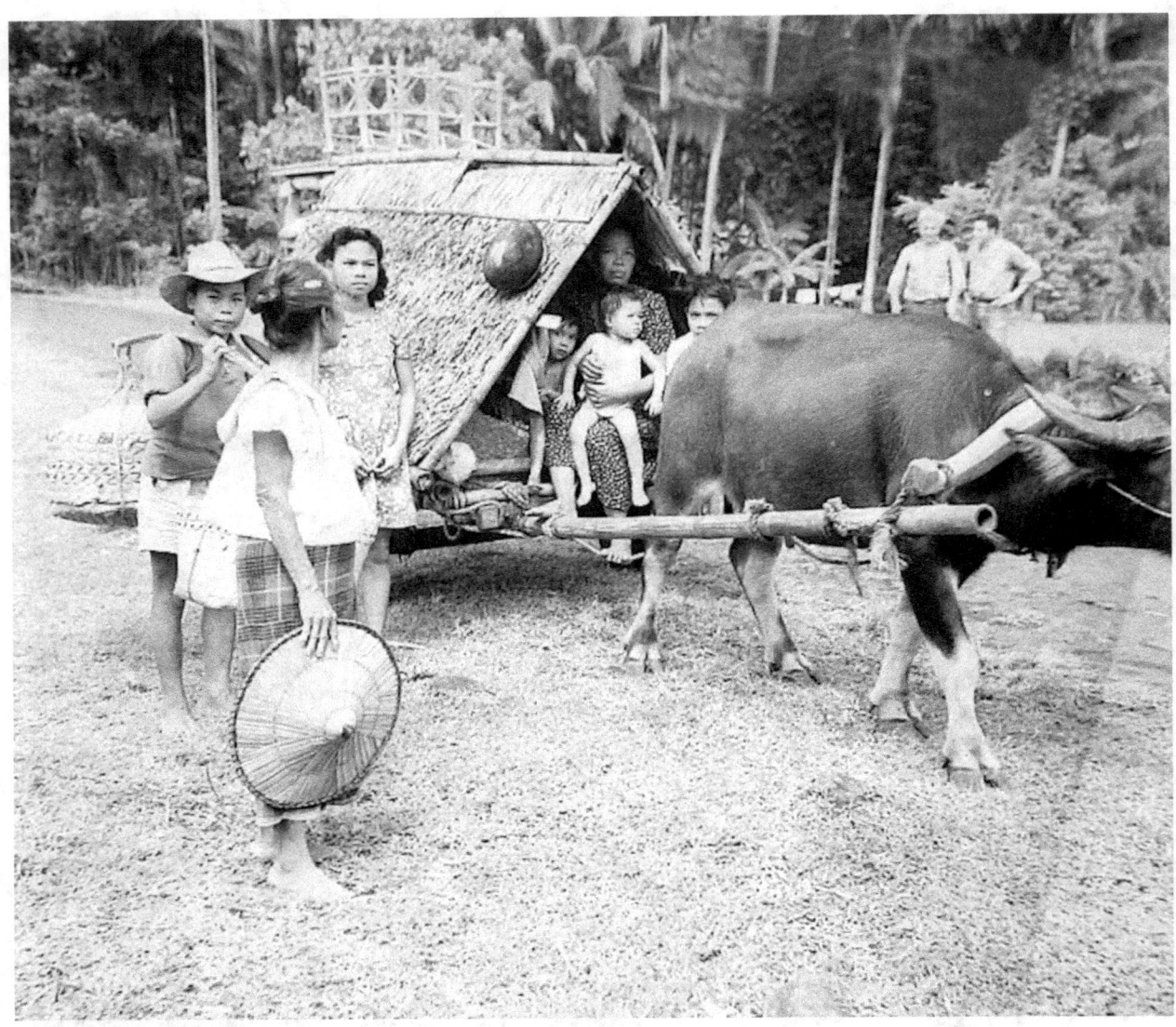

MOVING OUT, TOO This whole family was moving out to a temporary shelter as a result of the government's forced evacuation of residents along the danger zone of the erupting "Hibok Hibok Volcano" on Camiguin Island in Southern Philippines. (c. Between 1948 and 1953) Please see photo of the eruption of the "Hibok Hibok" volcano taken by Marcial on Page 92.

THE BEAUTY OF BLACK & WHITE

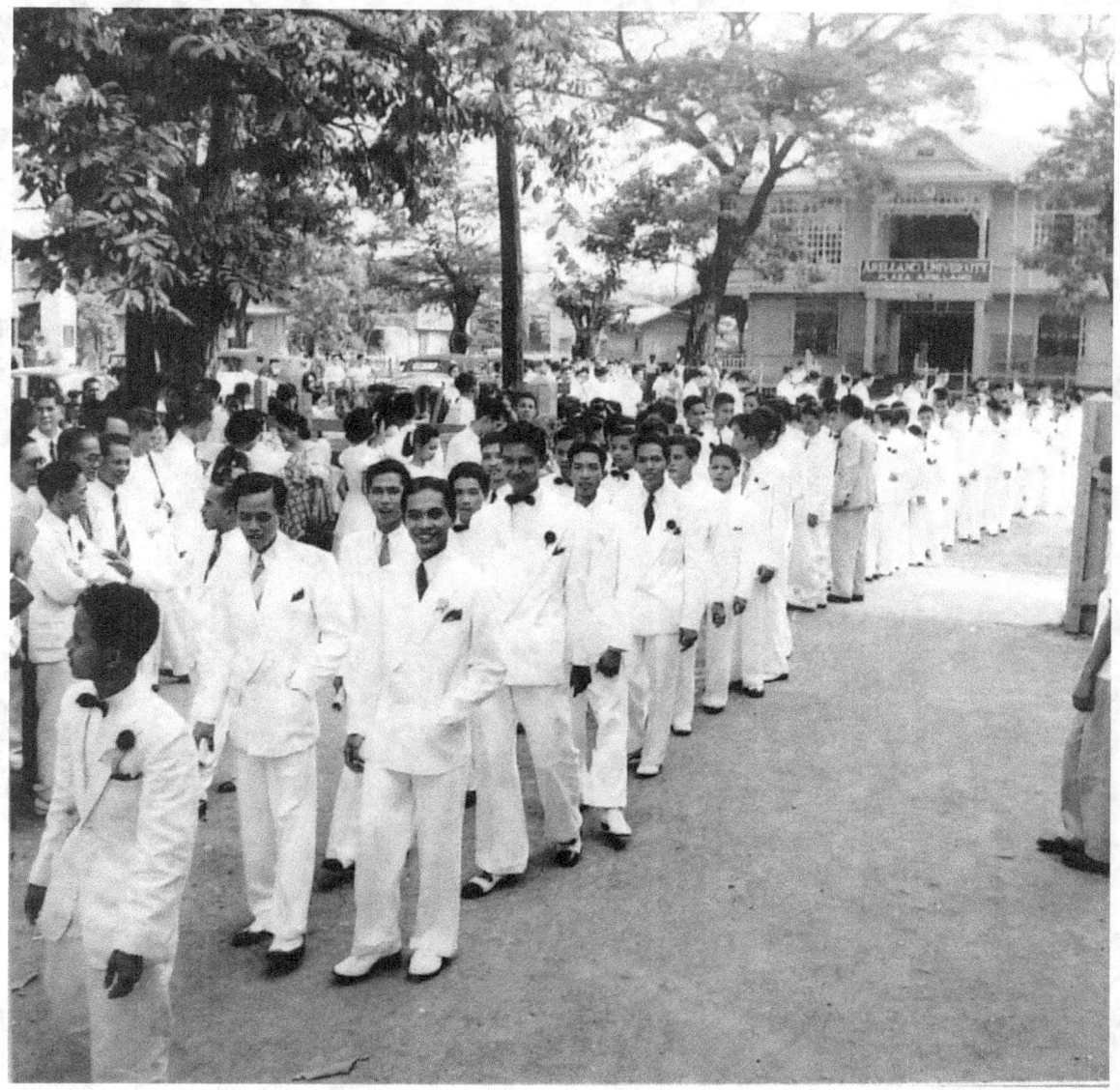

GRADUATION DAY AND THE LONG WHITE LINE These young gentlemen are all dressed up in white and tie ready for the start of the graduation ceremonies at a university in Manila.

THE BEAUTY OF BLACK & WHITE

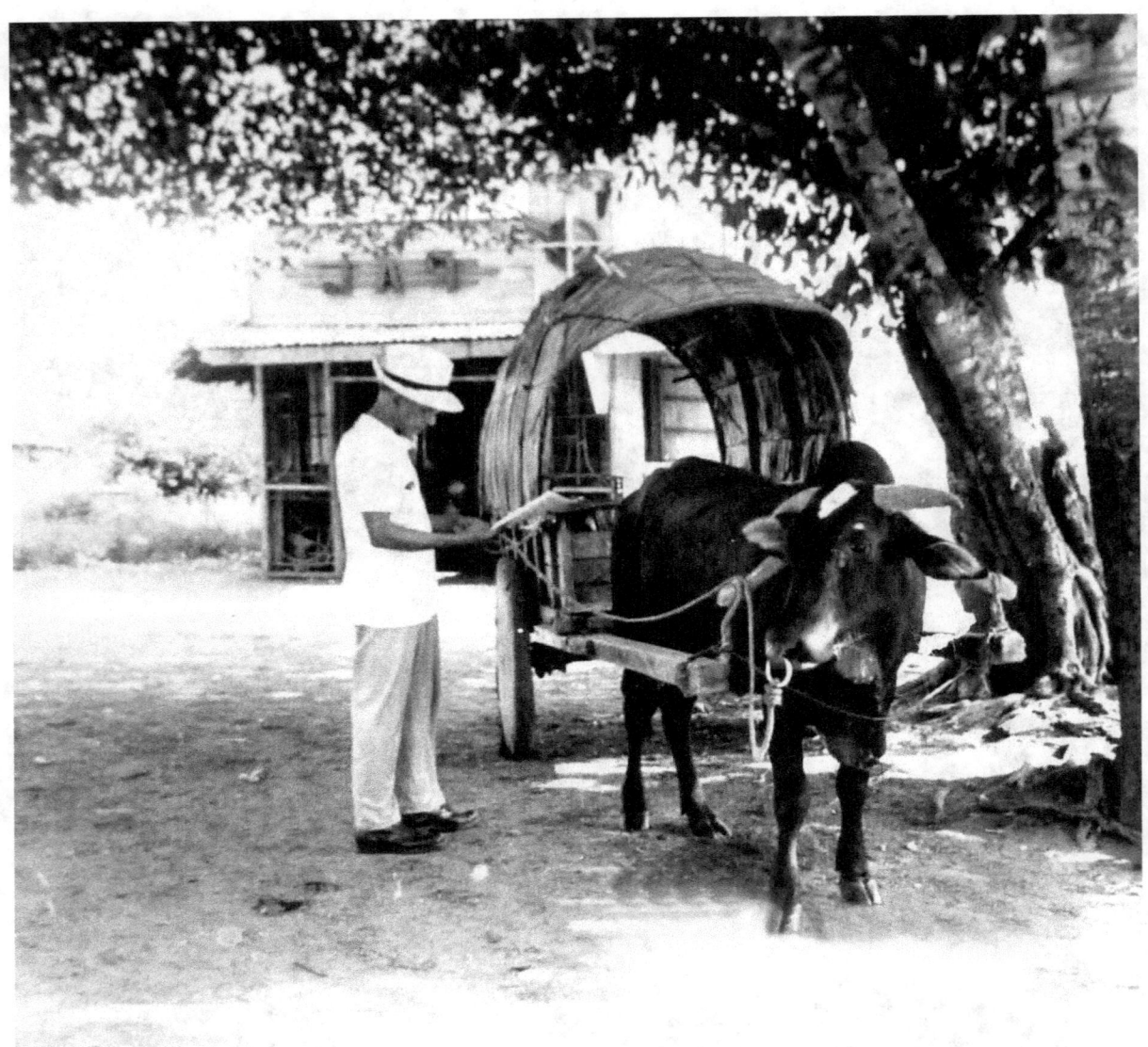

AND THE LATEST NEWS IS My father catches this idyllic setting of a man all dressed up probably for the once-a-week Sunday visit to the "poblacion" (town center) to read the papers while waiting for members of his family who are still attending Sunday service . Their bull cart is shown safely parked under the shade. Today, the once-a-week visit to the "poblacion" by rural folks are still practiced but minus the bull cart as the animal-driven conveyance had given way to motorized vehicles.

THE BEAUTY OF BLACK & WHITE

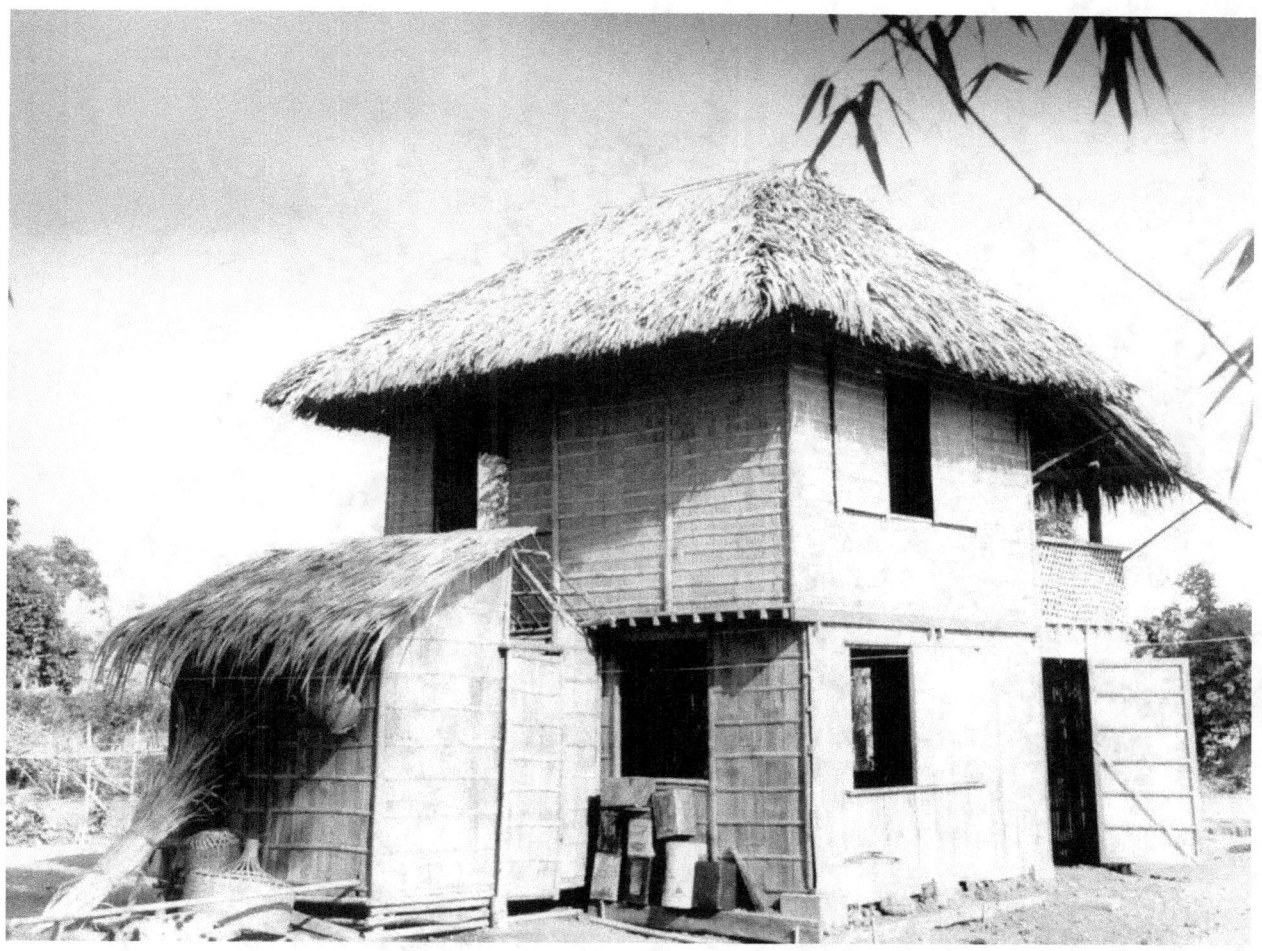

MY NIPA HOUSE Looking spic and span, this house is made of bamboo that has been sourced locally. Except for the roofing --- usually thatched dried palm leaves called *nipa* --- all materials are sourced in the backyard. For walling, the bamboo is flattened until they spread out and are joined together using bamboo ties. Nails are also made of bamboo.

THE BEAUTY OF BLACK & WHITE

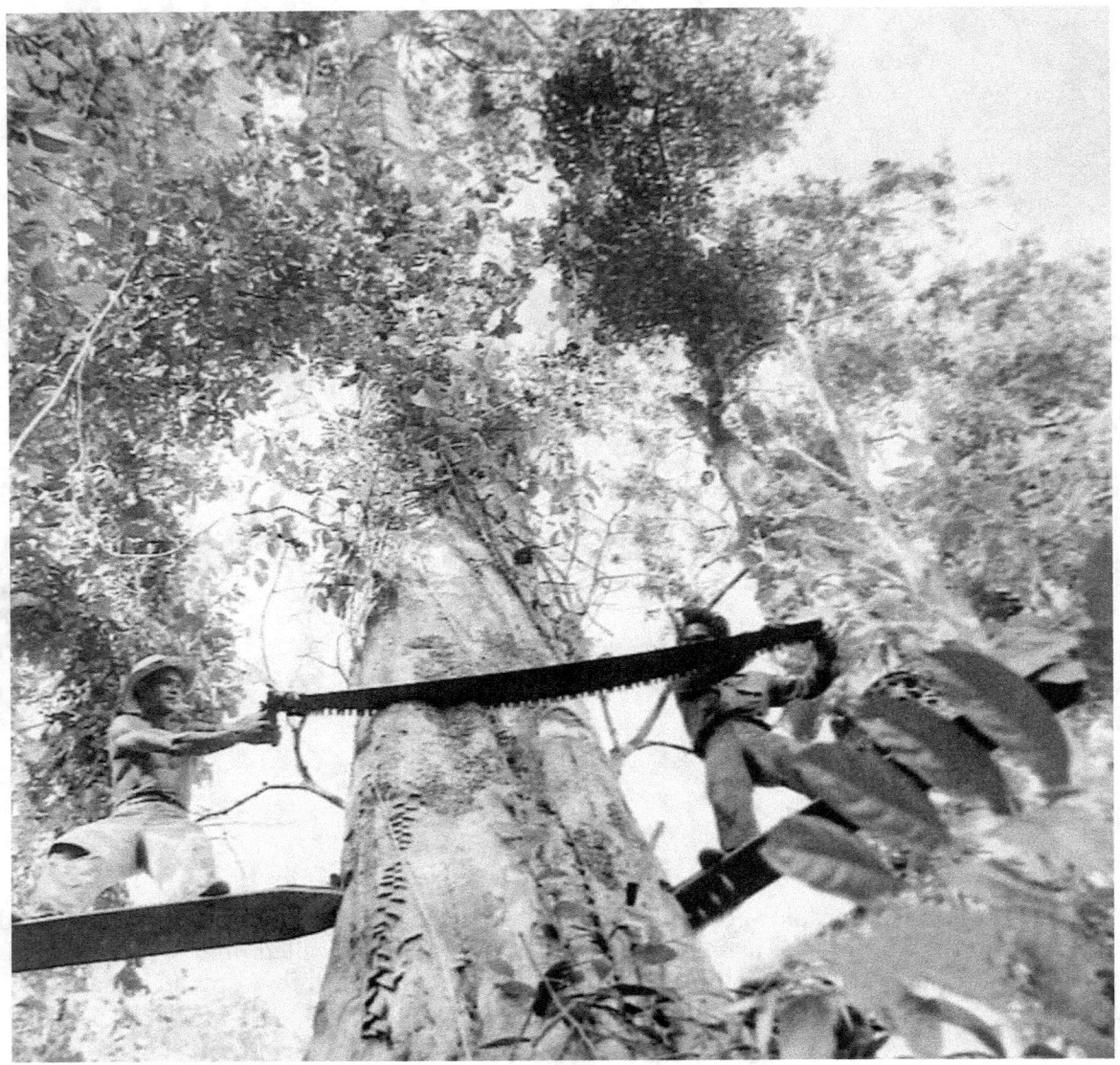

FELLING A CENTURIES-OLD TREE Two loggers, mounted on temporary platforms, operate a giant handsaw using brute manual labor to cut down a big tree. It must have taken Mr. Tree a hundred years to grow this tall and this big only to be felled in a matter of hours of continuous sawing. Today, the method had long been replaced by chain saws and other mechanized devices.

It bleeds my heart seeing big trees like this one felled and virtually "killed" for all eternity. Man must continue to find ways to replace wooden construction materials with man-made ones otherwise we cannot really reverse the creeping and destructive changes in the world's destructive weather.

THE BEAUTY OF BLACK & WHITE

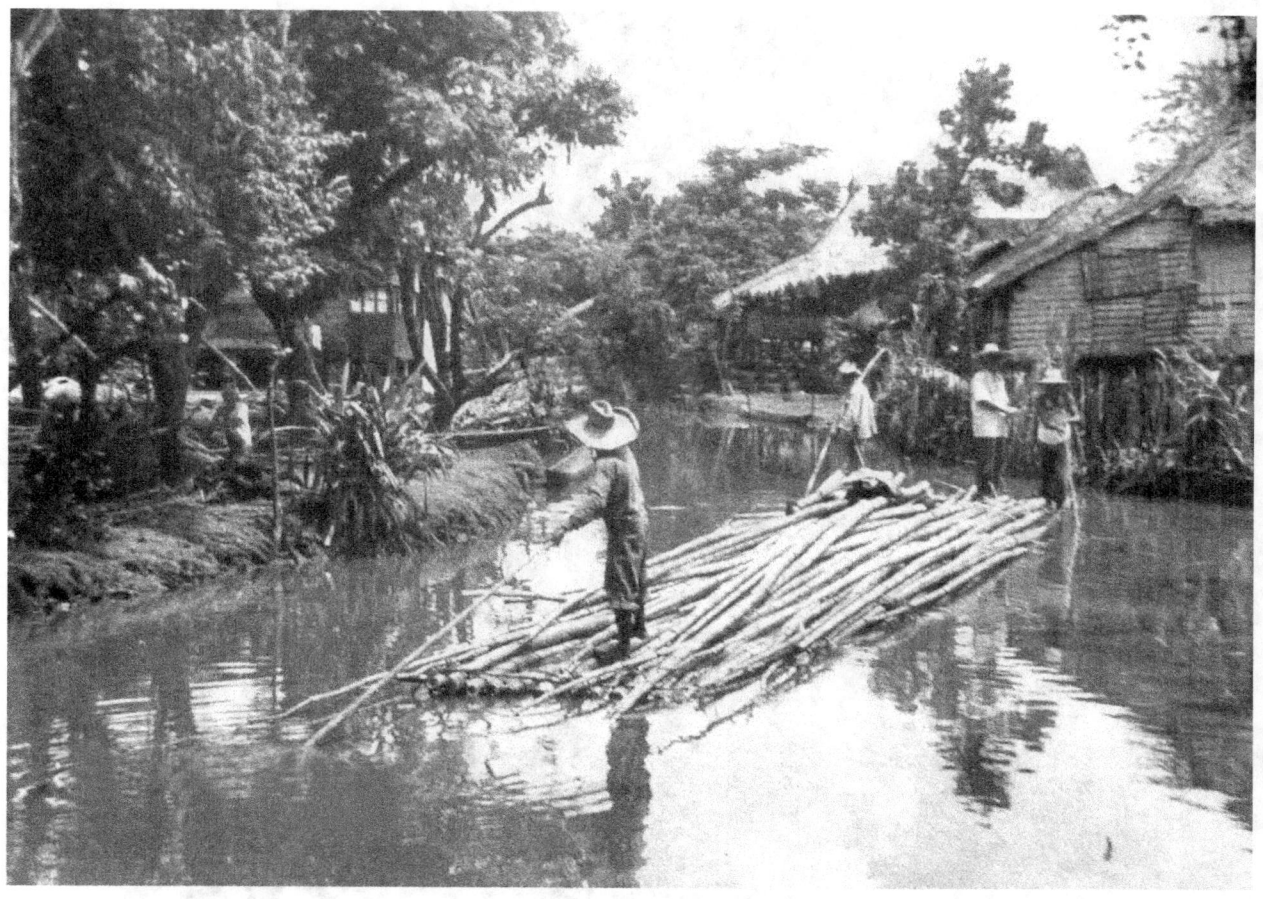

LOOK, NO NEED FOR GASOLINE Bamboo rafts are used to transport bamboo poles to the next village via the local river system. Notice the shallow depth of the water as could be gleaned from the two men to the right of the photo which my father could have taken at low tide.

THE BEAUTY OF BLACK & WHITE

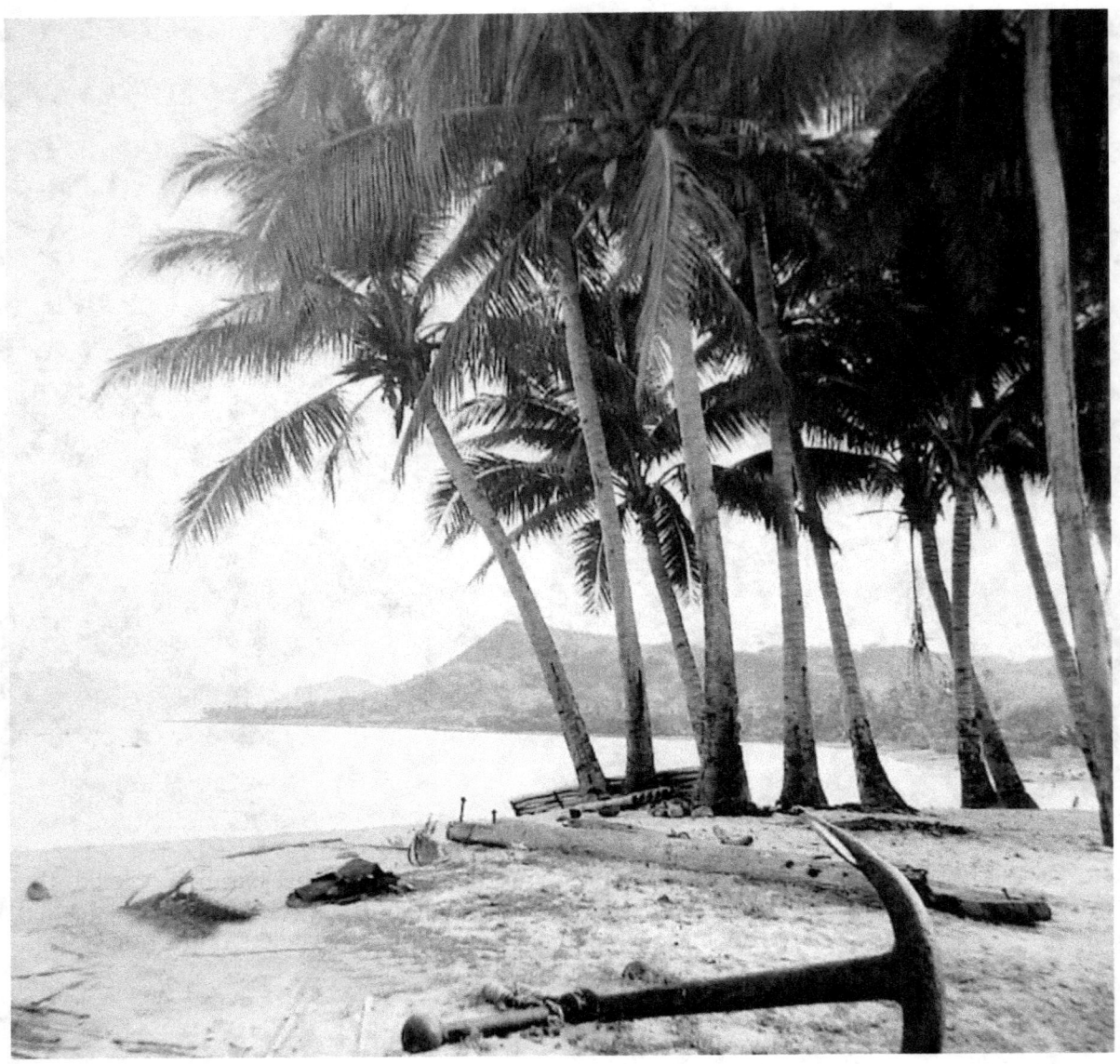

SAN SEBASTIAN COVE An old anchor rests on the beach (foreground) in this cove at the town of San Esteban in northwestern Philippines. This place is located right along the scenic highway of this province and, up to this time, it catches my fancy that I almost always have to stop to take pictures as this place always reminds me of my father.

THE BEAUTY OF BLACK & WHITE

EARLY MORNING AT A PAPER MILL At the back of the hard copy of this photo my father wrote the words "Koronadal Paper Mill." Koronadal town (in southern Philippines) was created in 1947 and my father must have covered the inauguration of the town. In the year 2000, the town became a city. It is also host to the province of South Cotabato as provincial capital. Notice my father's use of shades and shadows in capturing this photo.

THE BEAUTY OF BLACK & WHITE

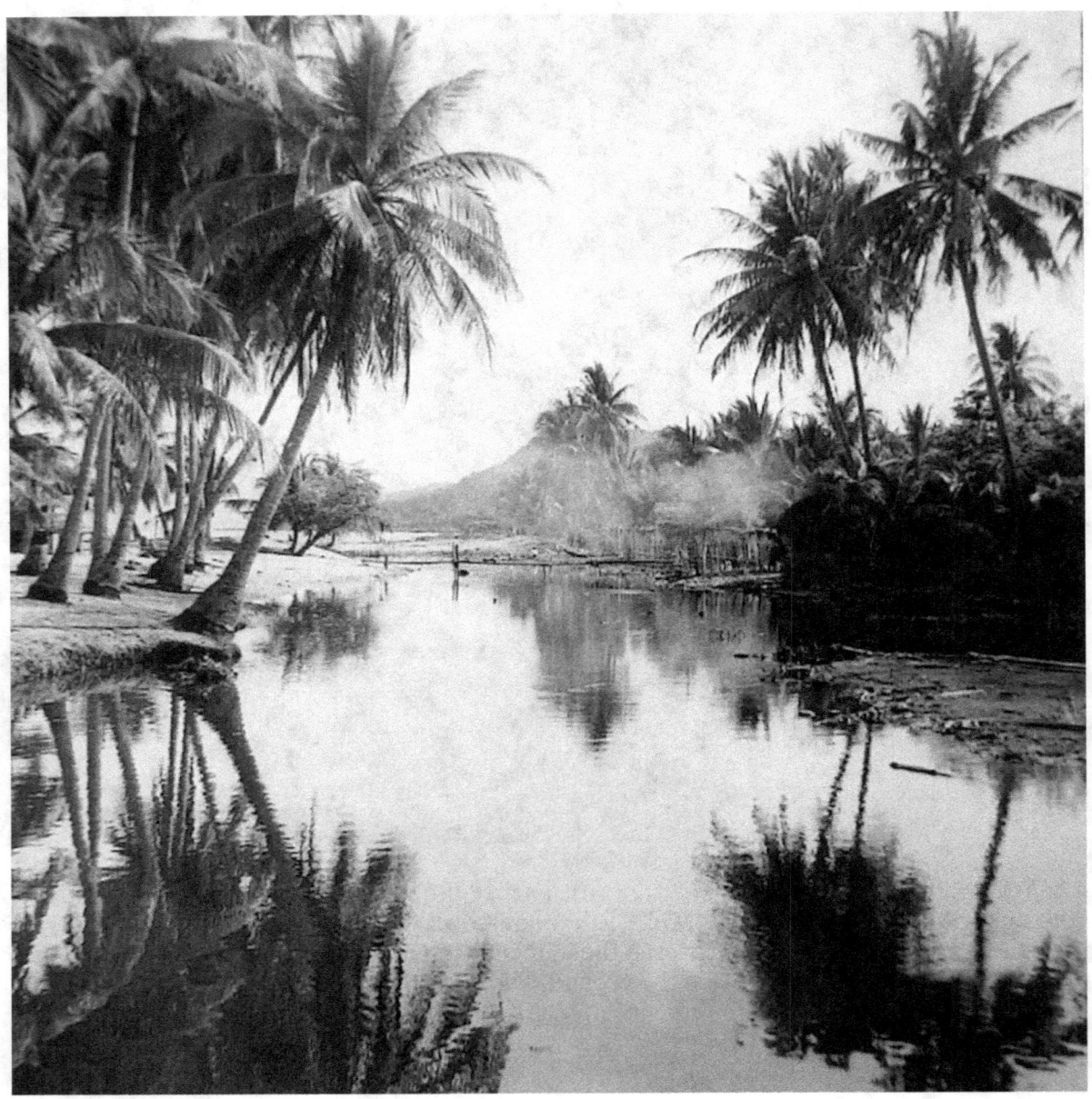

REFLECTIONS Fittingly, this picture of images of coconut trees reflected on the placid water is a mirror of my own efforts to immortalize the passion of my father in his pursuit of photography as an artistic expression. The preceding photos are reflections of his skills and talents in capturing life in many forms.

And now, through the next pages, let me take you back in time, when my father was a living witness to the history of the Philippines. He had a front row seat as he saw history unfolding right before his eyes.

THE BEAUTY OF BLACK & WHITE

I Saw History Unfold

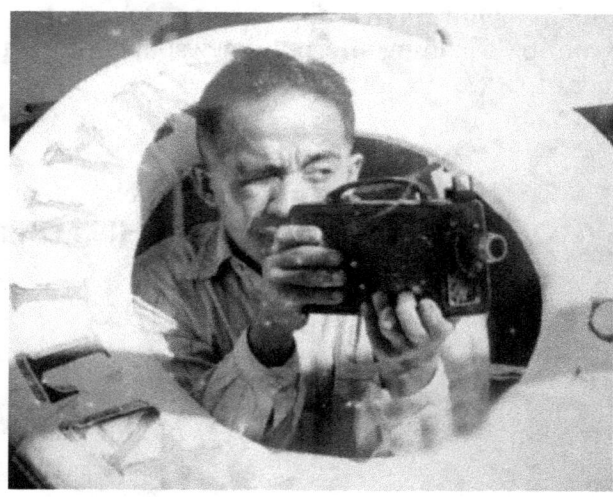

The daring exploits of Marcial Valenzuela as one of the Philippines' first photojournalis lasted from 1927 to 1968, a period of 41 years.

A FRONT ROW SEAT TO HISTORY

At age 20, Marcial S. Valenzuela became one of the Philippines' first photojournalists and perhaps the youngest. It was not by choice, but it was his destiny. He skillfully took dramatic news photos that spoke a thousand words from 1927 until he retired 41 years later in 1968. He covered breaking news with the intrepid boldness of a lens man, true to his calling. Marcial was called the "Dean of Press Photographers of the Philippines" in his senior years.

He is credited with having covered "all" the presidents of the Philippines in his lifetime starting with Commonwealth President Manuel L. Quezon in 1935 up to the time when President Ferdinand E. Marcos entered the corridors of power in 1965.

And much later, he was given the assignment of covering the Senate of the Philippines until his retirement in 1968. His photos always landed on Page 1, above the fold, of the iconic morning newspaper of the Philippines, THE MANILA TIMES and its sister afternoon daily, THE DAILY MIRROR with the credit *Timesphoto by Marcial S. Valenzuela*.

He always had a front row seat, watching and recording history as it unfolded before his eyes. He is shown in the photo above clutching a movie camera.

Marcial was first among his equals; affectionately called "Manong"(Big Brother) by peers and friends. In my heart, he will always be "The Big *Kahuna*" of Philippine photography.

The following is the full text of the interview with Marcial by the very popular newspaper columnist and TV host Jose "JQ" Quirino that appeared on October 10, 1955 in the Saturday issue of THE DAILY MIRROR, the country's leading afternoon newspaper of the 1950s until the 1970s, and sister newspaper of THE MANILA TIMES.

HERE IS ONE LENSMAN
WHOSE SHOTS HAVE MADE HISTORY
By JOSE A. QUIRINO
The Daily Mirror, October 10, 1955

Few living cameramen can equal the record of 48-year old Marcial Valenzuela, veteran Ilocano flashbulb burner.

He has covered all the presidents of the Philippines from Manuel L. Quezon to Ramon Magsaysay; photographed punitive campaigns against various outlaw groups; hobnobbed with over 50 generals among whom were Generals Douglas MacArthur, Ike Eisenhower (he was a colonel at that time), Jonathan "Skinny" Wainright, Segundo, Lim, Capinpin, Vargas, and 11 Constabulary Chiefs from Brig. Gen. Charles Nathorst (1927-1932) to the incumbent PC head, Brig. Gen. Manuel Cabal.

Started in 1924

A camera bug since he was only that big, Valenzuela's formal education in photography dates back to 1924 when he became an apprentice to Jacinto de Jesus, owner of the Luz Studio in Tondo (Manila). De Jesus taught him all the phases of photography.

In 1927, after three years of apprenticeship, Valenzuela was hired to take pictures by the LA DEFENSA, a Spanish newspaper, and the PHILIPPINE FREE PRESS. It was at this stage of his career that he covered General Nathorst, affectionately called by his men as "The Tiger" and "Old Man." Quezon then was a fast rising leader of the Filipinos in the constant struggle for independence.

The Constabulary troopers at that time were fighting "Emperor" Florencio Intrecherado and his fanatical followers in Negros Occidental (Central Philippines). Intrecherado claimed to be in communication with a spiritual guide and threatened the people with floods, earthquakes and other natural calamities if they would not follow him.

THE BEAUTY OF BLACK & WHITE

With 300 followers Intrecherado attacked the municipal building of Victorias (town) in Negros Occidental and took over the municipal government after killing two policemen. Pacified and brought to Manila by the PC (Philippine Constabulary), Intrecherado was later declared insane and confined at the San Lazaro Hospital (in Santa Cruz District in Manila). Valenzuela was able to take pictures of Intrecherado for the LA DEFENSA.

Transfers to the HERALD

After his three-year stint with the LA DEFENSA and the (Philippine) FREE PRESS, Marcial transferred to the PHILIPPINES HERALD in 1933. For six months his pictures covered the pages of the HERALD.

That same year, he applied for a job at the TVT (Tribune-Vanguardia-Taliba) and was hired as a photographer by the late Alejandro Roces, Jr., general manager of the TVT Publishing Company.

On the day he was hired, Marcial was told by the late Jose G. Claudio, chief of the TVT photo section to cover a "special assignment." Dave Boguslav, TRIBUNE editor, Manuel VillaReal, LA VANGUARDIA editor, and Deo del Rosario, TALIBA editor, began congratulating Valenzuela for his photo coverage(s).

Covers the *Sakdalista* uprising

On May 2, 1935 the *Sakdalista* revolt erupted in the provinces of Laguna, Rizal, Tayabas (Quezon), Bulacan and Cavite (provinces in Luzon Island north of the Philippines). The insurrection, which lasted up to May 14, started in the towns of Cabuyao, Laguna and San Ildefonso, Bulacan. Valenzuela was assigned to cover the uprising.

Over 1,000 *Sakdalistas* captured the town of Santa Rosa, 300 of whom were dispatched to assault Cabuyao, Laguna which was guarded by the valiant PC detachment of only nine men under Lt. (now colonel and commander of the 3rd Military Area) Cornelio Bondad. Bondad and his men repulsed all attempts of the *Sakdalistas* to capture the town.

At this juncture, reinforcements under Captain L. Angeles arrived to aid the beleaguered Bondad and his handful of men. With the reinforcement was Valenzuela who was immediately engrossed in the task of taking pictures right and left.

(In the many personal conversations I had with him in later years, my father Marcial related to me that during the government campaign against Sakdalista rebels in Laguna province, he was embedded with the soldiers of the Armed Forces of the Philippines covering live exchanges of fire when a bullet whizzed past him and landed on the wall behind him. He ducked lower and did not move for several minutes after which he sought a safer cover. He was also embedded with governrment soldiers during

the military campaign against communist rebels in Central Luzon. He told me that he would wrap consumed films and send these by bus to his newspaper office way ahead of the afternoon deadline. The following morning his newspaper would banner his photos on the front page for the whole nation to read and with the accompanying credit "Photos by Marcial S. Valenzuela."—Author)

Bondad and his men were deployed around the municipal building 2,200 yards away from the *Sakdalistas* who were firing from the church. Bondad himself was wounded in the back while Lt. Eulogio Balao (retired AFP vice chief of staff with the rank of Brigadier General) was wounded in the knee. Over 100 *Sakdals* were slain (whose corpses were piled) in front of the church. Laguna Governor Cailes ordered the arrest of two congressmen implicated in the revolt.

"It was a gory sight," Marcial recalls. "Corpses of the *Sakdals* were piled in front of the Cabuyao church. (Nonetheless) it was one of my exciting photo coverage(s)."

The Asedillo Campaign

Shortly after the *Sakdalista* uprising of May 1935, the provinces of Laguna and Tayabas (now Quezon) were again the scenes of a prolonged bandit campaign. Again Valenzuela covered the punitive drive to bag notorious bandit leaders Teodoro D. Asedillo and *"Kapitan Kulas"* Encallado.

Dismissed as Chief of Police of Paete, Laguna in 1929, Asedillo founded the *"Anak Pawis,"* (Child of Sweat) a communist inspired organization in San Antonio, Longos, Laguna. He went into hiding after the Minerva cigar factory strike in Manila in 1934 where two policemen were killed in a riot. He later joined the forces of Encallado.

It was Major General Vargas, chief of staff, then a lieutenant, who ended the life of the mustachioed and goateed bandit leader on New Year's Eve, December 31, 1935. Vargas killed Asedillo in the latter's hideout near the *Maladiangaw* Falls of Sampaloc, Tayabas (Quezon Province). Two of Asedillo's henchmen, Vicente Anerela and Juan Delantar were (also) killed by the men of Vargas while a third follower, Valentin Blaza, hurled himself into a rocky stream and escaped but later surrendered in Cavinti, Laguna.

Valenzuela took pictures of the corpses of Asedillo and his men when they were brought to the *poblacion* (center of the town). People whom the bandit leader terrorized while he was still living spat on his corpse.

THE BEAUTY OF BLACK & WHITE

Encallado surrenders

After Asedillo's death, the PC (Brig. Gen. Basilio Valdes was then Constabulary chief) concentrated their efforts in the capture of Encallado who was accompanied by three of his sons and 15 followers. Because he was already an old man and he could no longer bear the constant hounding of the peace authorities, Encallado finally surrendered (in) Cavinti, Laguna on January 17, 1936. As usual, Valenzuela was there to take pictures of the event.

When several officers, among whom were Vargas, Balao, Angeles and Bondad were decorated for their outstanding work in the peace and order campaign against the *Sakdalistas* and other bandit groups, it was only proper that Marcial was at hand to 'record' the ceremonies.

Other important coverage(s)

Valenzuela covered all the important events during President Quezon's administration. He captured on film the Commonwealth inauguration on November 15, 1935.

This short but indefatigable photographer was with Quezon when the latter met Princess Tarhata (in Mindanao) during the negotiations for the surrender of her husband, Datu Tahil.

When Major General Jose de los Reyes (PC chief from 1936 to 1938), accompanied by 10 PC soldiers went to Arayat, Pampanga to accept the surrender of the notorious de la Rosas (this father-and-son team led their own group (of bandits)), Valenzuela had a whale of a time burning flashbulbs.

During the term of President Elpidio Quirino as secretary of (the) interior, a Japanese smuggling syndicate (north of the Philippines) was busted by PC operatives. Quirino, accompanied by his PC advisers, inspected the Babuyan Islands and confiscated a Japanese flag in the area. The interior secretary also personally investigated the circumstances of the rampant smuggling in Babuyan and questioned some Japanese suspects. All these events were duly photographed by the up-and-coming Valenzuela.

Dangerous mission

When Japanese forces were entering Manila (during WW II), Luis Hizon, veteran (DAILY) MIRROR reporter, and Valenzuela (who were both) desirous of covering the event, met the hostile forces in Parañaque (south of Manila). The two rode in a small car with a big white flag. Machineguns were trained on the newshound and the photographer but the two proceeded

with Valenzuela snapping pictures right and left. Fortunately (for them), Secretary Jorge Vargas and (Japanese) Consul Nihiro were at the Parañaque town plaza.

"We thought we would never see the day of liberation when those Japs pointed their weapons at us," Marcial candidly stated. *(After this incident, my father evacuated his family from Manila to his home town in Mangatarem in Pangasinan province in northern Philippines. My mother was carrying me in pregnancy at that time in January of 1942.– Author)*

Interviews (Communist leader) Taruc

After Huk (communist) Supremo Luis Taruc was elected congressman (of Pampanga province in Central Luzon), he went into hiding because he was wanted by the authorities. Reporter Callanta and photographer Valenzuela were the first to interview the elusive Huk leader at his hideout in Lubao, Pampanga.

Since the launching of the anti-dissident campaign, Marcial has been in the field several times taking photos of actual combat operations. He was with Major General Mariano Castañeda when the latter was directing the anti-dissident drive in Bulacan, Pampanga and Nueva Ecija (provinces).

Other important events covered by Marcial included the negotiations for the acquisition of the Turtle Islands (in southern Philippines near the border with Malaysia); the trip of United Nations (UN) President Carlos P. Romulo to Indonesia and other Asian countries; the eruption of *Mayon* and *Hibok-Hibok* volcanoes. Every now and then Valenzuela meets with what he terms "hazards of my profession." There was the incident when he and TIMES reporter Ray Veloso were mauled by the Makati police in 1954.

Valenzuela today

Manong Marcial, as he is affectionately called by his fellow photographers, is still going strong although people continuously advise him to go slow especially after he collapsed from high blood pressure while he was covering a photo assignment at the V. Luna Hospital on September 3, 1954.

"Thanks to the kind treatment of THE MANILA TIMES administration," he said. "I have recovered my former health."

This veteran shutter bug is a native of Mangatarem, Pangasinan where he was born on July 30, 1907. Married to a childhood sweetheart (Segunda Gamueda of Santa. Lucia town in the province of Ilocos Sur), he has nine children---two girls and seven boys.

THE BEAUTY OF BLACK & WHITE

"No, I don't like my children to follow in my footsteps," he said when asked if he would like his boys to be professional cameramen. "It is too strenuous," he added with a twinkle in his eyes."

After that interview in 1955 with newspaper columnist and TV host Quirino, my father moved on with his regular assignment, covering President Disodado Macapagal and the first year of the administration of President Ferdinand Marcos. Much later, my father was assigned to cover the sessions of the prestigious Philippines senate until he retired in January of 1968.

His parting words in the interview with Qurino became poetic justice later on as some of his boys and descendants took on photography as a hobby and as full time source of income.

Valenzuela with his 120mm camera

THE BEAUTY OF BLACK & WHITE

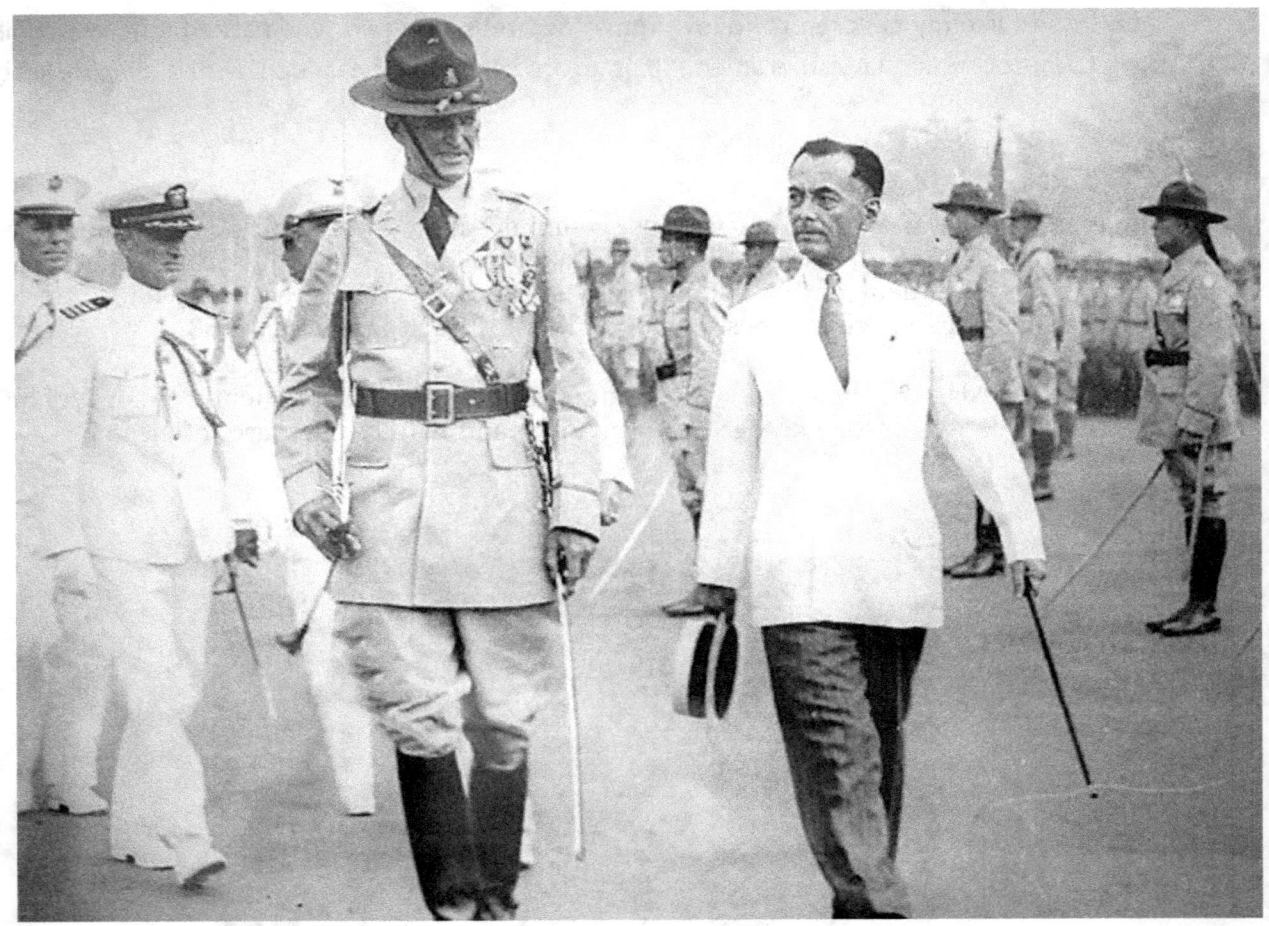

PRESIDENT QUEZON REVIEWS HONOR GUARD The very first Philippine president that my father covered was Commonwealth Pres. Manuel Luis Quezon shown here reviewing honor guards composed of American and Filipino troopers prior to his inauguration on Nov. 15, 1935 as the first Commonwealth president of the Philippines.

In later years, Quezon would lead an all-Filipino mission to Washington DC that lobbied for the granting of total independence to the Philippines. After WW II, on July 4, 1946, the United States granted total independence to the Philippines but retained two strategic military bases, Clark Air Field and Subic Naval base until 1990 when a treaty ended American presence on both bases. Quezon did not live to witness the granting of independence as he died of tuberculosis at a cure clinic in Saranac Lake, New York, USA. His remains were later brought to the Philippines and were re-interred after WW II in fitting ceremonies at the Quezon Memorial Circle in Quezon City.

https://en.wikipedia.org/wiki/Manuel L. Quezon

THE BEAUTY OF BLACK & WHITE

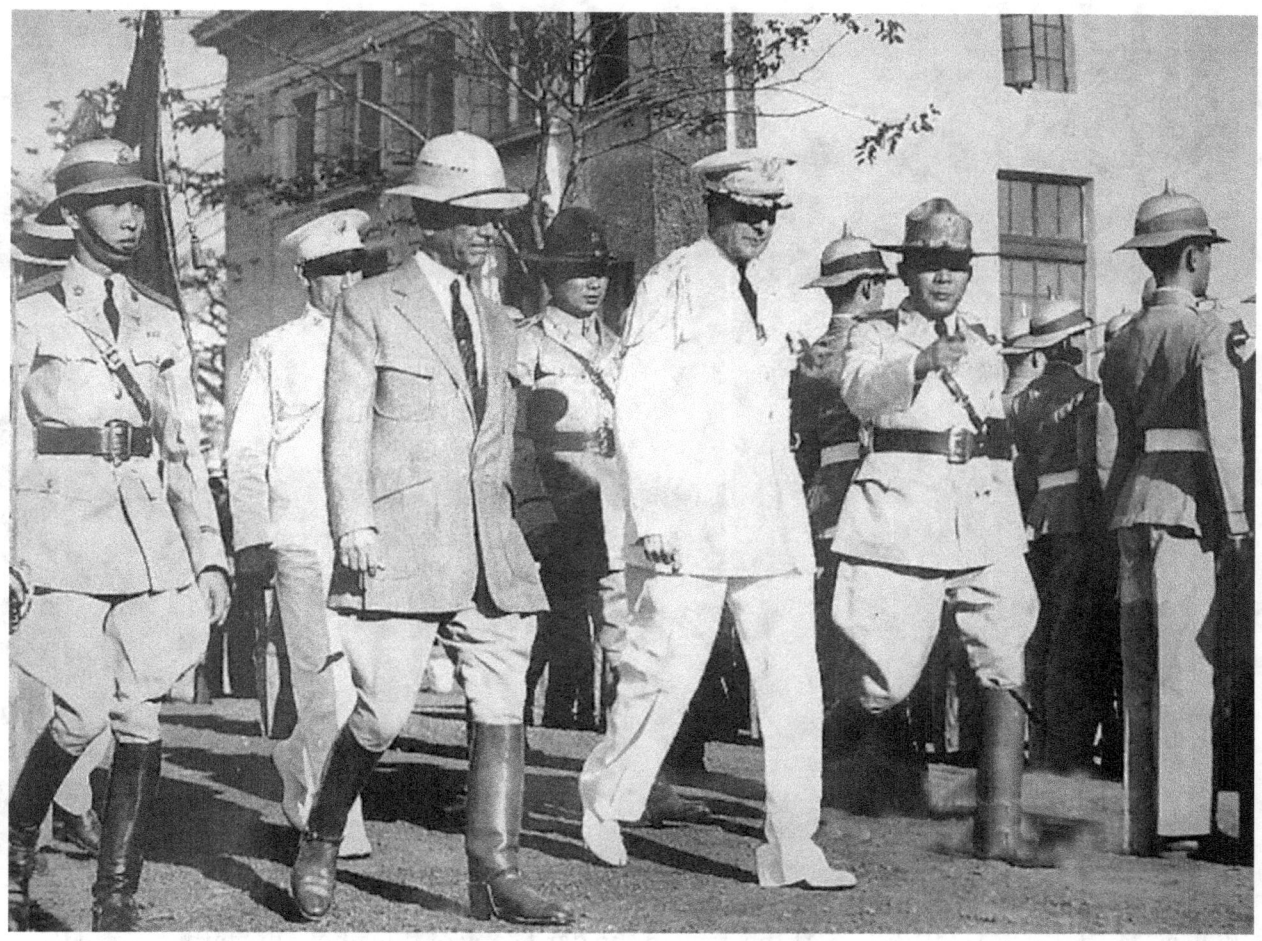

QUEZON TROOPS LINE WITH GEN. MacARTHUR Presiden Quezon prepares to troop the honor guards of Malacañang with Gen. Douglas MacArthur, (in an all-white gala uniform) field marshal of the Philippine Army prior to and at the time World War II erupted in 1942.

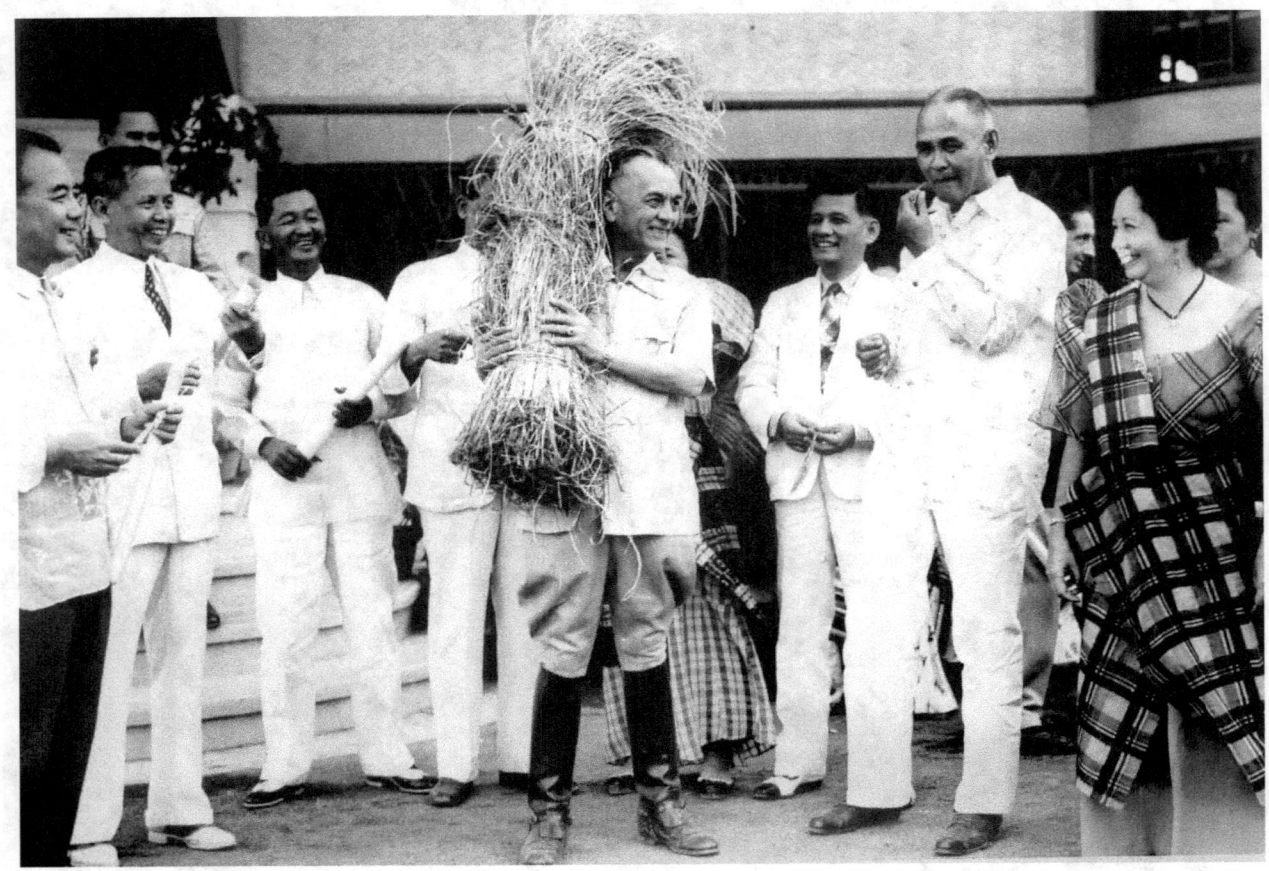

BOUNTIFUL RICE HARVEST At the back of the hard copy of this photo my father wrote the following notes: "Planted July 9, 1939, harvested Dec. 14, 1939." President Quezon proudly shows a bunch of long palay stalks the he himself could have harvested from a "demonstration" rice field. (Take notice of Quezon's boots which are caked with dust compared with the spic-andspan shoes of the others.) Shown at right is an equally happy Mrs. Aurora Antonia Aragon Quezon, wife of the president, while members of his cabinet (in white suits and barong) smile approvingly.

THE BEAUTY OF BLACK & WHITE

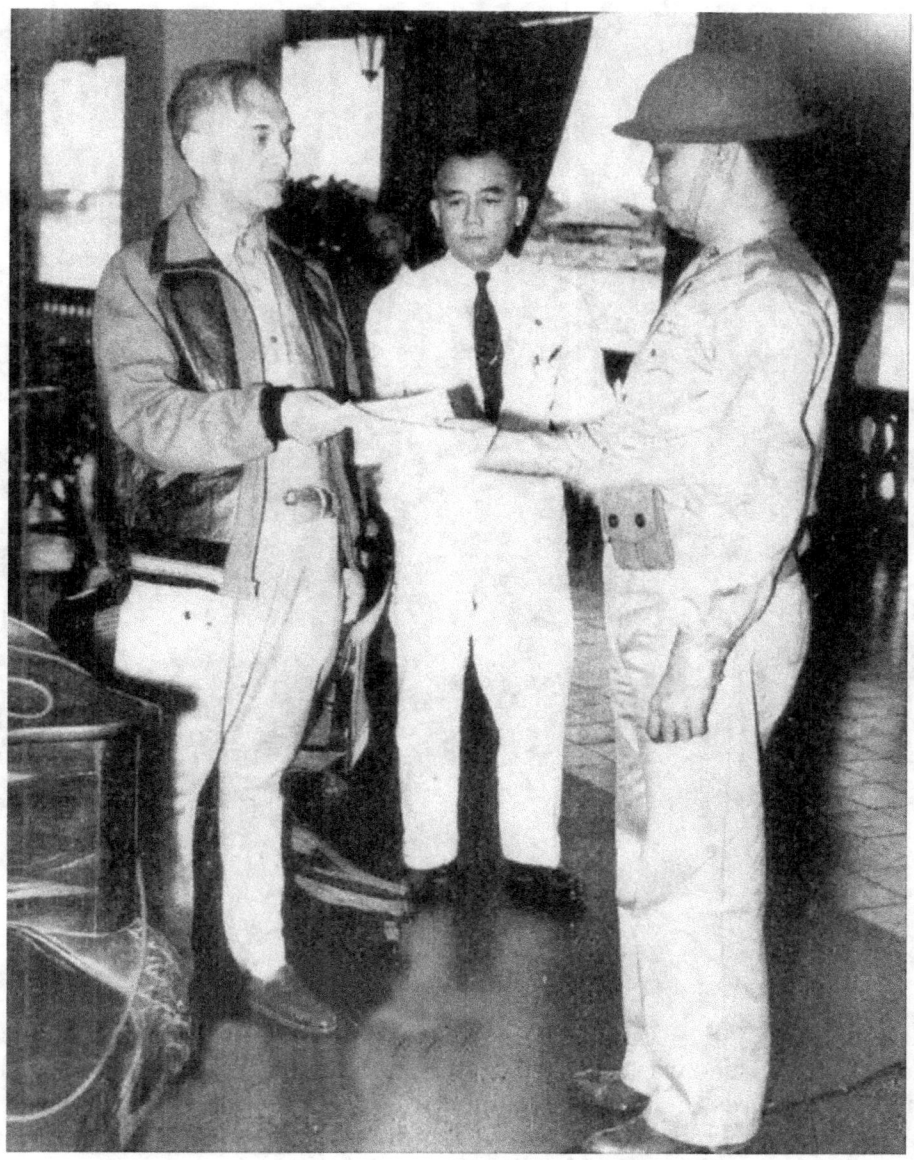

LAST PHOTO OF MLQ This would be my father's last photo of President Quezon at Malacañang, official residence of Philippine presidents, at the outbreak of World War II and prior to the Japanese invasion of the Philippines showing the president handing over to his Cabinet Secretary Manuel A. Roxas (shown in battle gear) a copy of Executive Order 390, that abolished the Department of the Interior and established a new line of succession. Third man in photo is Quezon's Executive Secretary Jorge A. Vargas who was also appointed by Quezon as mayor of the greater Manila area. (Source: Wikipedia) After this photo was taken, Quezon boarded the plane that took him to Corregidor off Bataan hence to New York, USA where he died of tuberculosis on August 1, 1944. According to my father, Quezon shook his hand, tapped him on the shoulder and thanked him for covering his presidency. (At the back of the photo my father wrote: "Dec. 18/41, Timesphoto by Marcial Valenzuela.)

https://en.wikipedia.org/wiki/Manuel_L._Quezon
https://en.wikipedia.org/wiki/Jorge_B._Vargas

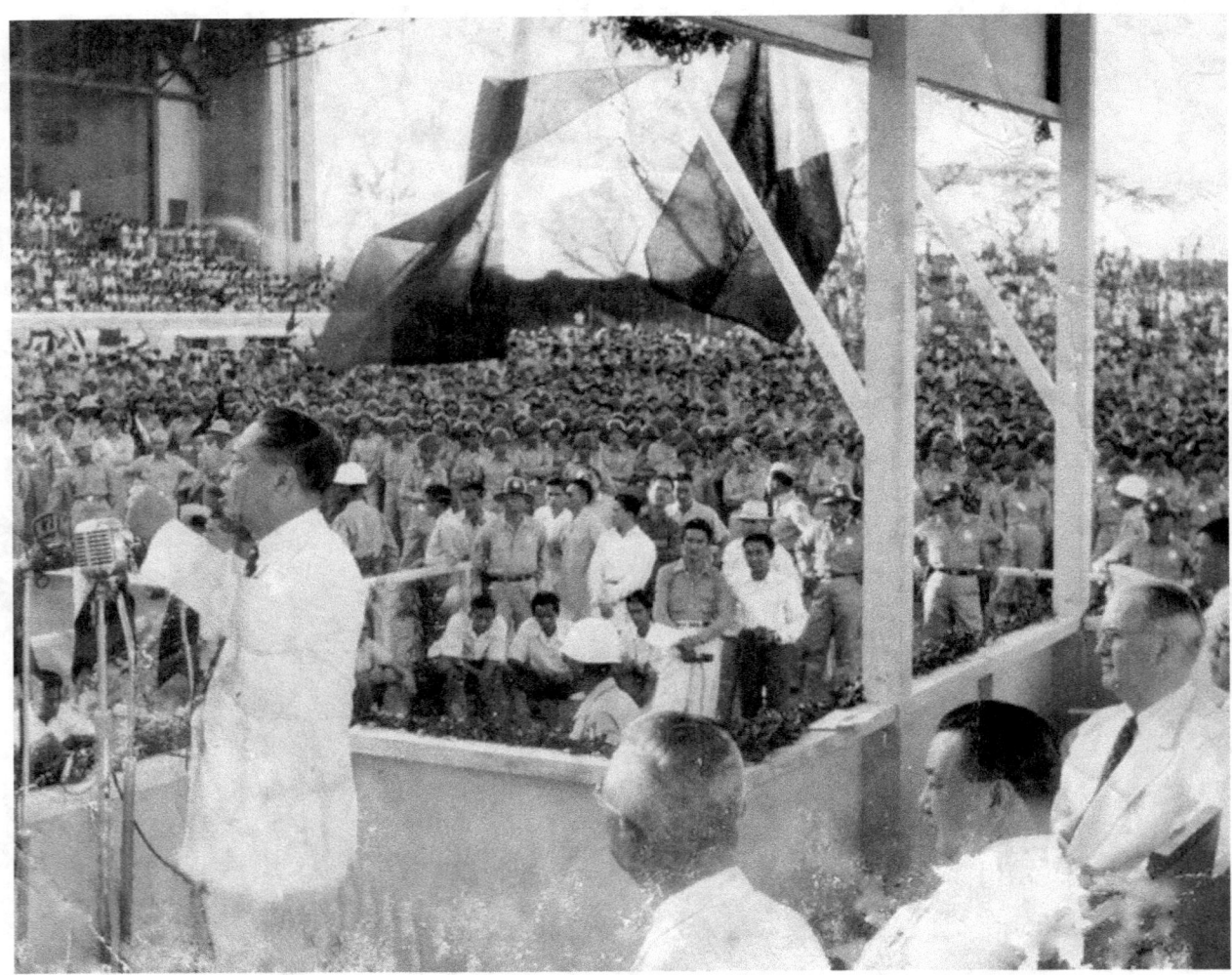

INAUGURAL ADDRESS OF PRESIDENT ROXAS The second president Marcial covered was President Manuel Roxas who was captured in this photo while gesticulating with his left arm during his inaugural address at the Rizal Memorial Coliseum in Pasay City. A large crowd is shown in the background while Vice President Elpidio Quirino is shown in the foreground (lower right). The US government sent an official (extreme right). Marcial must have framed this picture in his mind first before peeping through his viewfinder: The new president speaking, a large crowd, officials in attendance and the Philippine flag fluttering overhead.

Roxas did not finish his full four-year term. On the morning of April 15, 1948 Roxas delivered a speech before the United States Thirteenth Air Force. After the speech, he felt dizzy and was brought to the residence of Major General E.L. Eubank at Clark Field, Pampanga. He died later that night of a heart attack. Roxas' term as President is thus the third shortest, lasting one year, ten months, and 18 days. On April 17, 1948, two days after Roxas' death, Vice-President Elpidio Quirino took the oath of office as President of the Philippines.

https://en.wikipedia.org/wiki/Manuel Roxas#Death

THE BEAUTY OF BLACK & WHITE

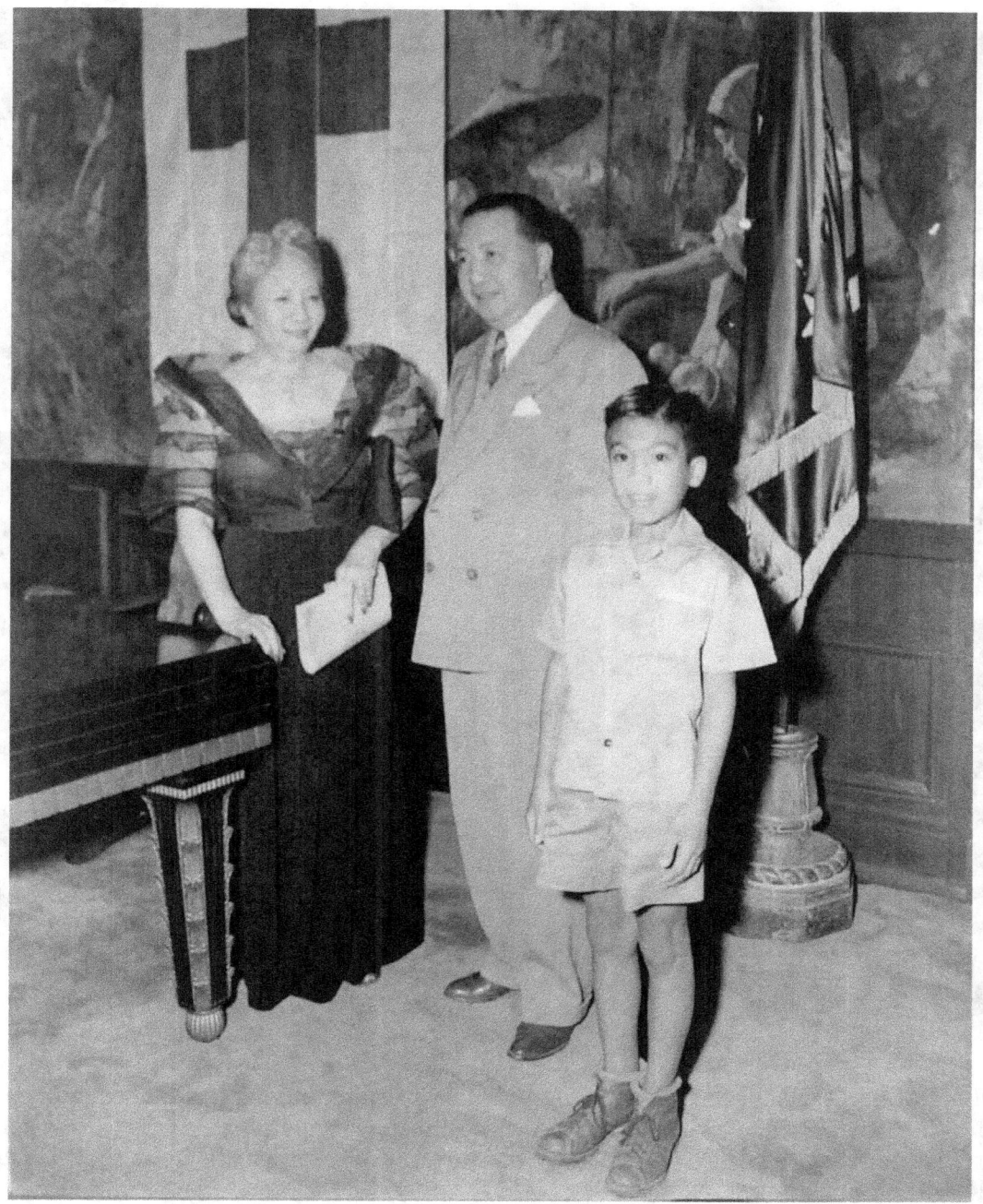

PRESIDENT QUIRINO The third Philippine president Marcial covered was President Elpidio Quirino. This is one of the few hard copies in my father's file of President Elpidio Quirino (although I know that there are quite a good number in the negatives for printing). The president is shown here with Mrs. Aurora Antonia Aragon Quezon who was just sworn in, or about to be sworn in, as President of the Philippine National Red Cross (notice the Red Cross flag in the background). The young man shown with them in this photo is my brother, Fernando. My father must have broken protocol knowing very well his closeness to the president who would not disapprove of this photo opportunity for my brother.

THE BEAUTY OF BLACK & WHITE

PRESIDENT MAGSAYSAY President Ramon Magsay was the fourth president of the Philippines that my father covered at Malacañang for his newspaper. Magsaysay (also referred to by the press at that time as RM) would also be the closest to my father's heart as they developed a special bond for one another.

On the morning RM won the presidential elections, my father was dispatched by THE MANILA TIMES to his residence and took a photo of the president still in his pajamas holding a table clock and seated by his bedside. That photo landed on page 1 . My father would later have Magsaysay write an autograph on a copy of the picture. (See photo on page 98). Unfortunately, I could not locate a copy of that photo among the hard copies.

THE BEAUTY OF BLACK & WHITE

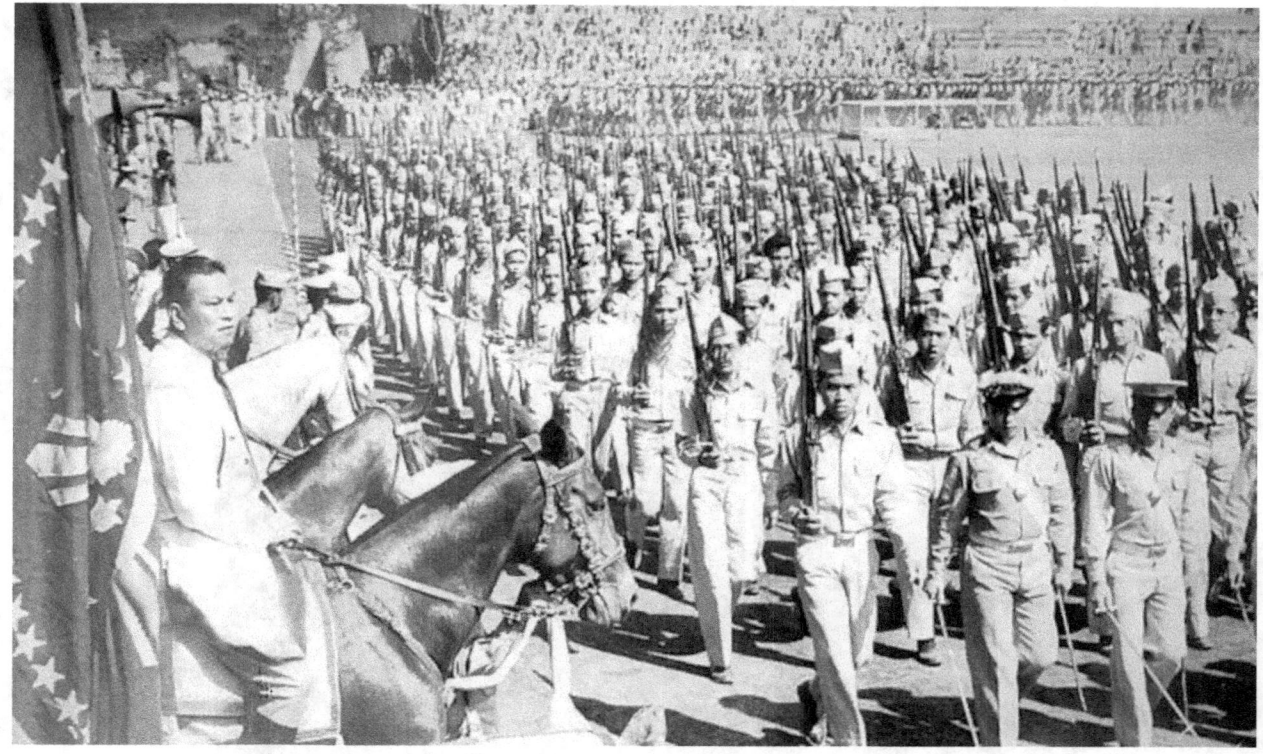

REVIEWING ROTC CADETS President Magsaysay had thought of mobilizing the ROTC corps of cadets when the communist rebels were almost at the doorsteps of Manila in the early 1950s.

MAGSAYSAY DIES IN PLANE CRASH In the early hours of March 17, 1957 Magsaysay perished in a plane crash on Mt. Manunggal in Cebu province along with 24 others (https://en.wikipedia.org/wiki/Ramon_Magsaysay). My father's newspapers screamed with "extra" copies. People openly wept on the streets of Manila (where I grew up) upon learning of the president's death. Radio stations kept a running account of breaking news for days.

MARCIAL "SURVIVES" PLANE CRASH Marcial was almost always in all of the official functions of RM, covering him for his newspapers, THE MANILA TIMES and THE DAILY MIRROR. My father could have died in the plane crash where Magsaysay perished had it not been for reporter Nestor Mata (a relative of my father's) who requested my father to defer to him the seat in the presidential plane that was allotted by President Magsaysay's staff to my father. Mata wanted to interview the president on the way back to Manila from Cebu. My father related to me in later years that before the president boarded the plane in Cebu, the president asked for my father. He came up to the president and informed him that Mata wanted the interview to which the president acceded. Mata was the only survivor of that plane crash which killed the president and 24 others --- officials and staff members of RM. Mata occupied the seat at the rear-most end of the plane and never got to interview the president as the plane was just gaining momentum after take-off when it crashed. Up to this time, the cause of the crash remains a "mystery."

THE BEAUTY OF BLACK & WHITE

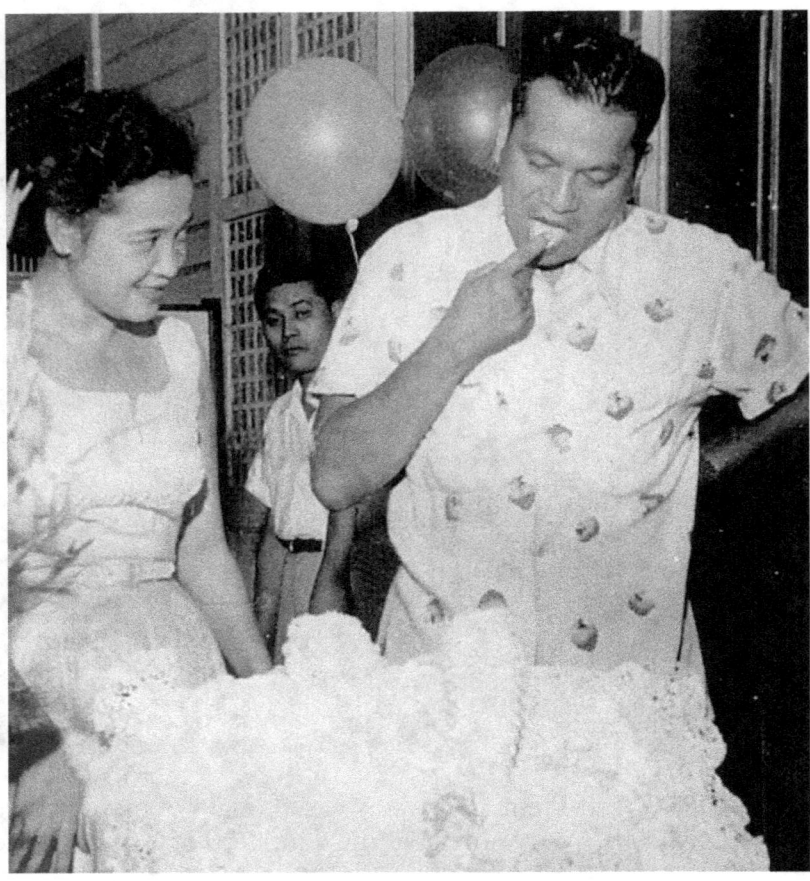

PRESIDENT-ELECT MAGSAYSAY DIPS FINGER INTO CAKE How my father got the president-elect to dip his finger into the "victory" cake still baffles me up this time. Mrs. Luz Banzon Magsaysay watches in amusement over her husband's "common man" demeanor. It was exactly the coin word "Man of the masses" which brought Magsaysay to victory. The photo was taken the morning when Magsaysay (official candidate of the Nacionalista Party) was announced the winner in the election. (He defeated incumbent President Elpidio Quirino of the Liberal Party.)

MEMORIES OF RM'S FUNERAL During the funeral for RM, a million people lined up five deep along the whole stretch of Rizal Avenue (Avenida Rizal) where the entourage passed on the way to the Manila North Cemetery for the noonday interment.

 I still vividly remember the muted sounds of marching drums as the funeral cortege passed by our neighborhood in Manila; the sound of the hoofs on the pavement made by the president's vacant horse with the president's boots mounted in reverse; the contingents of smart-marching men in uniform sweating in the mid-morning summer sun; the cars bearing a mourning Mrs. Luz Magsaysay and her children; the long line of black cars carrying Philippine government officials and ambassadors from different countries; the passing of the caisson bearing the president's flag-covered casket bedecked with pastel-colored flowers with two honor guards seated in front of the casket while others march smartly alongside; and the soft sighs and sniffles from the grieving crowd where I belonged as a 12-year old kid.

THE BEAUTY OF BLACK & WHITE

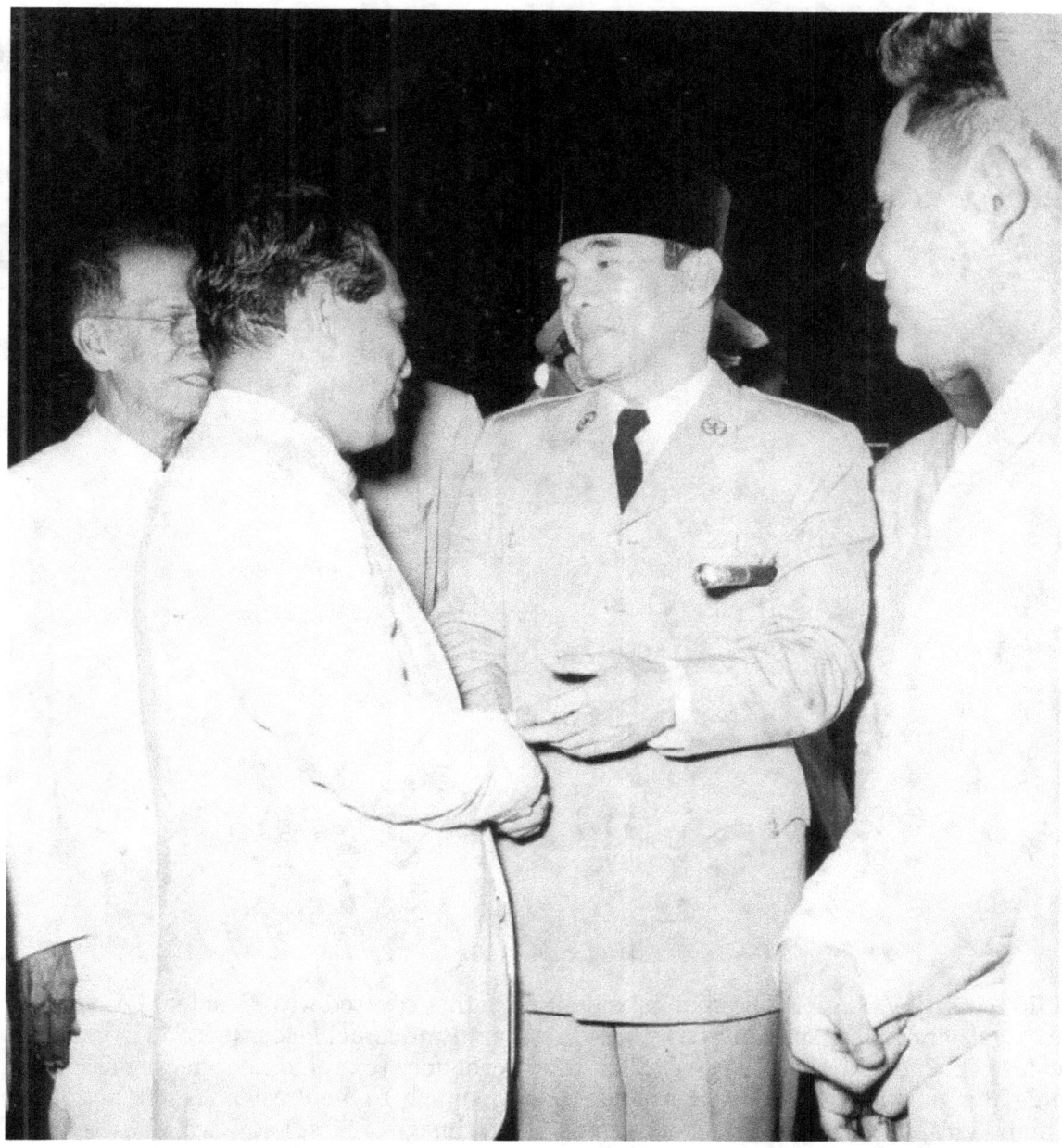

PRESIDENT GARCIA WELCOMES PRESIDENT SUKARNO The fifth president Marcial covered was President Carlos Garcia shown here welcoming Indonesian President Sukarno to Malacañang Palace while young diplomat Jose de Venecia (right) waits to be introduced. De Venecia would later rise to become the only 5-time Speaker of the House of Representatives of the Republic of the Philippines. (Read De Venecia's Foreword to this book.)

THE BEAUTY OF BLACK & WHITE

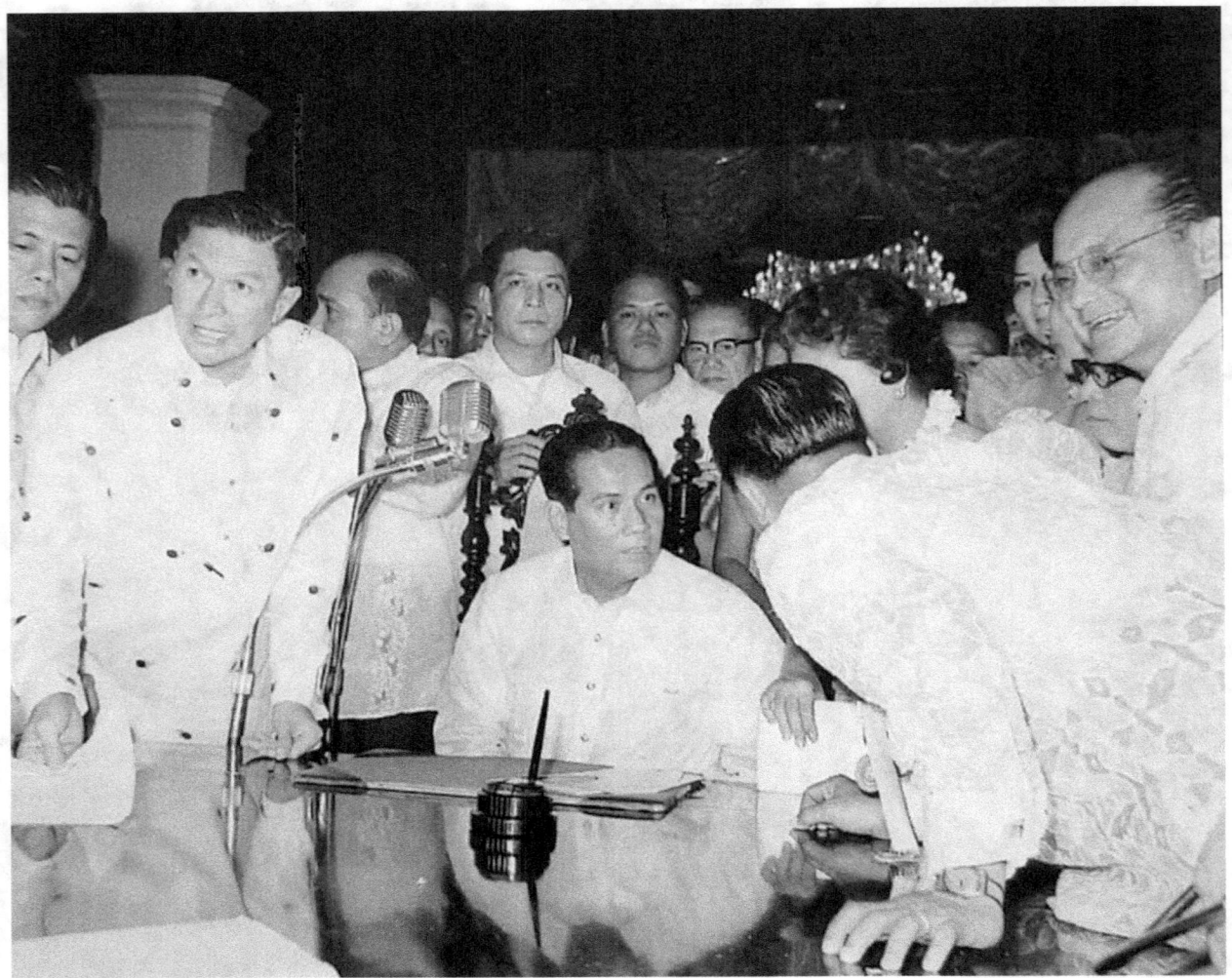

CRISIS AT THE PALACE The sixth president my father covered was President Disodado Macapagal shown here surrounded by Vice President Emmanuel Pelaez (second from left), and Sen. Jose Diokno (extreme left), Sen. Estanislao Fernandez (extreme right in eyeglasses) and Mrs. Imelda Marcos (partly hidden by Fernandez). Immediately to the President's left, but obscured by the man Macapagal is talking to, is the unmistakable image of First Lady Eva Macapagal with garland around her neck.

From the looks of it, this was taken during one of the official functions at Malacañang as shown by the formal attire worn by persons in the photo: Barong Pilipino for the gentlemen and terno for the ladies (as worn by Mrs. Macapagal and Mrs. Marcos in the picture).

THE BEAUTY OF BLACK & WHITE

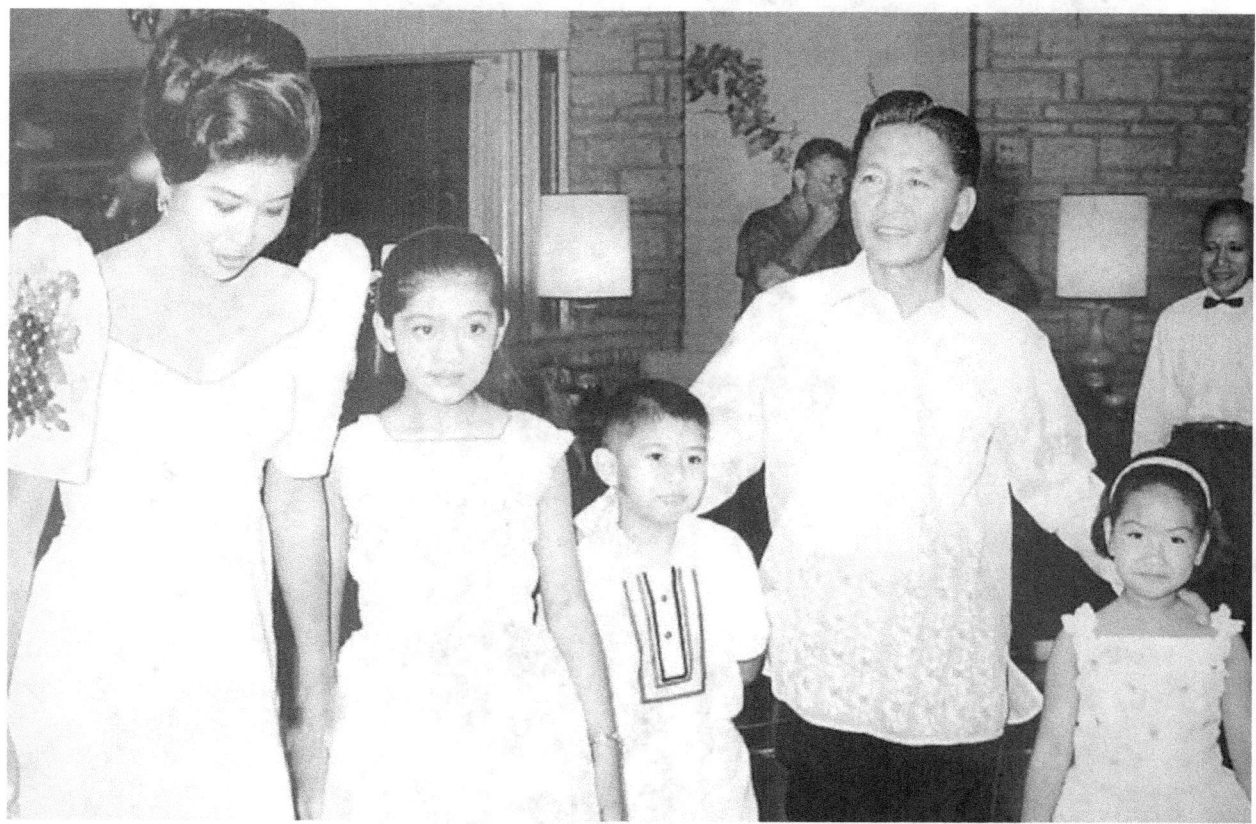

INTO THE CORRIDORS OF POWER The seventh and last president my father covered was President Ferdinand Marcos (who bolted the Liberal Party and joined the opposition Nacionalista Party as official candidate for president), captured in this photo as he ushers in members of his family into the Malacañang Palace (official residence of Philippine presidents) after winning the 1965 presidential elections, defeating President Macapagal (of the Liberal Party).

Marcos later declared Martial Law in 1972 and ruled the country for the next 14 years until he was toppled in a People Power Revolt in 1986 which was kicked off by a mutiny led by then Defense Minister Juan Ponce Enrile and Deputy Chief of staff Fidel V. Ramos. Enrile later rose to become senator of the land until his retirement in 2016 while Ramos became the country's president in 1992.

Former First Lady Imelda R. Marcos (left) is currently a member of the Lower House of the Philippine Congress (2017) representing the home district of the former president. Daughter Imee Marcos (second from left) is currently the governor of Marcos' home province Ilocos Norte while only son Ferdinand, Jr., a former senator, ran for vice president in the 2016 elections but failed to make it on account of alleged massive cheating by the family's long-time political opponent, the Aquinos. Irene (extreme right) is married to one of the country's richest businessmen Greggy Araneta.

THE BEAUTY OF BLACK & WHITE

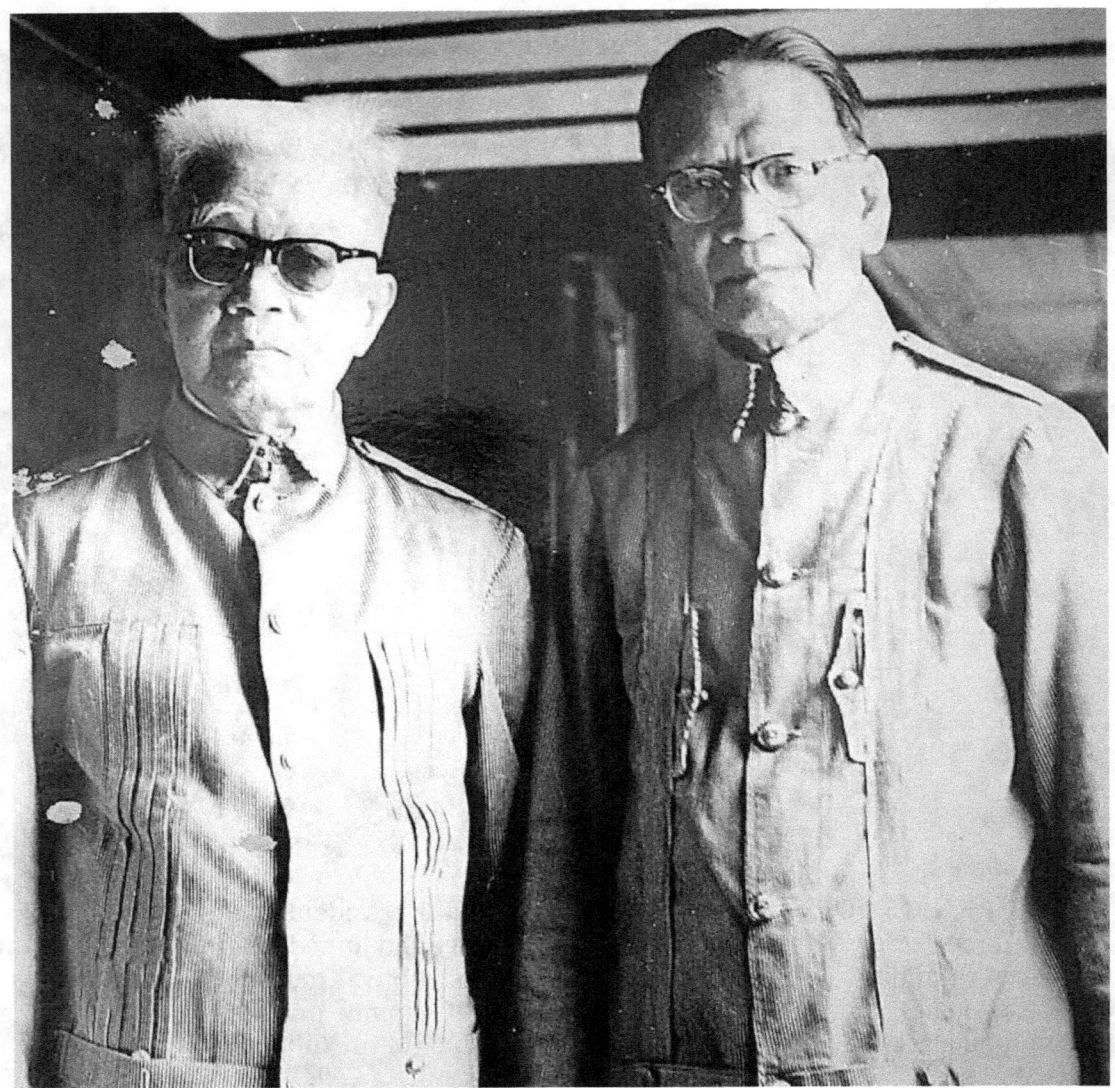

THE FIRST PRESIDENT OF THE FIRST PHILIPPINE REPUBLIC, Emilio F. Aguinaldo (left) was photographed by my father a few months before Aguinaldo died in February 6, 1964. A former general, Aguinaldo led the Philippine Revolution against Spain and declared independence from Spain on June 12, 1898 at his home town Kawit in Cavite province south of Manila.

The Philippine Revolution dragged on even after the United States had bought the Philippines from Spain for US$20 million in December 1898 through the Treaty of Paris. The intrepid general continued his War of Independence until he was captured by American soldiers in Palanan, Isabela province northeast of the Philippines in March 23, 1901.

https://en.wikipedia.org/wiki/Timeline of the Spanish American War
https://en.wikipedia.org/wiki/Emilio Aguinaldo

THE BEAUTY OF BLACK & WHITE

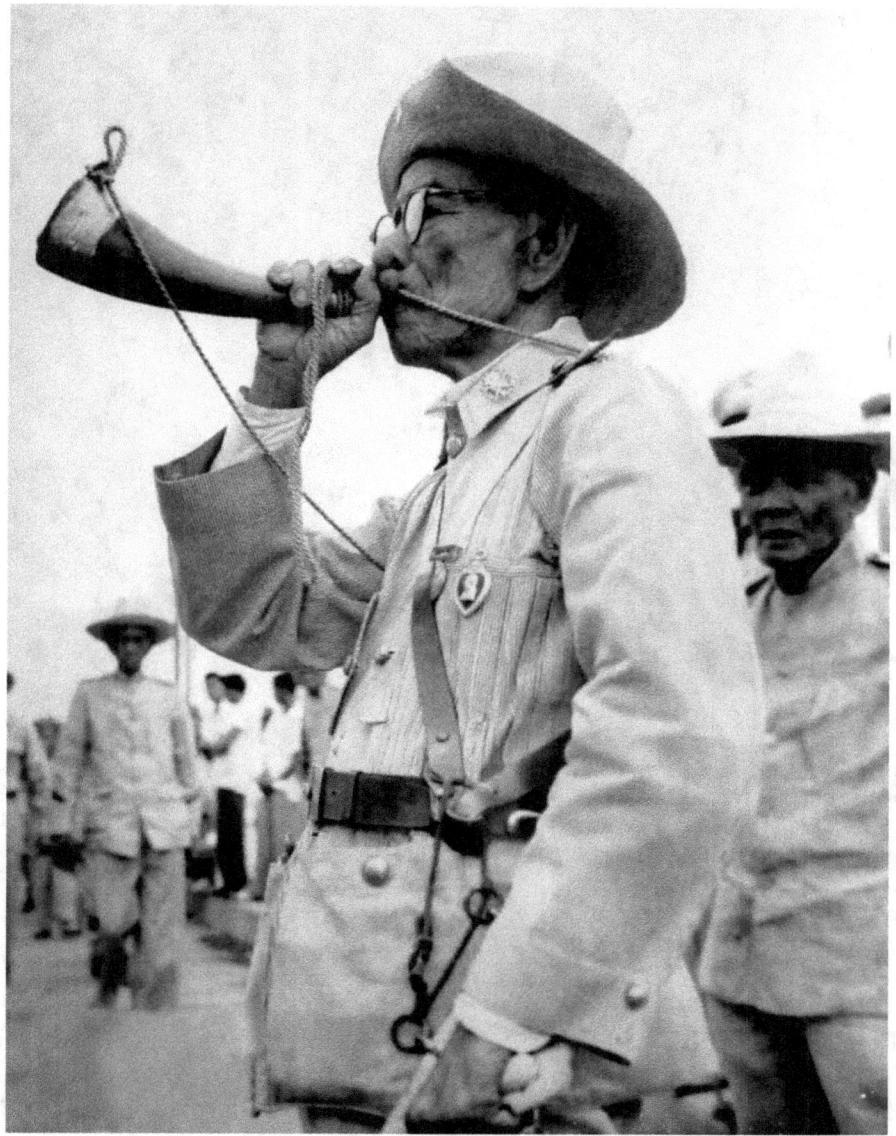

A CALL TO ARMS A graying veteran of the Philippine Revolution of the 1890s blows his "tambuli," a makeshift trumpet that he used during the revolution of 1890 to rally his comrades or to sound the retreat. The horn, which makes a long low octave sound, is carved from an animal horn. In this photo, he is shown calling all his comrades to formation during the Independence Day Parade in the early 1950s at the Luneta Grandstand in Manila. The soldiers of the gray line in the rich history of the Philippine Revolution of the late 1800s have all gone to the Great Beyond but not before Marcial captured them in this photo.

THE BEAUTY OF BLACK & WHITE

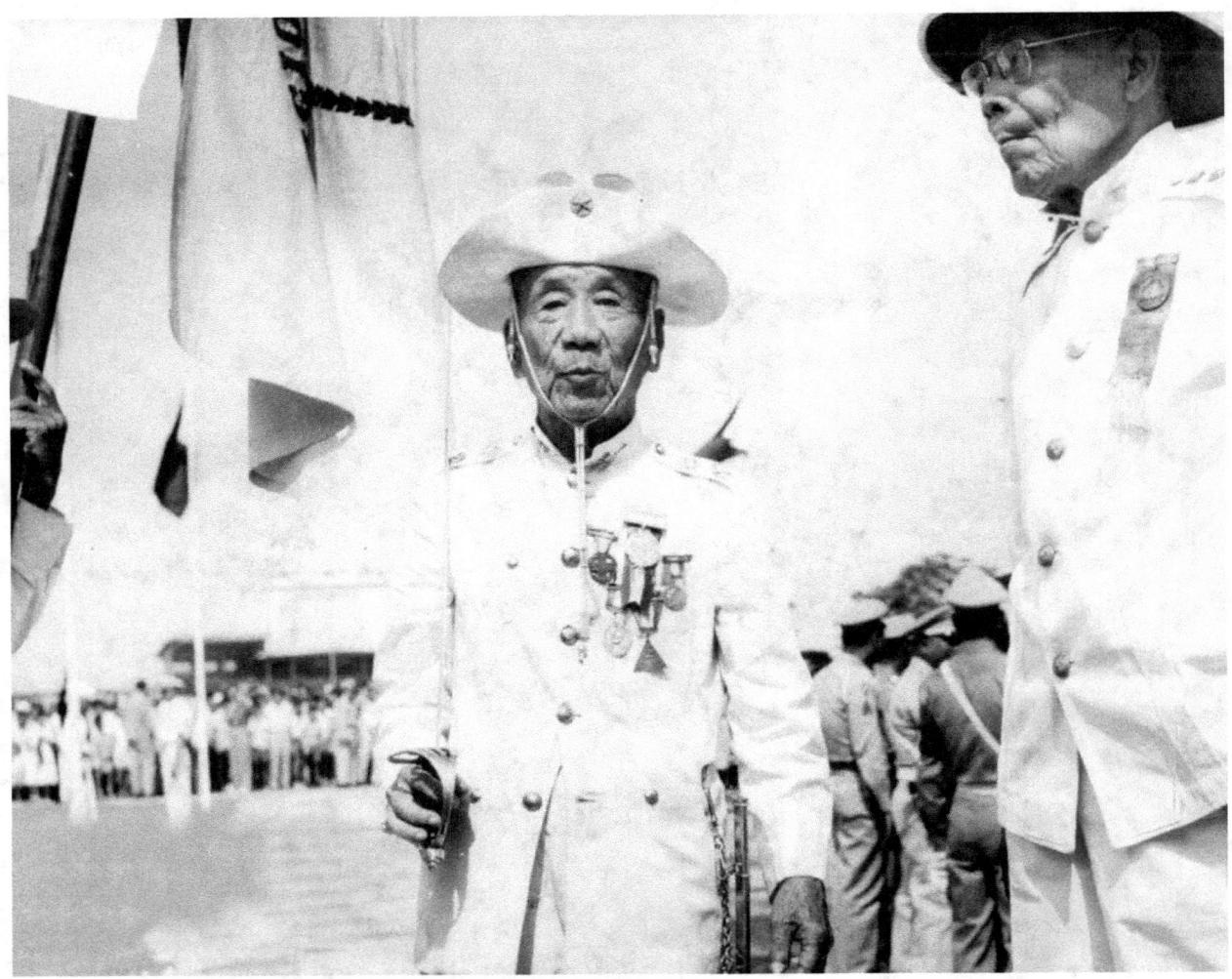

BEMEDALLED, GRAYING BUT STILL MARCHING With five medals proudly displayed on his left chest, this former officer of the great Philippine Revolution of 1898 makes "right shoulder arms" with his sword while his former underling and comrade-in-arms watches at right. The occasion was the annual Independence Day Parade at the Luneta Park in Manila in the 1950s.

These brave men could have been the last to march in the annual parade. As the old barrack saying goes: "Old soldiers never die. They just fade away."

THE BEAUTY OF BLACK & WHITE

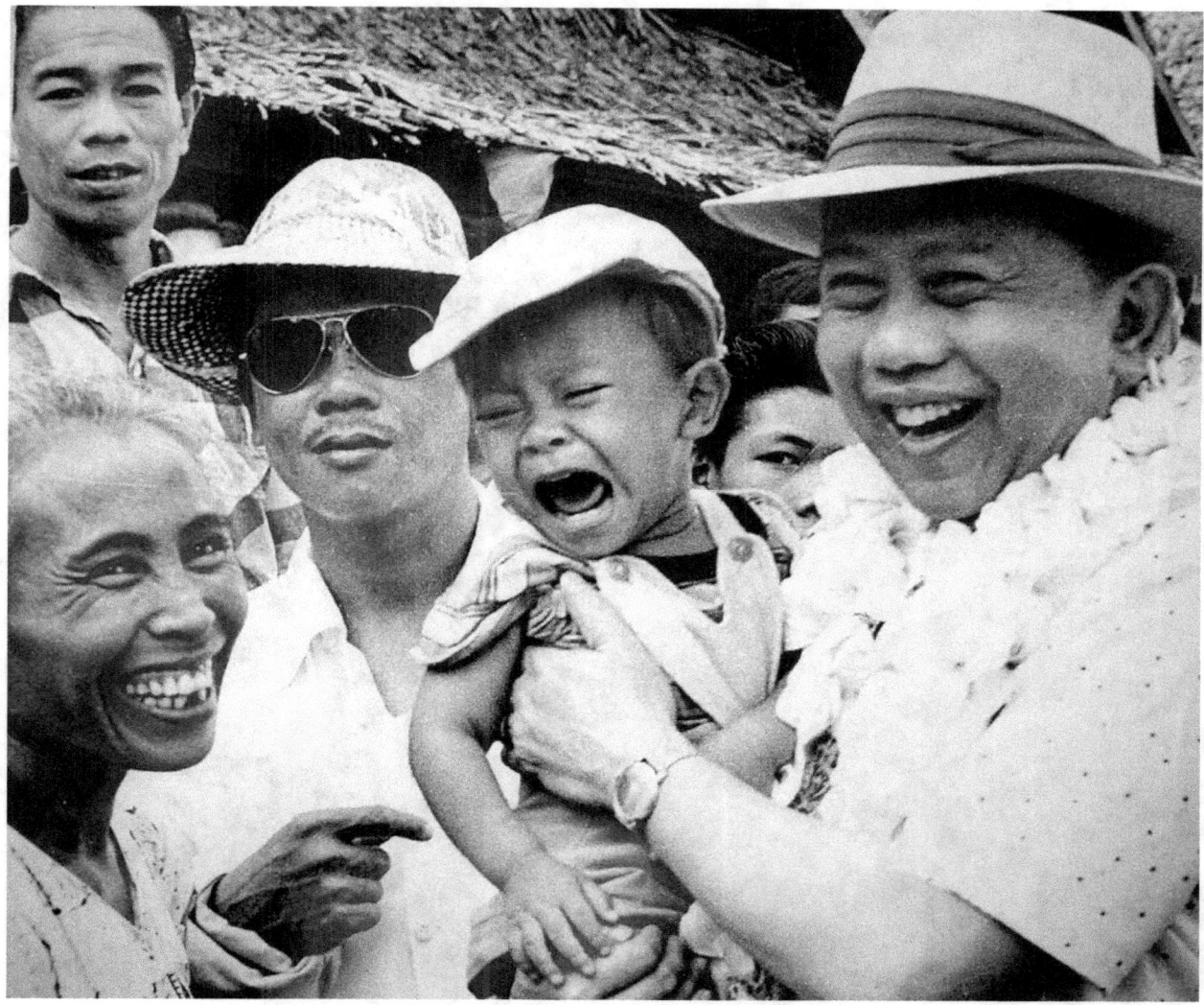

JUST NOT YET The man of many talents (and titles before his name) Carlos Romulo stumped around the Philippines in the early 1950s aspiring to become president of his country but lost in an open-vote nomination (of the Liberal party) to incumbent President Elpidio Qurino. He joined the campaign of Defense Secretary Ramon Magsaysay of the opposing party. Quirino would later lose to Magsaysay.

When Romulo was president of the United Nations, the very first to become so, my father accompanied him on his Asian visits to Indonesia, Cambodia and Hong Kong. (Read full account of the interview by writer and TV Host Joe Quirino with my father on Pages 64-69.)

https://en.wikipedia.org/wiki/Carlos P. Romulo#Philippine Presidential Aspiration

THE BEAUTY OF BLACK & WHITE

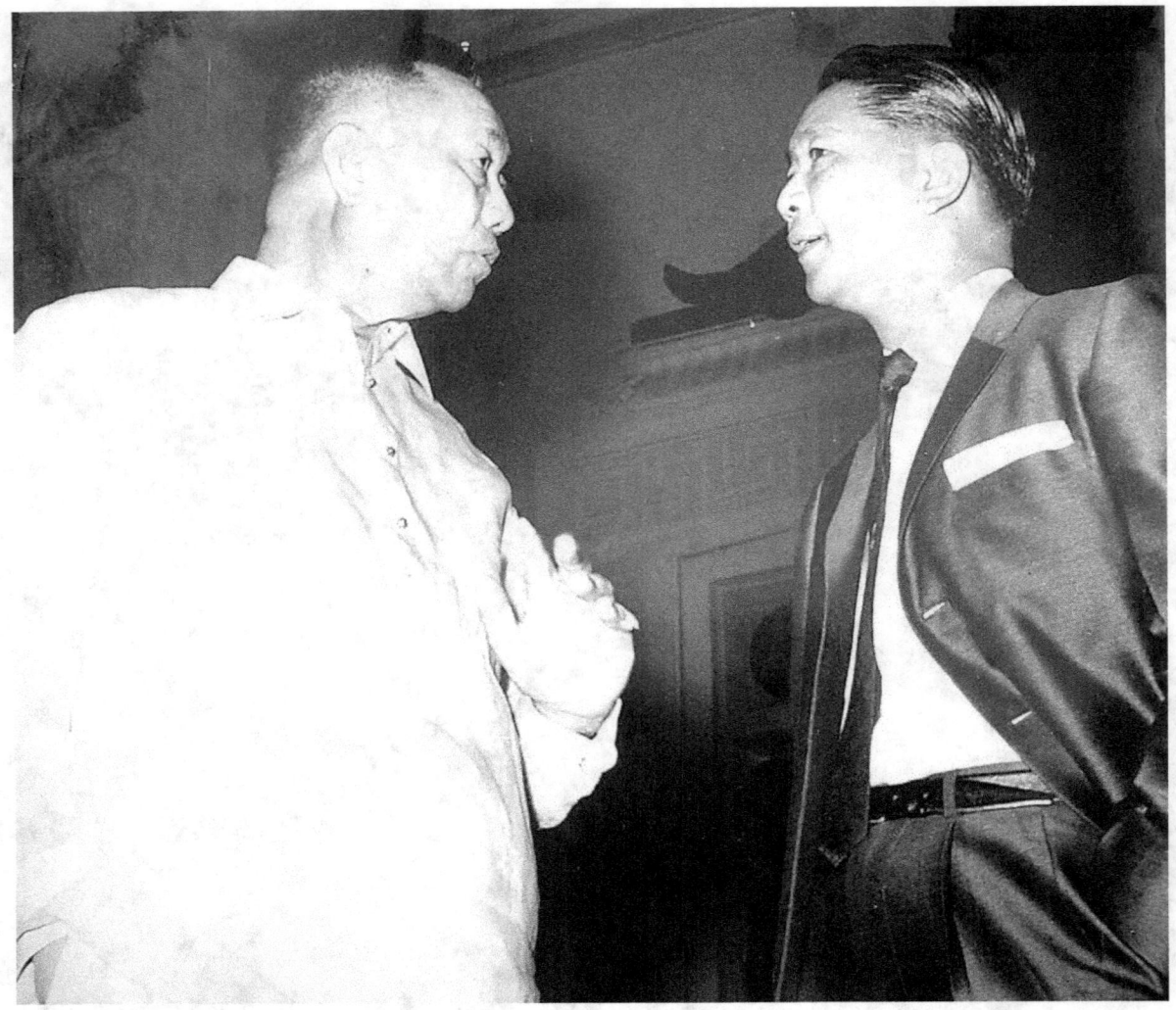

THE BUSINESS TYCOON AND THE ASTUTE POLITICIAN On the floor of the Philippine Senate, when my father snapped this picture with a flash bulb, are shown former Senator Fernando Lopez (left) and Senate President Ferdinand Marcos (right). Marcos and Lopez would later join hands to run as president and vice president respectively and won. However, in later years, the two had to part ways owing to, what is talked about in my country, as deep-seated political and business differences.

THE BEAUTY OF BLACK & WHITE

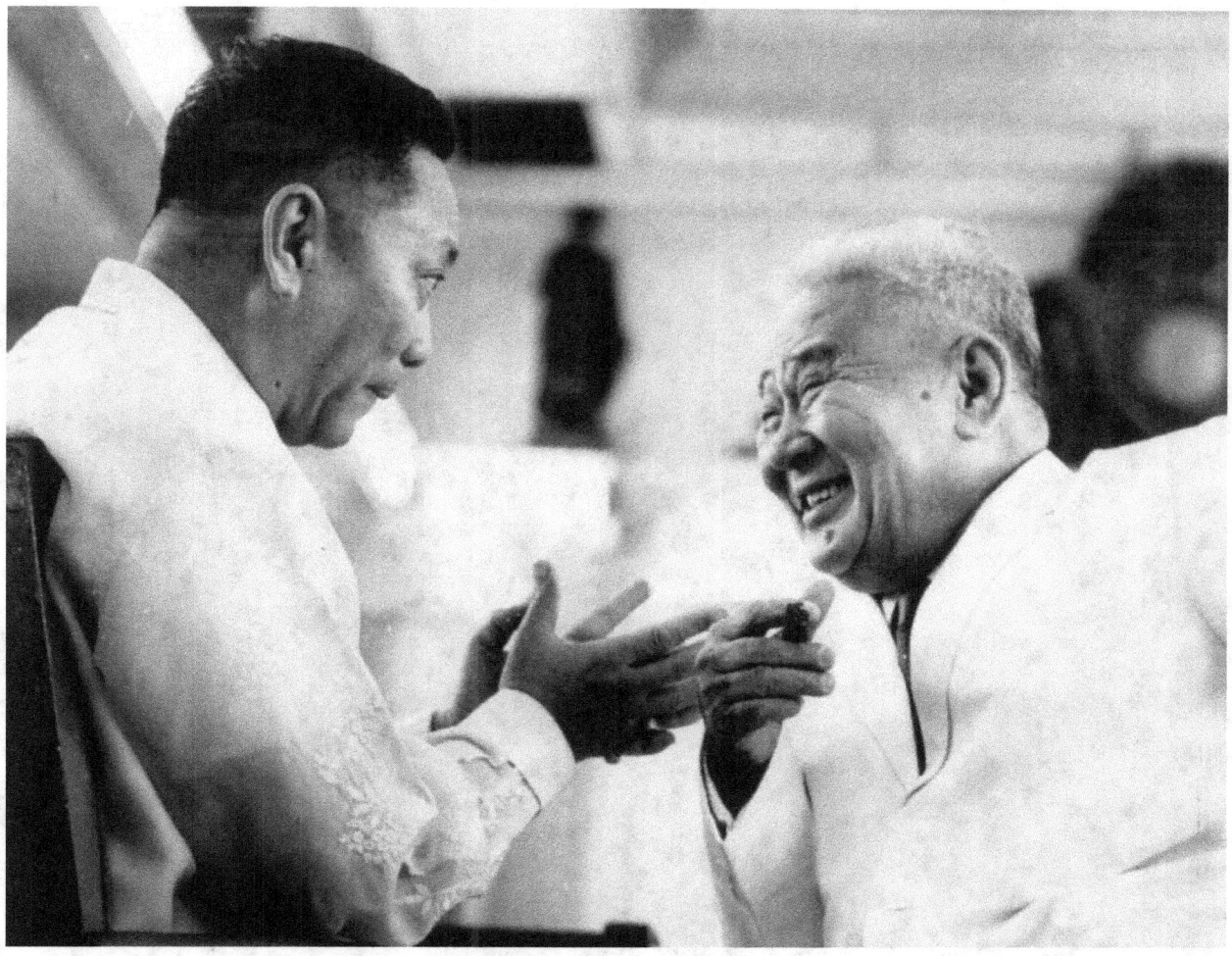

LOPEZ AND THE DOWN-TO-EARTH POLITICIAN In this photo Senator Lopez is shown in an animated conversation with Senate President Eulogio "Amang" Rodriguez, Sr. (right) "the longest serving Senate President (of the Philippine Senate—Author) after Manuel L. Quezon, serving the post from April 30, 1952 to April 17, 1953 and May 20, 1953 to April 5, 1963."

In the final two years of his career as an ace photojournalist, my father was given the "lighter" assignment of covering the Philippine Senate until he retired in January of 1968.

https://en.wikipedia.org/wiki/Eulogio_Rodriguez

THE BEAUTY OF BLACK & WHITE

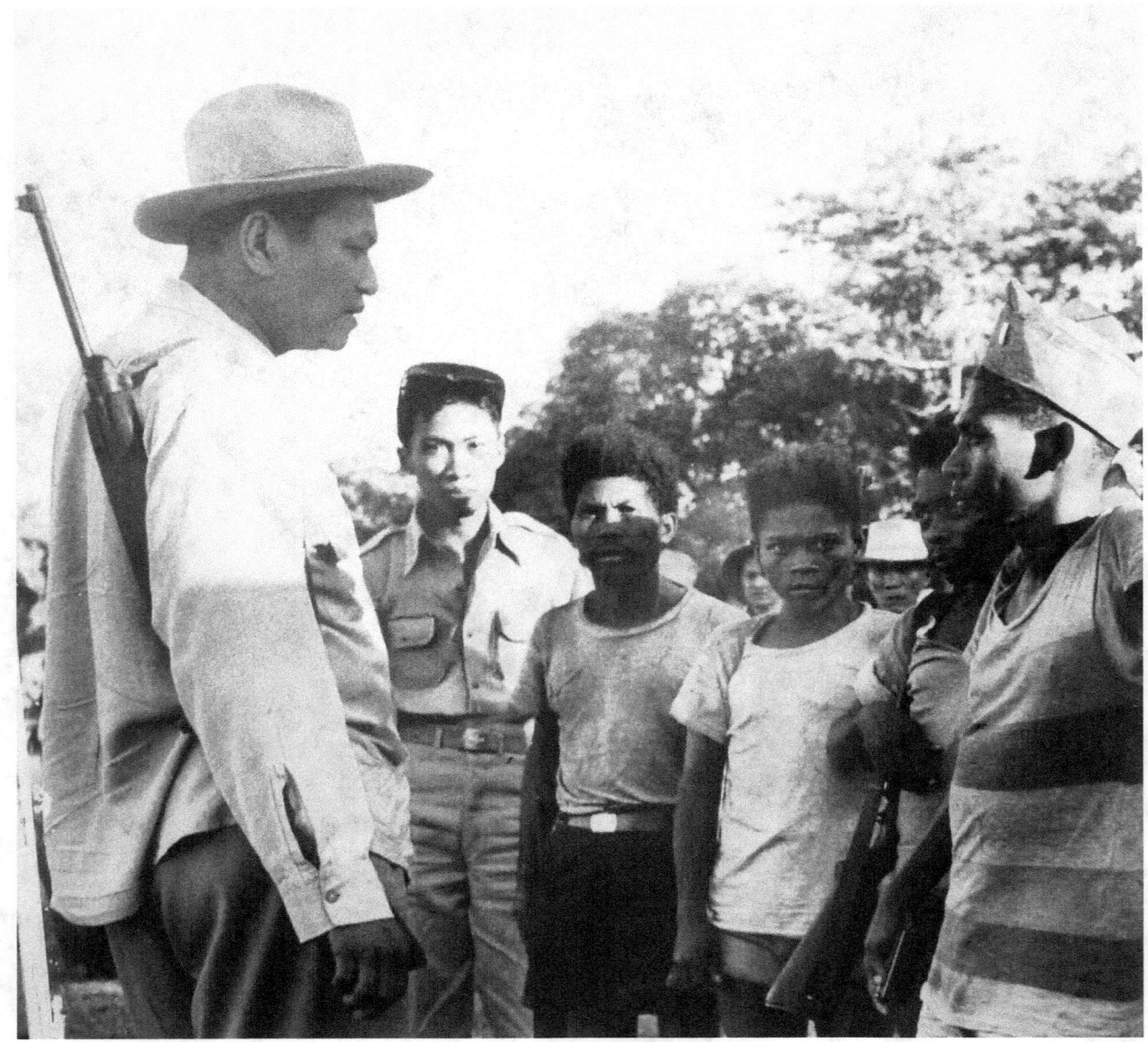

PRESIDENT MAGSAYSAY WITH TRIBAL LEADERS At the height of his campaign against communist insurgency in the early 1950s, President Ramon Magsaysay touched base with upland tribal leaders of his home province of Zambales. The president is shown here conversing with commissioned "Negrito" scouts while a carbine rifle is slung on his right shoulder.

THE BEAUTY OF BLACK & WHITE

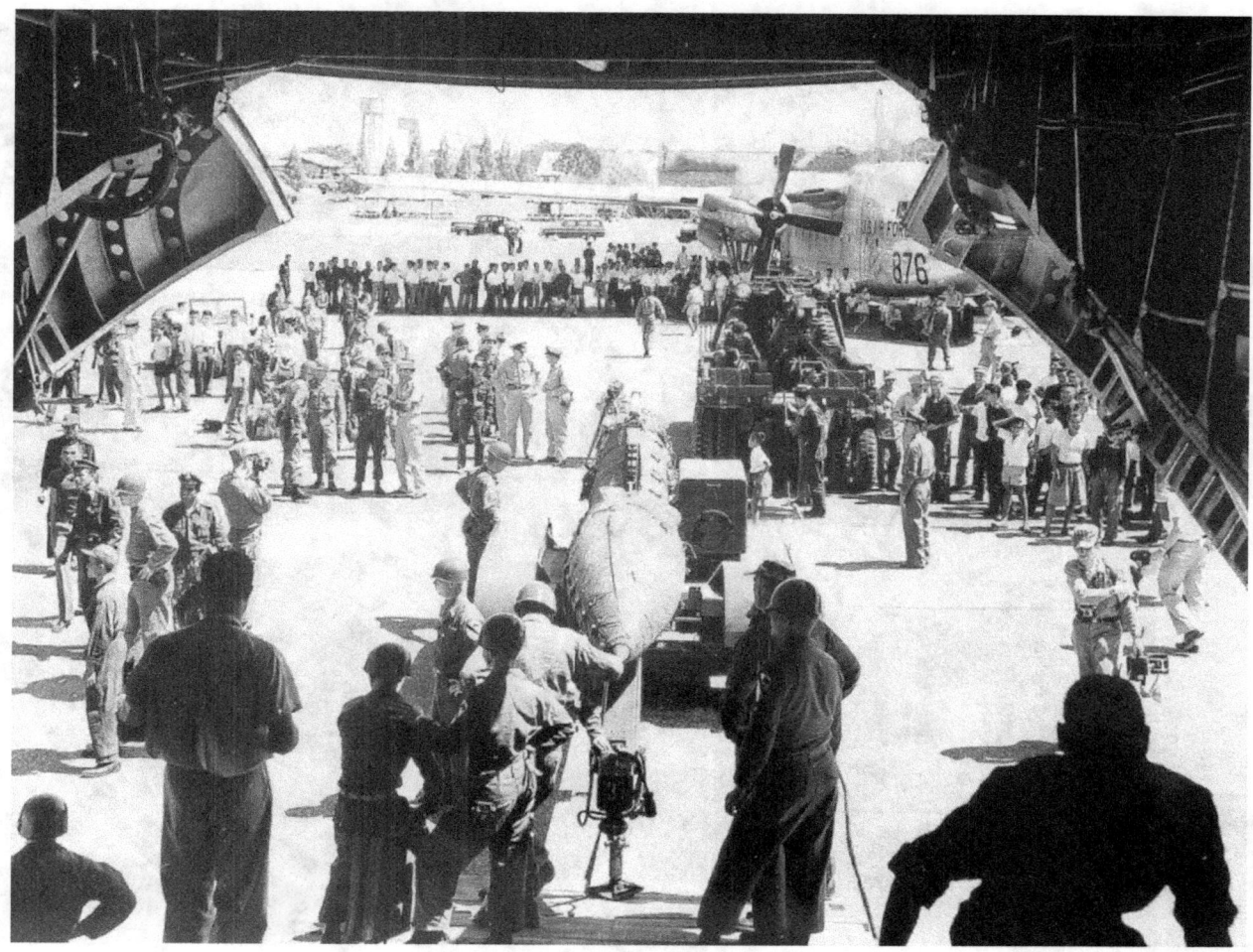

EXCESS ATOMIC BOMB is loaded into the belly of an American Air Force plane parked on the tarmac of the old Manila International Airport. It will be recalled that the United States dropped two such bombs over Hiroshima and Nagasaki in Japan toward the end of World War II which brought the country to its knees. Japan later signed an unconditional term of surrender on September 2, 1945 . A few months later, the US shipped back excess (and defused) A-bombs to the United States and my father was already back on the job to cover the news. Notice the lack of proper security measures as civilians mingle with US and Filipino military personnel.

https://en.wikipedia.org/wiki/Surrender_of_Japan

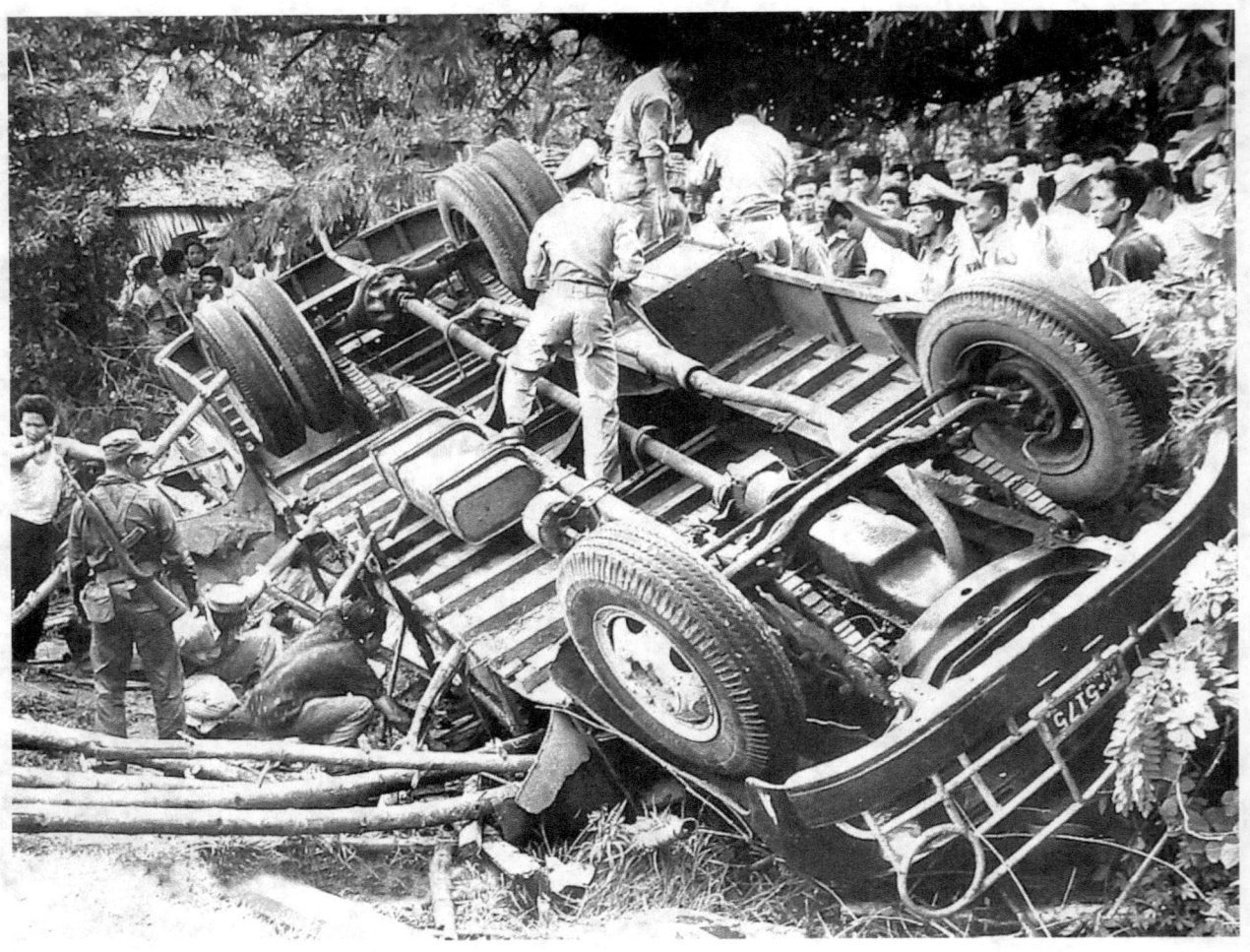

BUS MISSES CURVE, TURNS TURTLE This bus missed the curve and flipped over killing and causing injuries to an undetermined number of passengers. Valenzuela was dispatched by the desk to the scene with the office driver whose name I can only recall as Mang Basilio.

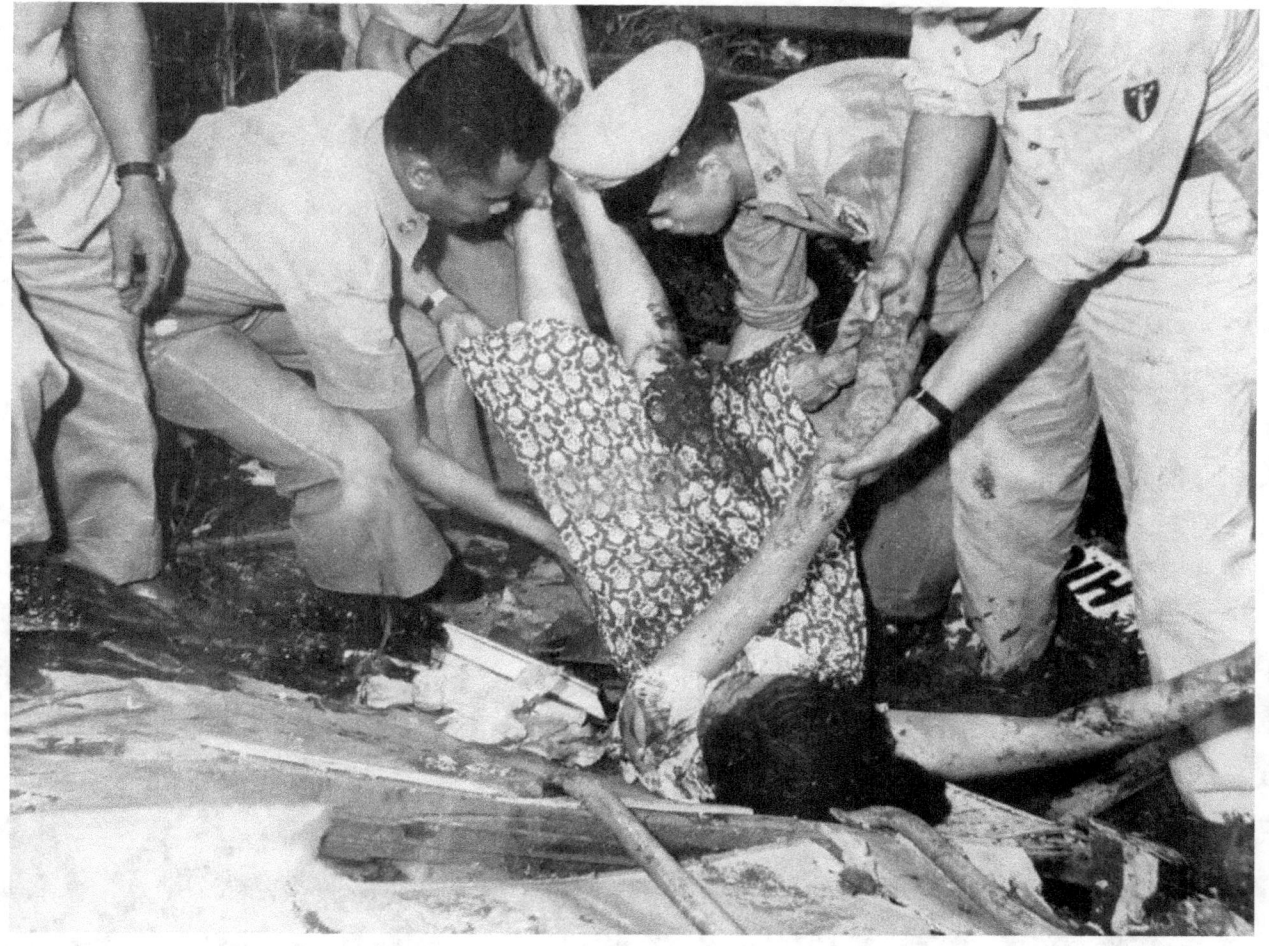

FATALITY The lifeless form of an unfortunate passenger is taken out (mishandled) of the wreckage of the bus.

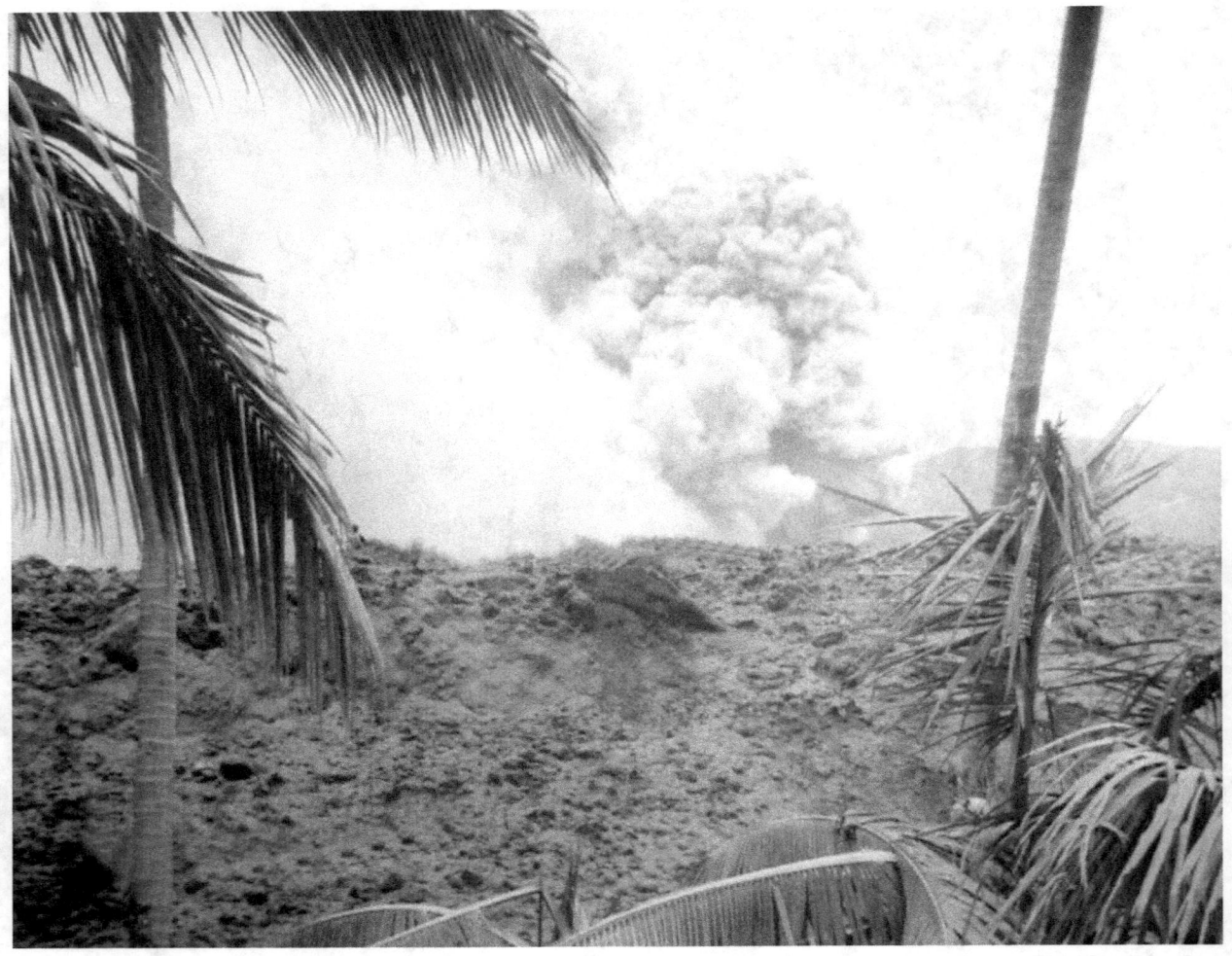

ERUPTION OF "HIBOK-HIBOK" VOLCANO Ashes are spewed from the mouth of the angry volcano which erupted between the period 1948-1953 as mudflows (lahar) are shown in the foreground. "Hibok-Hibok" is located at the northeastern end of the island of Camiquin off the main island of Mindanao, south of the Philippines. My father was on the scene for many days sending rolls of films to his desk by commercial airplane.

http://www.phivolcs.dost.gov.ph/html/update_VMEPD/Volcano/VolcanoList/hibok.htm

THE BEAUTY OF BLACK & WHITE

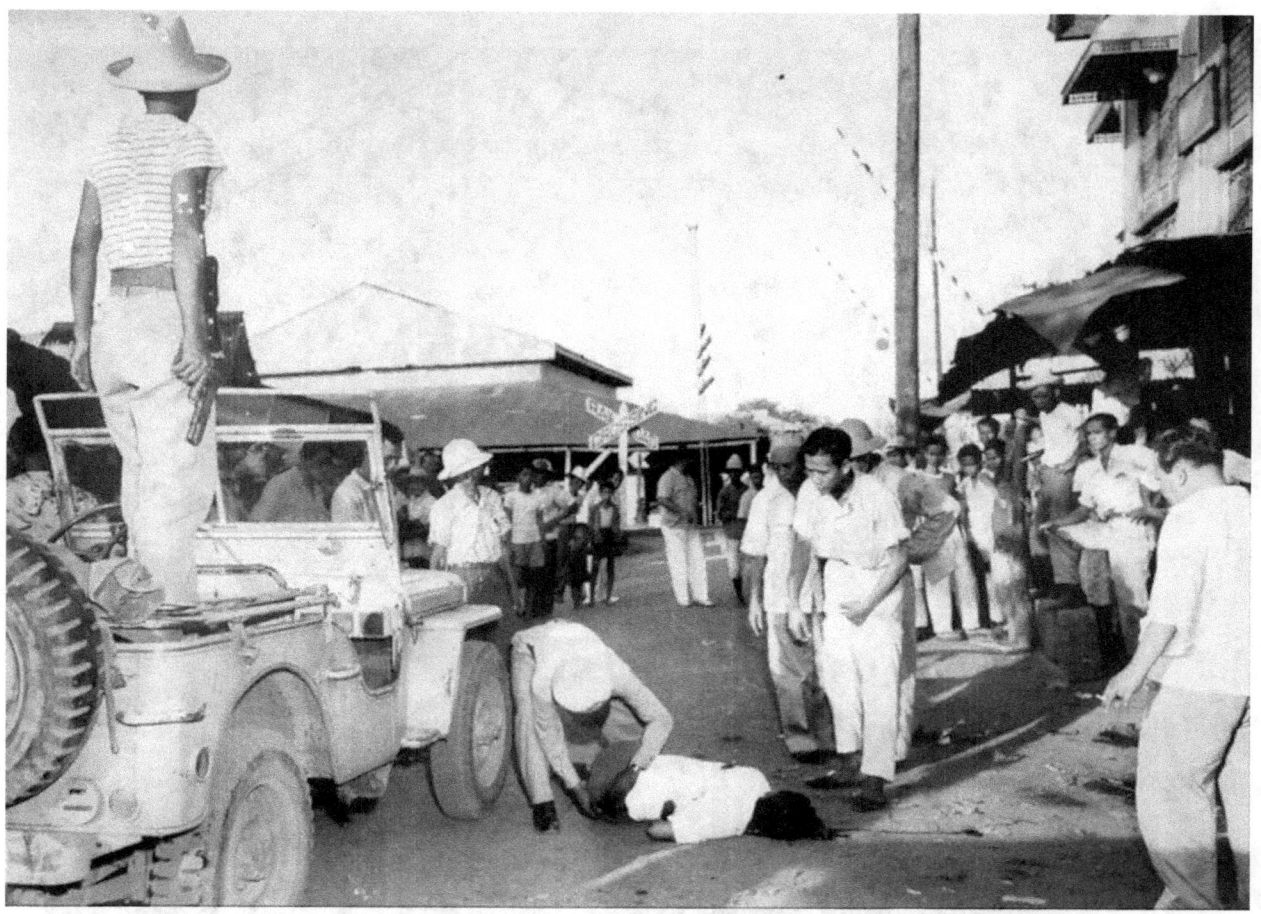

GUNFIGHT AT THE RAILROAD CROSSING I asked my father where he took this picture, and he replied: "At the railroad crossing in Meycauyan, Bulacan," a province north of Manila. According to him, the victim was a communist "agent" and he was gunned down by government troopers one of whom is shown standing atop a 4x4 Jeep holding a .45 cal pistol. Notice the reactions on the faces of onlookers while a government agent searches for identification. My father was then embedded with troopers of the Philippine Army during the government's campaign against the communists in the Bulacan-Pampanga provinces just north of Manila. This is one rare occasion when my father used a flash as fill-in light to highlight his subject.

THE BEAUTY OF BLACK & WHITE

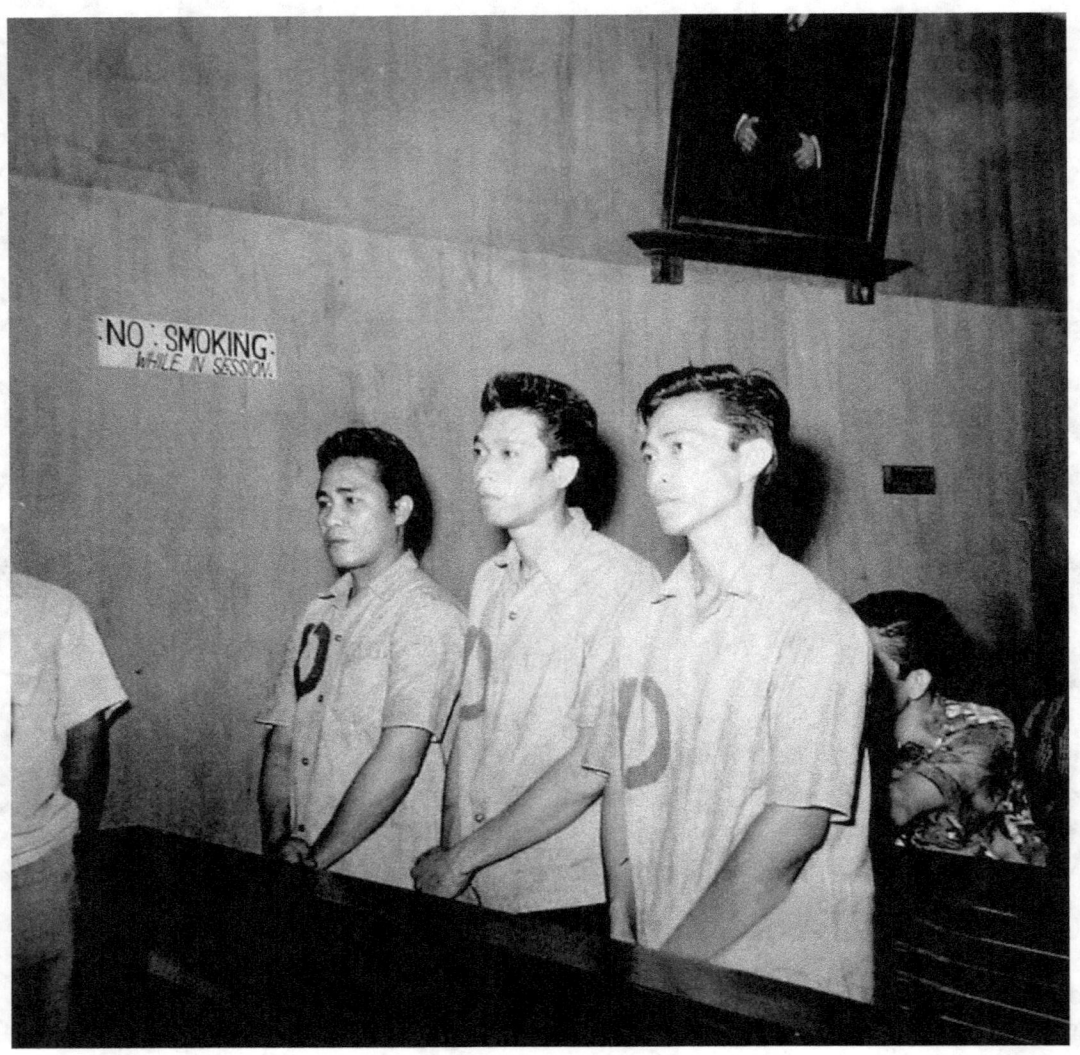

DEATH SENTENCE Three men stand in stark silence, their demeanor written on their face as they listen to the promulgation of death by electric chair (the mode in my country at the time this photo was shot). Today, the Philippines is at a crossroad whether to re-impose the death penalty or not after it had been suspended in 1987. This is another rare occasion that Marcial used a flash bulb to document this news event. It must have been a celebrated case that his publisher had it covered.

THE BEAUTY OF BLACK & WHITE

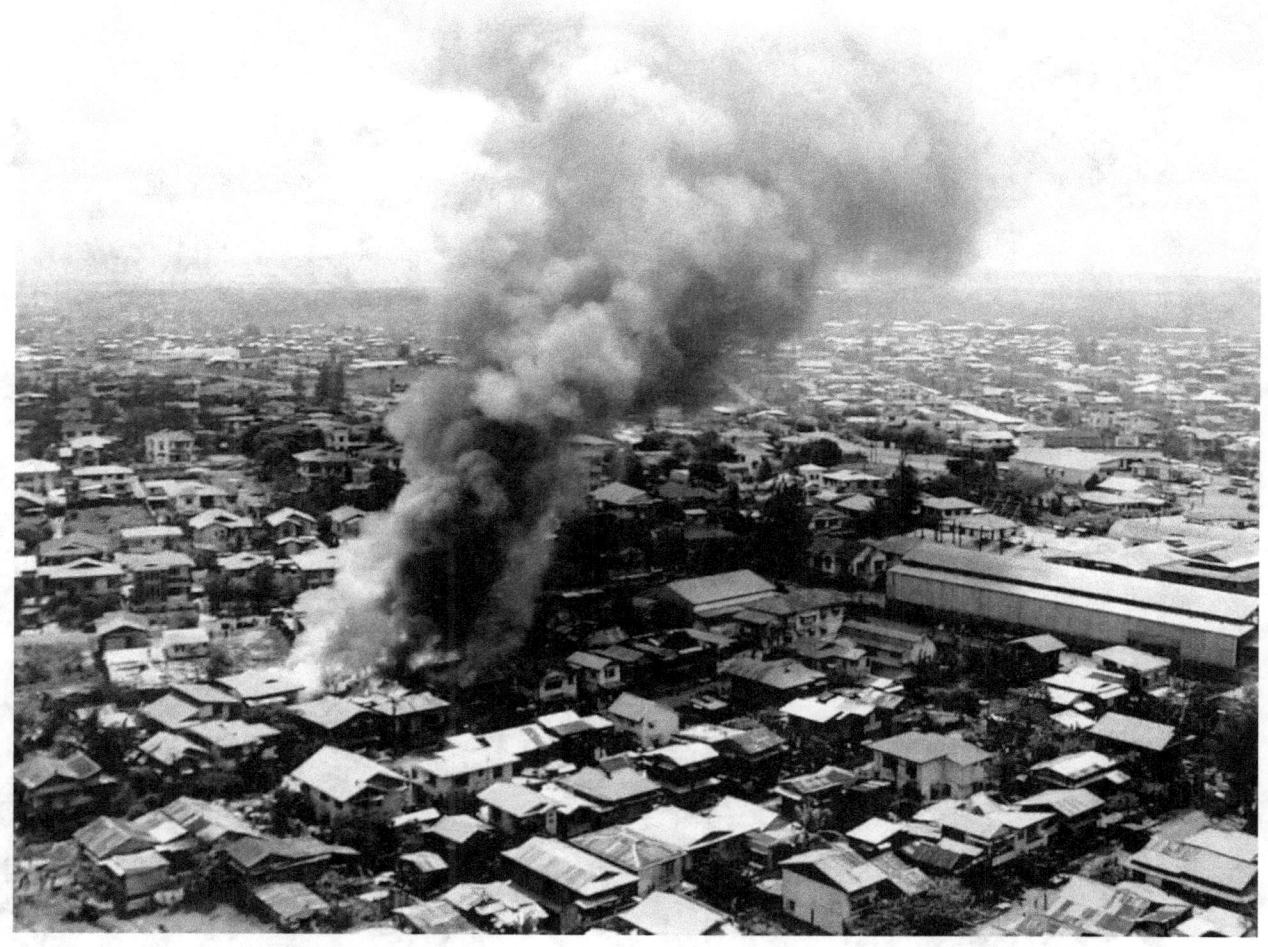

A FIRE IN THE CITY Marcial goes airborne on board the company fixed wing aircraft to take this photo of houses on fire right in the heart of the city of Manila. Back in the early 1950s, only two publishing companies were known to have owned an aircraft that was used for photo coverage such as this one.

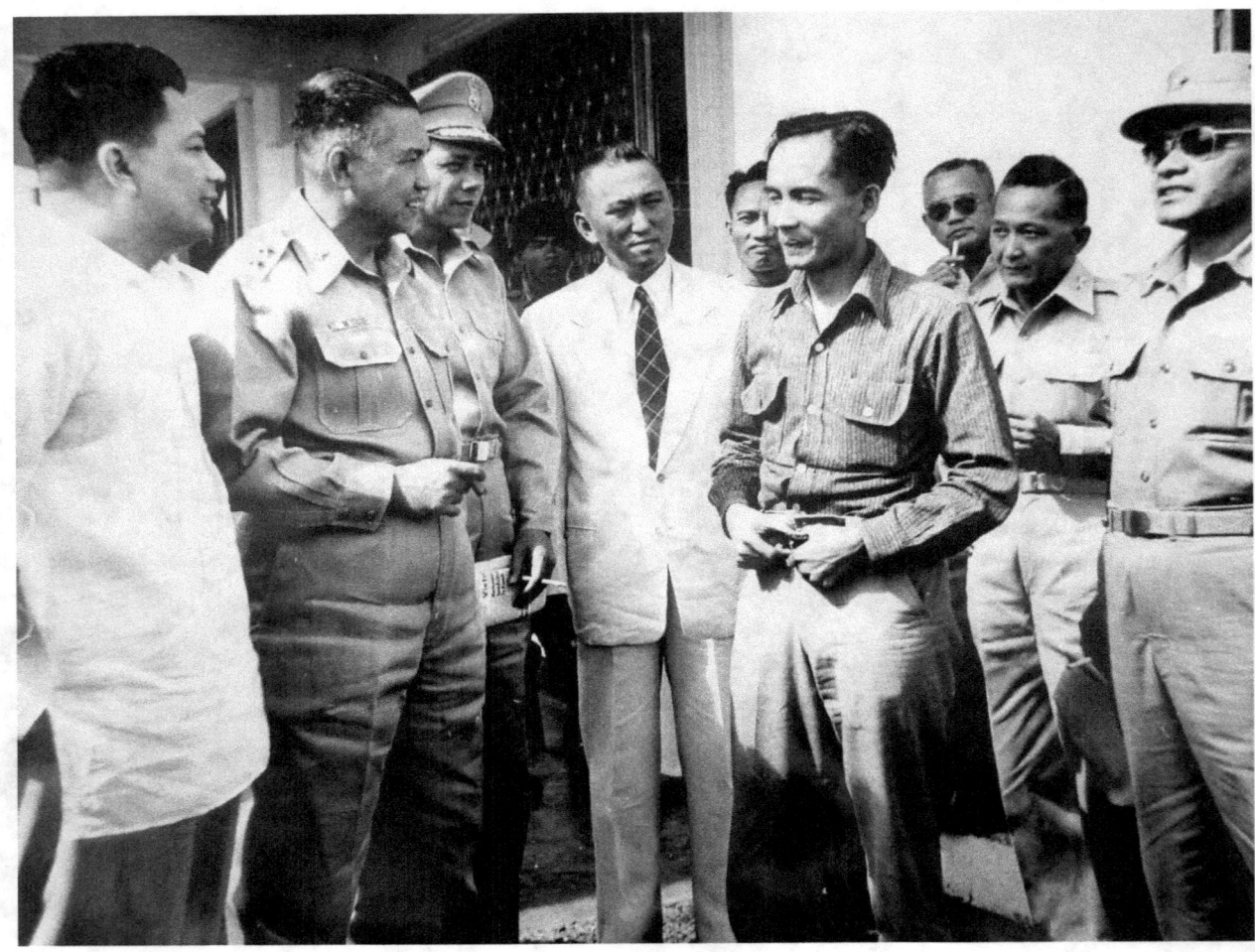

TOP COMMUNIST LEADER LUIS TARUC SURRENDERS My father captured this moment in Philippine history during the surrender of Luis Taruc (June 21, 1913 – May 4, 2005) shown here in a conversation with then AFP Chief of Staff Gen. Jesus Vargas at Camp Murphy (now Camp Aguinaldo).

Taruc was "a Filipino political figure and insurgent during the agrarian unrest of the 1930s until the end of the Cold War. He was the leader of the Hukbalahap or *Hukbong Bayan Laban sa Hapon* group between 1942 and 1950. The Huk movement commanded an estimated 170,000 armed troops with a base of two million civilian supporters at the apex of their power in 1952. After four months of negotiations, Taruc surrendered unconditionally to the government (under Pres. Ramon Magsaysay--Author) on 17 May 1954, effectively ending the Huk rebellion."

https://en.wikipedia.org/wiki/Luis Taruc

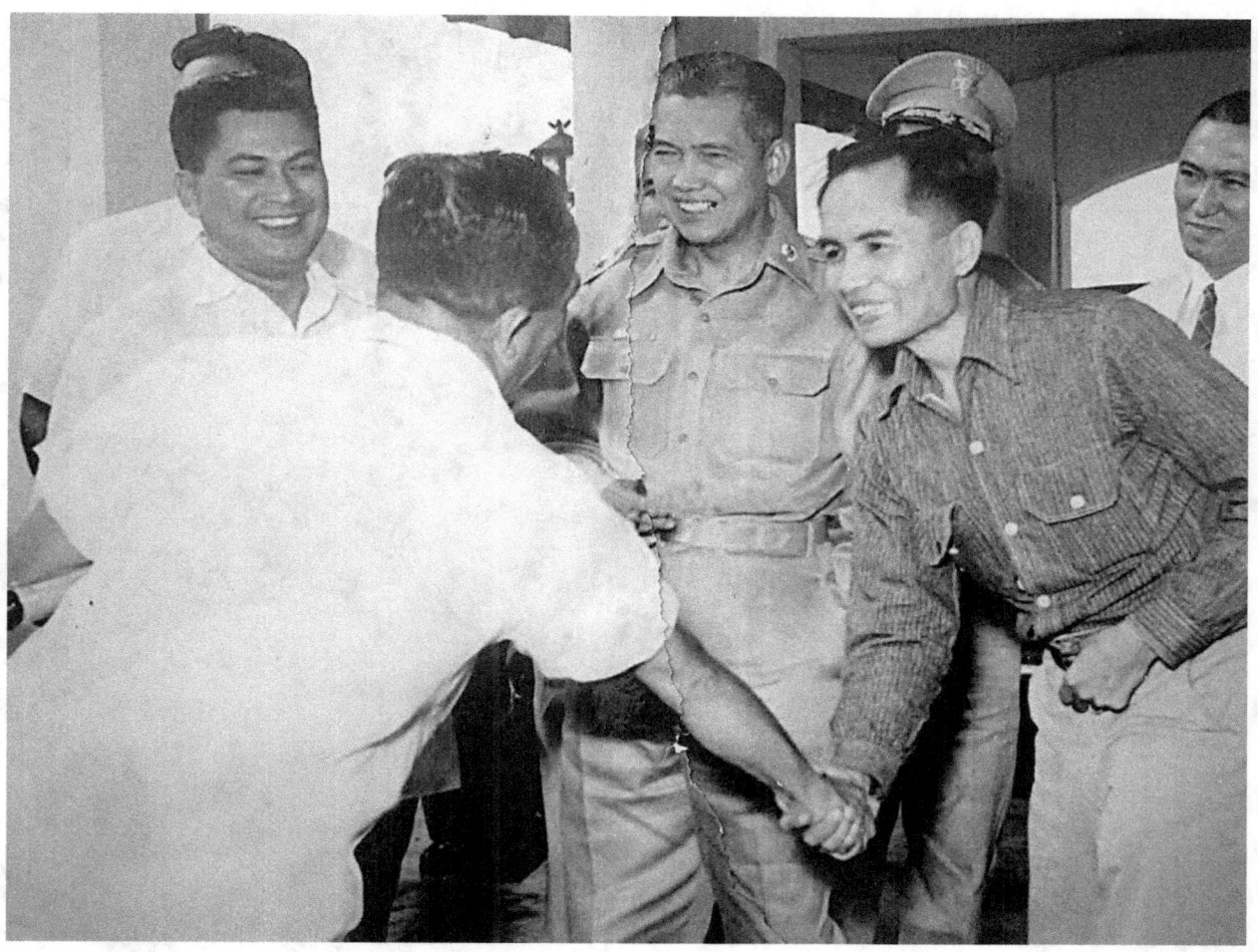

THANK YOU FOR THAT EXCLUSIVE COVERAGE Several months before Taruc surrendered to General Vargas, my father had the rare opportunity of taking exclusive pictures of Taruc in hiding in the mountains of Mt. Arayat in Pampanga during a scoop interview with him and THE MANILA TIMES reporter Veloso. This photo was taken by a fellow photojournalist showing my father, left clutching his camera, shaking hands and greeting the former top Philippine communist leader as Veloso and General Vargas watch.

THE BEAUTY OF BLACK & WHITE

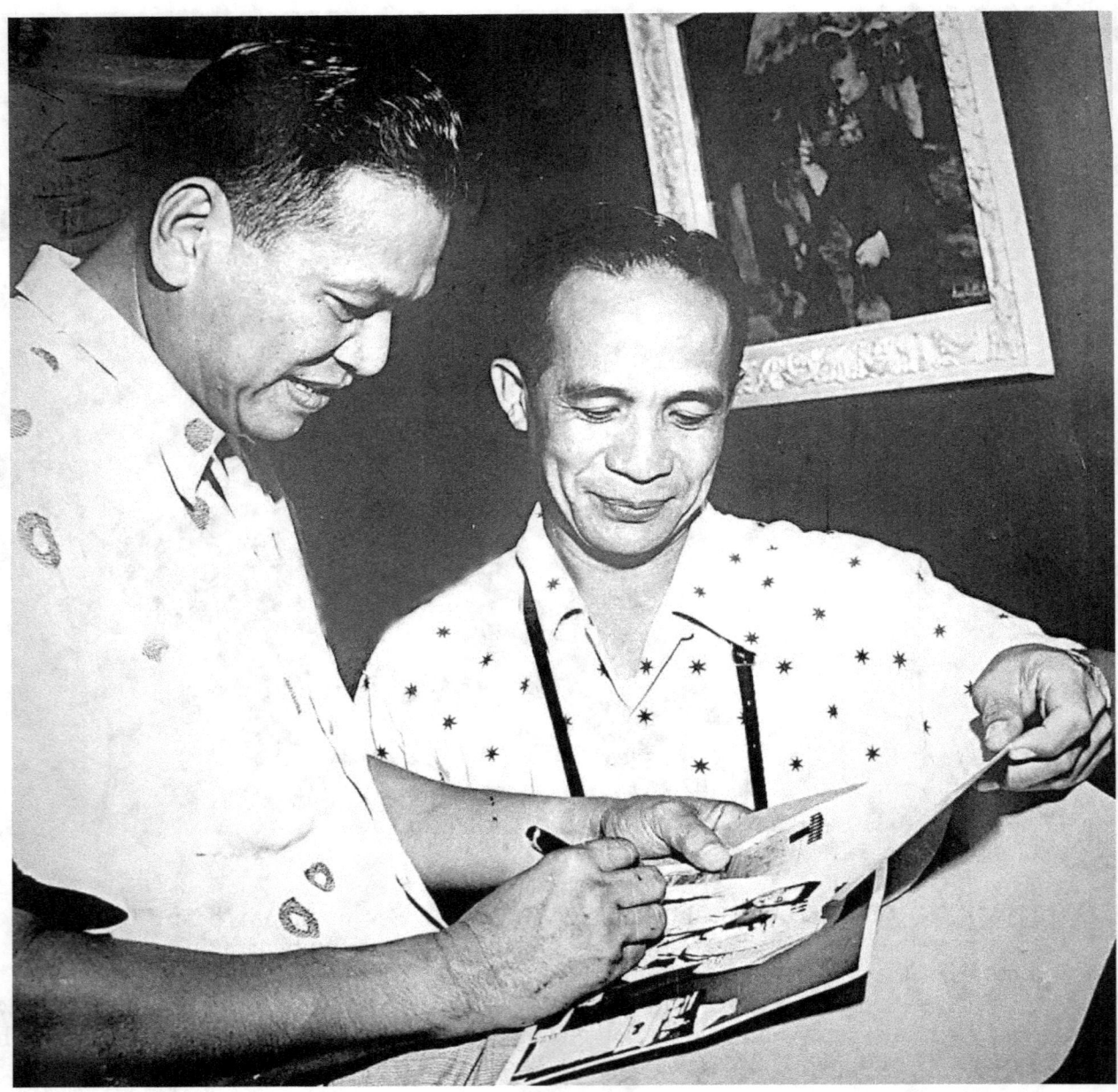

THE PICTURE THAT MADE HISTORY This is the picture I was referring to in my caption on Page 76 of this book. Here, President Magsaysay autographs a copy of the famous picture that my father took which was printed on the front page of THE MANILA TIMES for the entire nation to see which unofficially proclaimed that Magsaysay had won by a landslide in the presidential elections of November 1953, unseating incumbent President Elpidio Quirino.

THE BEAUTY OF BLACK & WHITE

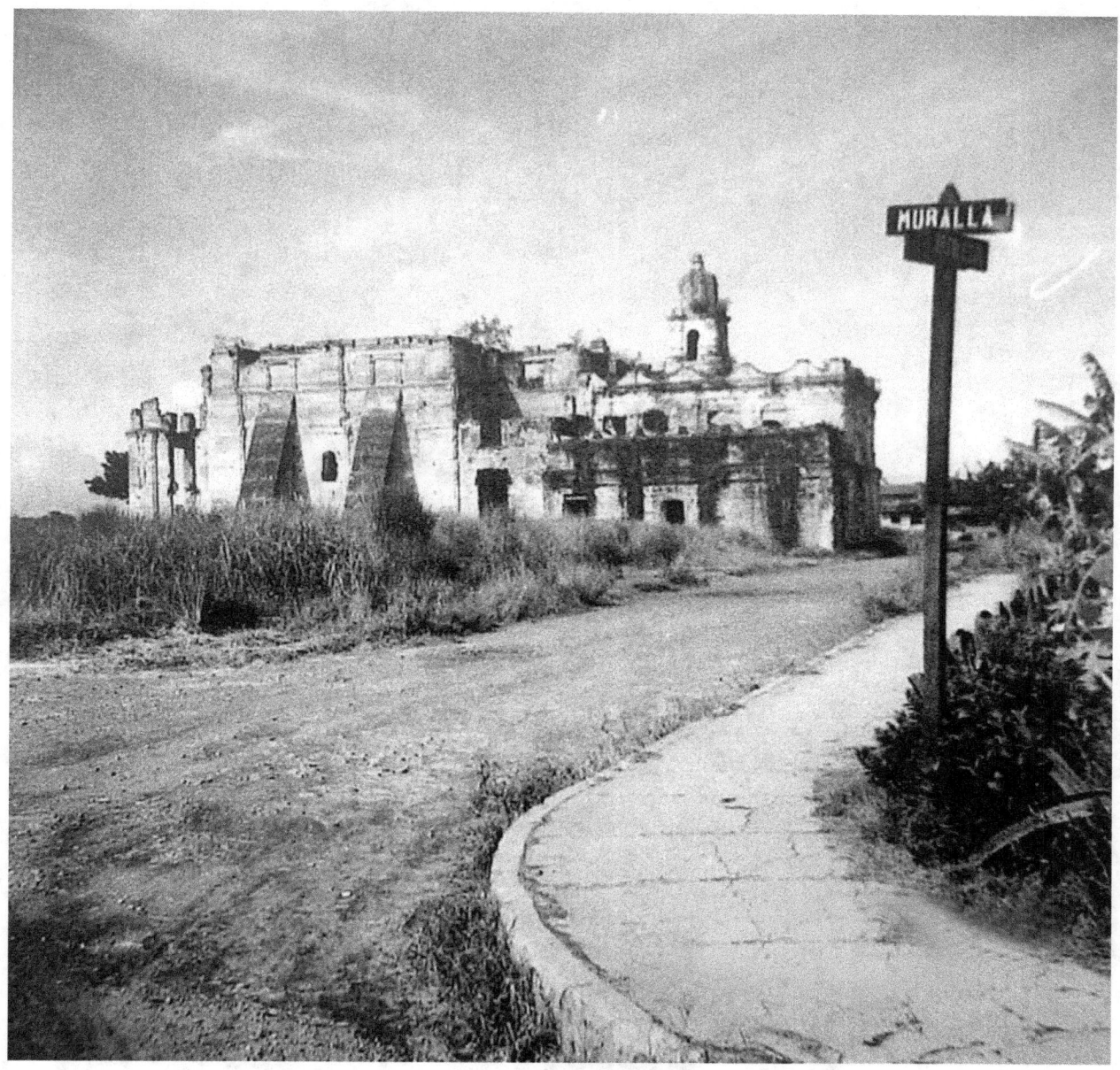

RUINS OF WORLD WAR II Next to Warsaw, Poland, the southern part of Manila suffered heavy damage and casualties in the aftermath of the WW II that ended in September 2, 1945. Upon his return to work, the desk assigned Valenzuela to document the ruins of Manila. Shown in this photo are the ruins of a Catholic church in the district of Intramuros in Manila.

THE BEAUTY OF BLACK & WHITE

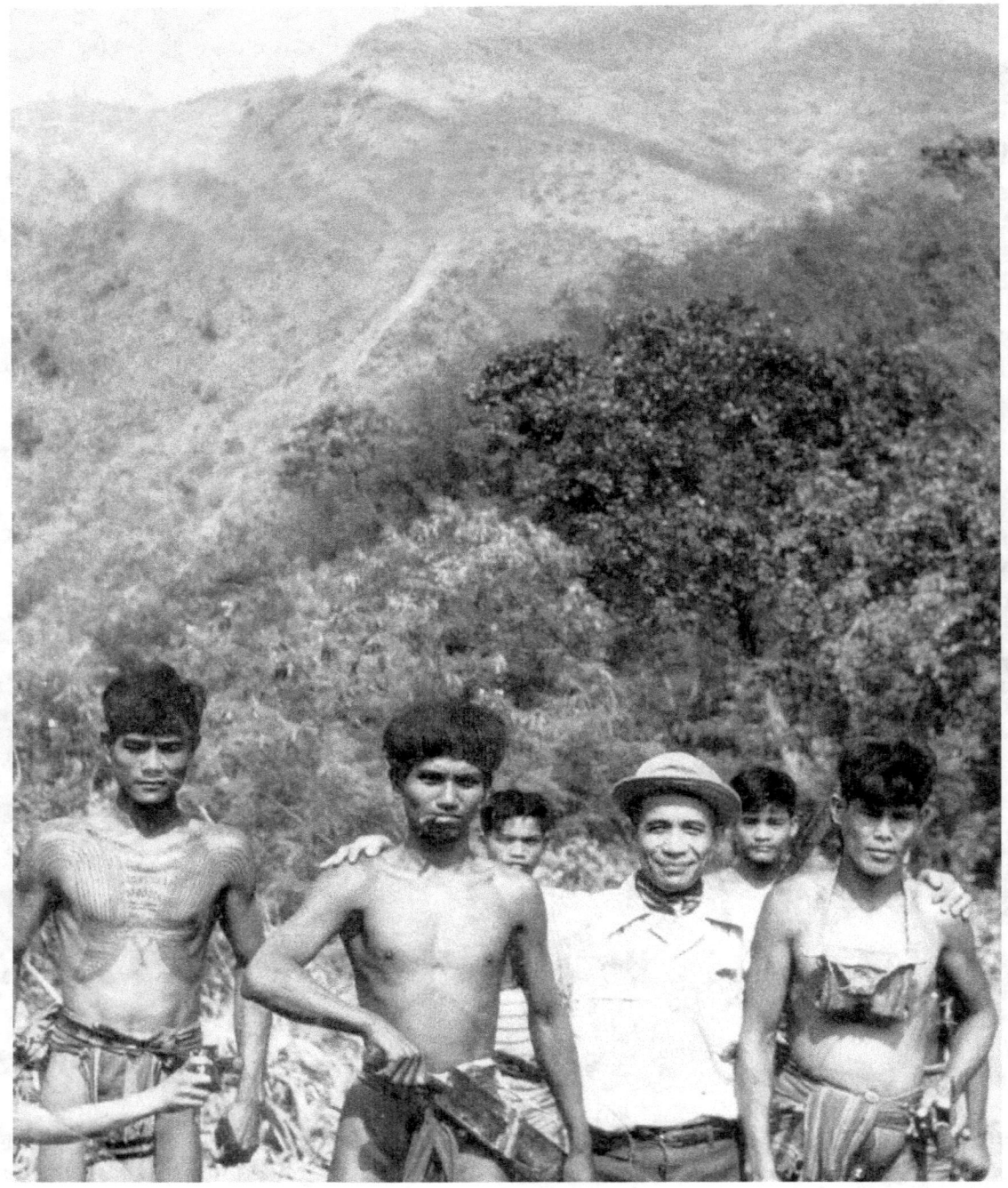

FROM THE MOUNTAINS of the Cordillera in northern Philippines with fierce-looking upland tribal warriors...

THE BEAUTY OF BLACK & WHITE

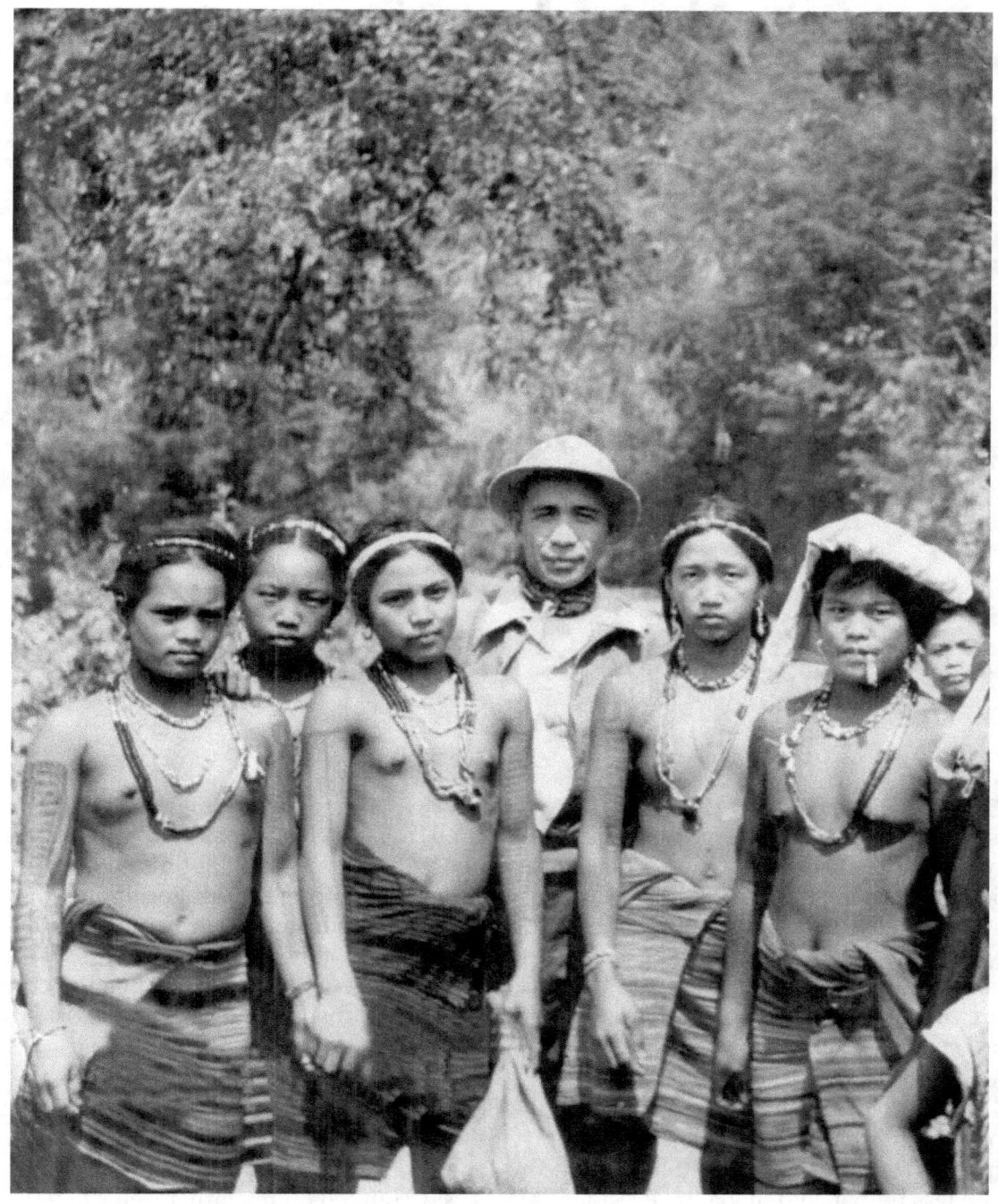

AND AMONG NATIVE MAIDENS...

THE BEAUTY OF BLACK & WHITE

TO THE STREETS OF OLD HONG KONG ON A RICKSHAW, my father always had a front row seat to the drama of everyday living and captured them like paintings on a canvass. He always had a front row seat to the official and off-the-cuff demeanor of "all" his country's presidents from the time of President Manuel Quezon in 1935 to President Ferdinand Marcos in 1965 and recorded them through the lens of his camera, for history to keep and for the next generations to relish. He had brushes with death like skipping a fiery plane crash with President Magsaysay in 1957. He was also locked up for contempt by a judge when he took pictures of a court hearing of a celebrated case. He was also mishandled with his reporter by Makati cops and threatened with a machinegun by Japanese soldiers.

THE DEAN Through it all, he earned the full respects of his peers that, in his later years as a top photojournalist, he was given the honorary title, "Dean of Press Photographers of the Philippines" and was recognized for "his record long service to Philippine photojournalism" with no less than a gold medal by President Magsaysay (pinned on my father's chest by the president's daughter, Mila) and was honored with a similar recognition by the National Press Club of the Philippines through its president, Domingo Abadilla.

THE FAMILY MAN And at the end of the day, he would come home to us carrying some snacks; occupy his favorite seat at the living room as he relaxes in deep thoughts, native coffee in hand, while I pour over the pages of the afternoon copy of his newspaper that he would bring home. I remember him always advising me to: "Read, read and read." Yes, the ace photojournalist was also an ace of a father.

THE BEAUTY OF BLACK & WHITE

The Son Also Rises

Photos and narrative texts by Art G. Valenzuela

When my father said, "No, I don't want my children to follow in my footsteps," he must have spoken with tongue in cheek.

The pictures featured in this section were shot mostly in the provinces of Pangasinan, La Union, Ilocos Sur, Ilocos Norte and Isabela between 2010 and 2016. I have converted all the photos from colored to black and white in keeping with the overall theme of the book.

I had my very first experience with a camera way back in 1949 when I was seven years old, courtesy of course of my father, the Dean -- Marcial S. Valenzuela. It was a Brownie (*Kodak*, the leading brand at that time), box type cam, maybe 5" x 5" x 6" in size, lightweight with the mirror-like viewfinder mounted on the left side corner on top. Good for a starter like me. It was a 120mm film format in black and white. My first models were members of my own family with my 90-year-old grandpa who was then vacationing with us from the province. (My grandpa died in 1959, a full decade after that visit, at age 100.) How I wish I have a copy of that photo.

Between 1978 and 1988, photography was both my passion first, and a profession second. Today, I always carry around a lightweight and compact digital cam wherever I go as I pursue photography purely for passion----in between travelling and writing. Here are some of the results of my personal efforts, of being a "trying-hard copycat" of my father.

Yes, I just could not catch up with his footsteps. Marcial S. Valenzuela, the *Big Kahuna* of Philippine photography will always be in a class all by himself, a cut above the rest

THE BEAUTY OF BLACK & WHITE

MY FAMILY'S PERSONAL HISTORY STARTED HERE, at the imposing baroque Saint Augustine church of Paoay in Ilocos Norte, a UNESCO Heritage Site. It was here where, in the 1880s, my grandfather Vicente, my father's father, worked as a laborer---forced by the Spaniards to render manual labor in exchange for unpaid taxes. In 1898, when the Philippine Revolution started (against the Spanish colonial rule), my grandpa (who was then 44 years old) packed up his gears and, together with his brothers Mariano and Enrique, left Paoay town in haste and migrated down to Mangatarem town in the province of Pangasinan, where my father Marcial was born in 1907.

THE BEAUTY OF BLACK & WHITE

THE FISHERMAN AND THE SEA The sea was calm one cold Tuesday afternoon in January of 2014 in Bangui Bay when this view presented itself. I waited for the precise moment when the fisherman would be directly aligned with the setting sun to no avail because the sun was setting fast. I could hardly move on the exposed and slippery corals fearful that I might trip, damage my cam and injure myself. I had to snap as many frames as I can. This was taken at the beach front of Casa Teresita Resort in Pagodpod, Ilocos Norte.

THE BEAUTY OF BLACK & WHITE

A STRANGER ON THE SHORE In early 2014, my friend, the late Deomedes Lorenzo of Laoag City asked me to do a photo sales kit for his beach resort which he was selling to a foreigner who was based in the United States. The model he provided was his niece, the former Patricia Gorospe. In this photo are a photographer's delight, the four basic elements of nature in one frame which are: Clouds, water, sand and plants. Add the model to complete the picture. Ten months later, the resort was sold and two months after it was sold, my friend Lorenzo died. A year later, Miss Gorospe became Mrs. Zerjo Albano. I did not find any use for a flash as fill-in light in this photo as I always stick to available light in almost all of the photos that I take.

THE BEAUTY OF BLACK & WHITE

A HOUSEFUL OF GARLIC My driver veered away from the main highway and took a hard turn to the left almost missing this large storage of local garlic in Burgos town in Ilocos Norte, northern Philippines. The lady was waiting for the truck to pick up her goods and I was just lucky to document this rare opportunity.

THE BEAUTY OF BLACK & WHITE

SWIFT SWEEPING My farm caretaker Lito uses a sweep made of bamboo midrib sticks in cleaning the yards of fallen dry leaves. This is a tedious everyday exercise most specially after a wind-swept day. I was taking breakfast *al fresco* early in the morning when I took this photo. I always delight in capturing moments like this one early in the morning after sunrise and late in the afternoon as soon as the sun starts to bank itself at 3.00 o'clock.

THE BEAUTY OF BLACK & WHITE

CENTURIES-OLD HOUSE IN VIGAN CITY These are some of the 247 "mestizo" houses (Spanish era houses) in the historic city of Vigan. Walking the old streets of the city and visiting these old houses take you back in time, to the 1800s, at a time when the whole Philippines was under the stewardship of Spain.

"It is a UNESCO World Heritage Site in that it is one of the few Hispanic towns left in the Philippines where its structures have remained intact, and is well known for its cobblestone streets and a unique architecture that fuses Philippine and Oriental building designs and construction, with colonial European architecture.

In May 2015, Vigan City was officially recognized as one of the New 7 Wonders Cities together with Beirut, Doha, Durban, Havana, Kuala Lumpur and La Paz."

https://en.wikipedia.org/wiki/Vigan

THE BEAUTY OF BLACK & WHITE

ALL TIRED FROM WALKING My grandchildren appear tired from touring the historic streets of Vigan City, a UNESCO Heritage Site and one of the New 7 Wonder Cities of the World, when they decided to sit by the roadside and take a breather. Karl and younger sister Gabbie (both on vacation from Australia) seem to be waiting for their mom while their cousin Monique is busy listening to music on her mobile phone. In the background is a curio shop.

THE BEAUTY OF BLACK & WHITE

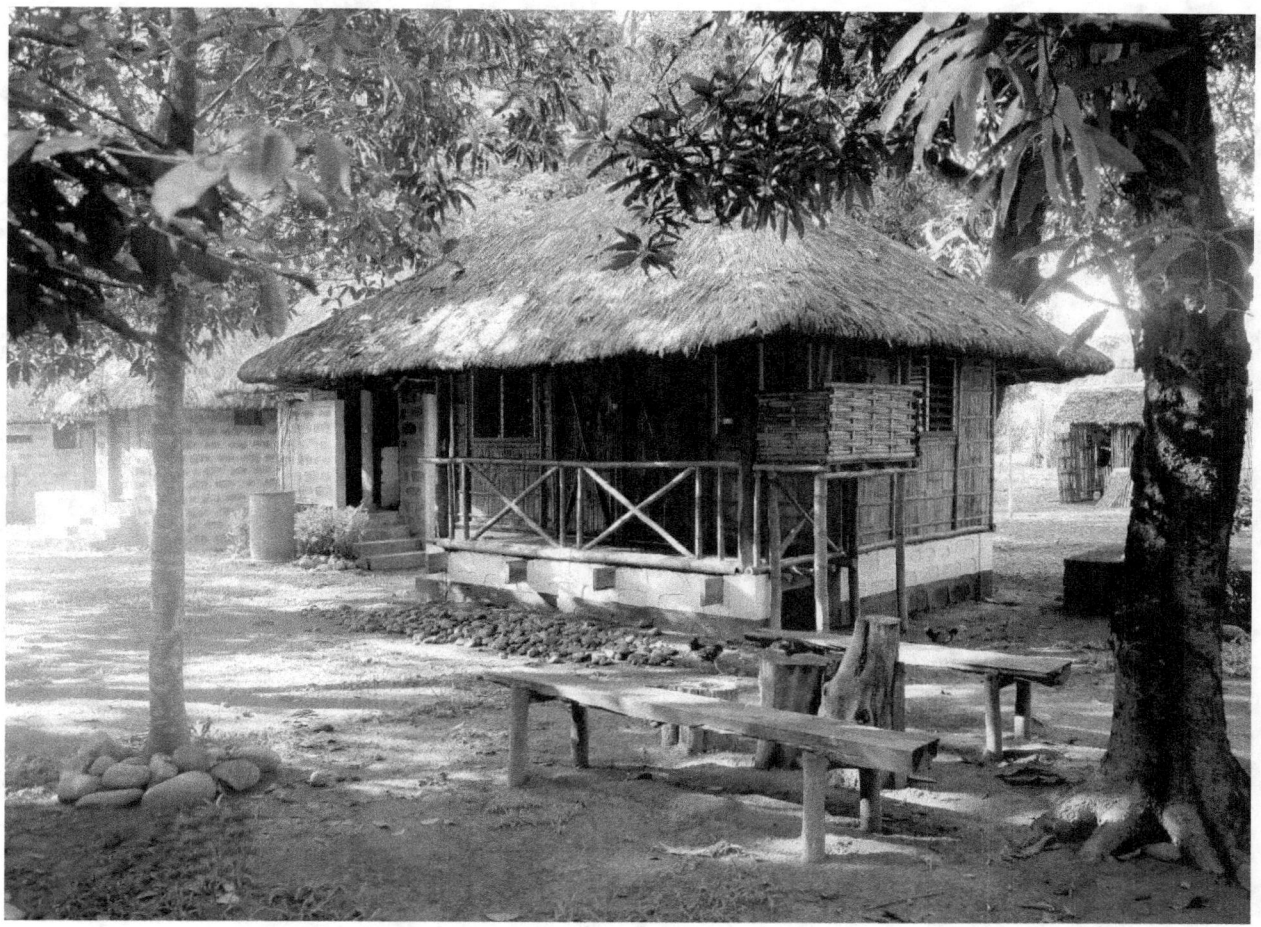

A COTTAGE FOR TWO I discreetly took this shot of Cottage 2 at my farm while two guests were still sleeping one early morning. My personal friends and relatives love it here as they take "refuge" from the concrete jungles of Metro Manila. This place is just three hours from the metro. The place teems with shady trees. In the morning, you awaken to the crowing of the roosters, chuckling of mother hen, the chirping and singing of birds, the sound of rustling romance between the leaves and the gentle wind, and the scent of coffee brewing in the outdoor kitchen. Yes, you can almost hear the grass grow at the farm.

NO FISHING TODAY A fisherman, left, scans the sea as his raft is shown "anchored" among the rocks in the foreground. With a small and rickety raft like this one, it is not safe to venture out among big breaking waves. This is one of the photos I shot along the picturesque San Esteban Cove located along the main highway in Ilocos Sur.

THE BEAUTY OF BLACK & WHITE

OFFERING OF CANDLES My grandchildren Karl and Gabbie offer lighted candles inside this centuries-old Christian church in northern Philippines. I used available light for this shot as is my usual way of taking pictures, whether indoors or outdoors. My father, Marcial, was a master of the use of available light. And that inspires me no end.

THE BEAUTY OF BLACK & WHITE

SILHOUETTE In this photo -- one of the several that I took for the marketing sales kit of Casa Teresita Resort – I had to request the subject to stand still as I waited for the precise moment when the sun would be behind her head. Then I snapped and clicked here and there. The Bay of Bangui was calm when we had this photo session. (See photo No. 3 in the previous page for more reference.)

THE BEAUTY OF BLACK & WHITE

THE WALLS OF CAPE BOJEADOR LIGHTHOUSE Instead of showing a photo of the lighthouse tower itself (a common sight), I have chosen to highlight this sturdy wall which had withstood the tests of time. The walls are made of bricks produced from clay which were then abundantly available in the area. The lighthouse was commissioned and first lit on March 30, 1892.

"The intense earthquake of 1990 that hit most of Luzon damaged the lenses and displaced the mechanism alignment of the original first-order apparatus making it inoperable. The beam now comes from a modern electric lamp that is powered by solar panels. The light before was provided by pressurized kerosene lamps very much like "Coleman lamps". In 2005, the old pressure vessels and wicks for the light could still be found in the shed."

https://en.wikipedia.org/wiki/Cape_Bojeador_Lighthouse)

WINDMILLS IN BURGOS I took my first photos of the windmills in northern Philippines way back in 2010 when there were only 24 windmill structures in the area. During my last visit (June 2016), the number of windmills have grown to more than a hundred that now dot the shores of Burgos, Bangui and Pagodpod towns all in Ilocos Norte, stretching for about 25 kilometers along the coastline and providing renewable electrical power to many homes in northern Philippines.

THE BEAUTY OF BLACK & WHITE

UNDER MOTHER'S PROTECTIVE WINGS Mother hen takes her chicks under her wings and away from the prying and sharp eyes of a hawk flying overhead. This photo was taken at my farm some time in 2010. Since that time this hen had given birth to no less than a hundred chicks even surviving a big flood (the only survivor from among 85 roosters and hens) and again during a big pestilence that swept the village last year that knocked down all but this hen. And so from a population of one hen middle of last year, there are now 31 new chicks at the farm, and growing, thanks to this prolific and sturdy Mother Hen. (As of January 2017.)

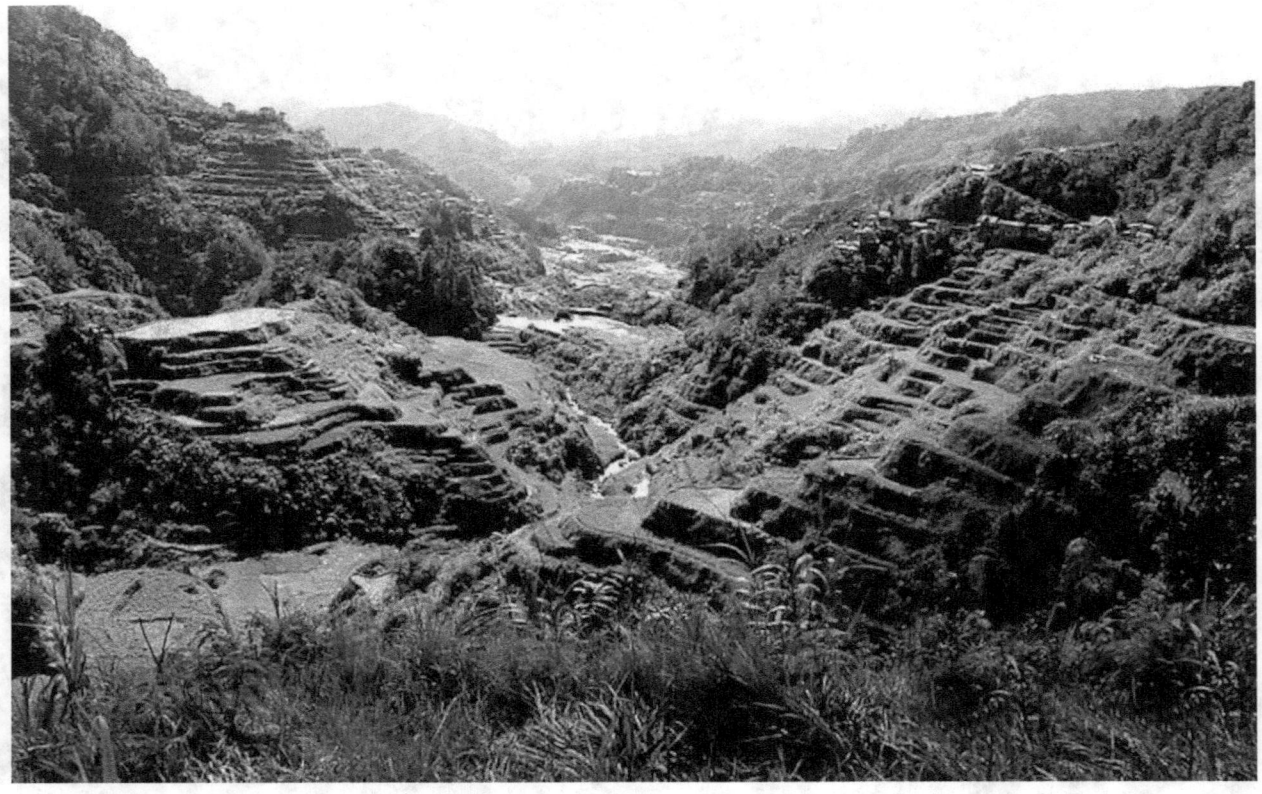

THE BANAUE RICE TERRACES I was on a business trip in Isabela province in northeast Philippines when I decided to break away from schedule and take off for a short visit to this place some 180 kilometers and three hours away. My driver and I spent more time travelling along the zig-zag road than at this scenic place. The Banaue terraces in Ifugao province are said to have an area of 5,000 hectares.

'The Banaue Rice Terraces (Filipino: *Hagdan-hagdang Palayan ng Banawe*) are 2,000-yearold terraces that were carved into the mountains of Ifugao in the Philippines by ancestors of the indigenous people. The Rice Terraces are commonly referred to as the "Eighth Wonder of the World". It is commonly thought that the terraces were built with minimal equipment, largely by hand. The terraces are located approximately 1500 metres (5000 ft) above sea level. They are fed by an ancient irrigation system from the rainforests above the terraces. It is said that if the steps were put end to end, it would encircle half the globe."

https://en.wikipedia.org/wiki/Banaue_Rice_Terrace

THE BEAUTY OF BLACK & WHITE

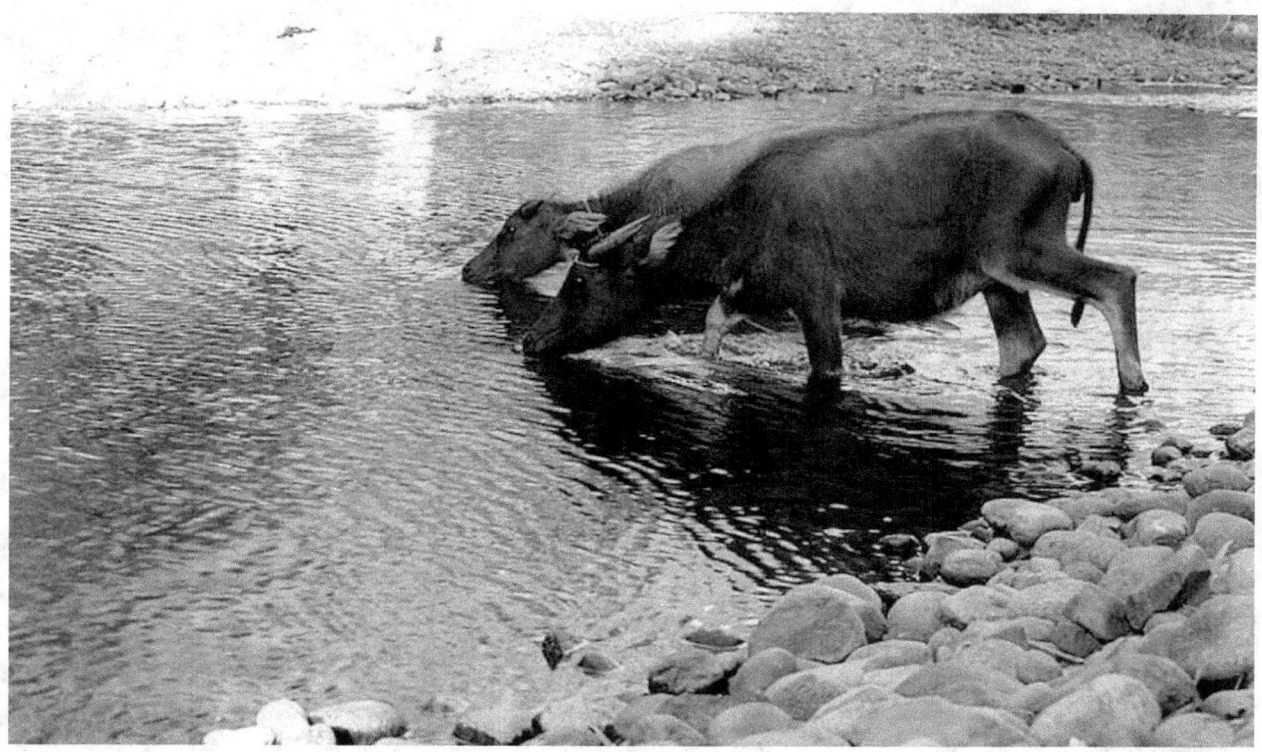

GOYA AND GOYO Mother carabao (water buffalo) takes her Goyo for an afternoon drink by this river near my farm in the province of Pangasinan (Philippines). It is customary for farmers to lead their work animals for a drink by this river in the same manner as my father did when he was still farming in this place (before be migrated to Manila to become one of the country's foremost photojournalists).

FOREST FOOT TRAIL Shown in this photo is a foot trail covered by vines and bushes while young Philippine mahogany trees grow on the left side. At the end of this trail is a small river where I used to spend many hours bathing while on summer vacation at the 2-hectare farm that I inherited (by purchase) in 2001 from my grandfather through my first cousin Paquito Valenzuela.

THE BEAUTY OF BLACK & WHITE

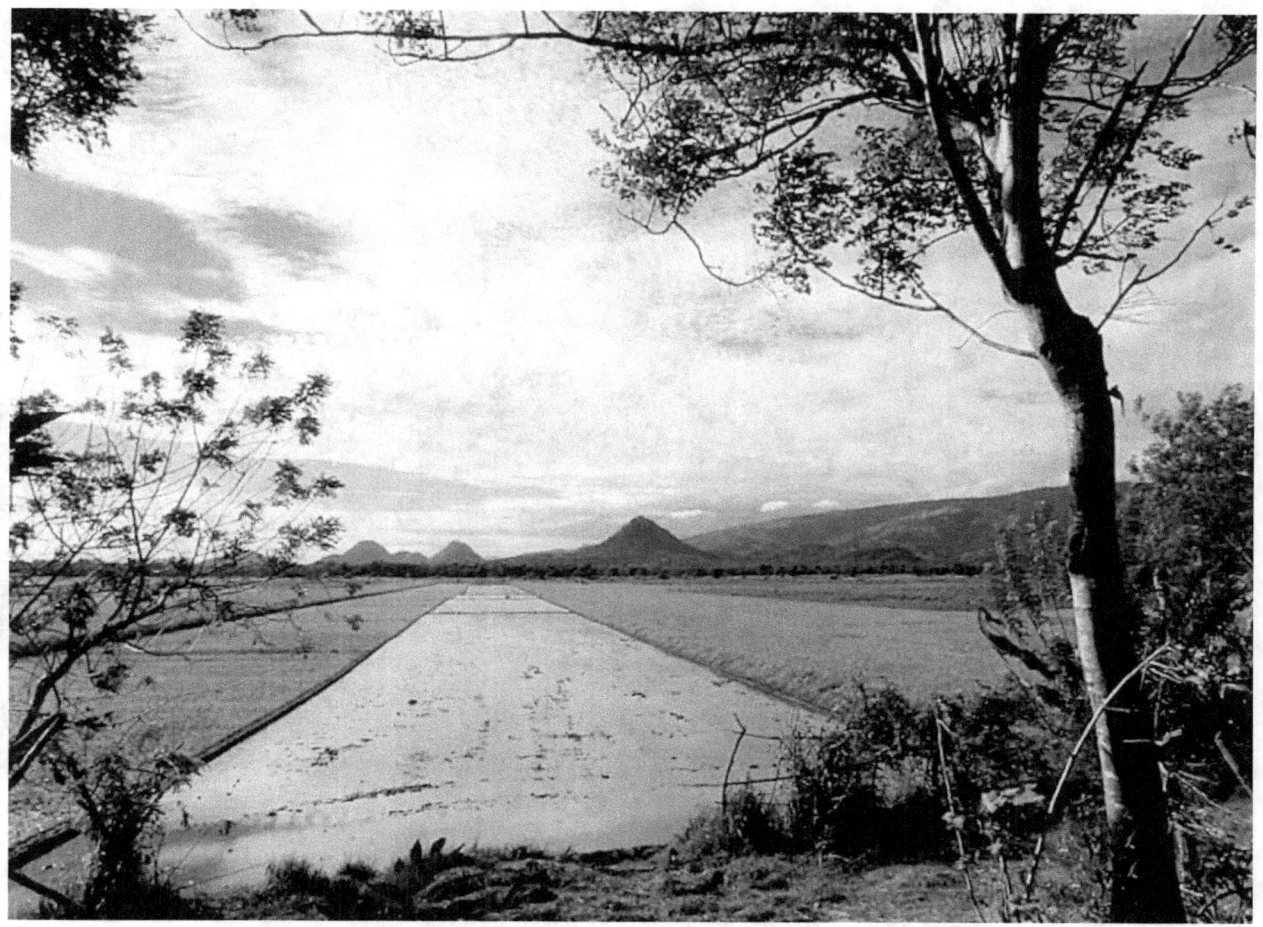

PLACID RICE PADDIES In most Asian countries, including highly industrialized Japan, rice is the major table fare. It is a water-intensive crop that needs plenty of water to survive the initial stages of growth. Land preparation is important like weeding and harrowing, and entrapment of irrigation such as shown in this photo. When rice seedlings have grown to about eight inches tall, they are transplanted to these paddies. Shown at right of this photo are grown rice stalks ready to be harvested. At the foot of the mountains at far right is the government protected Manleluag Spring National Park consisting of virgin forests and a hot spring. (Mangaterem town, Pangasinan province.)

THE BEAUTY OF BLACK & WHITE

THE CHURCH WITH A THOUSAND STEPS This is the façade of the Church of Our Lady of Assumption located in the town of Santa Maria in Ilocos Sur, Philippines. The picture could have been better had it not been for those dangling wires.

"The church was designated as a UNESCO World Heritage Site on December 11, 1993 as part of the Baroque Churches of the Philippines, a collection of four Baroque Spanish-era churches.

The Santa Maria Church is an attraction to both tourists and Catholics in Ilocos Sur. It is not only a reminiscent of the four centuries of Spanish domination of that area but also a unique structure with a diversified architectural design of bricks and mortar. It was built on top of a hill not only as a lookout and a citadel but as a religious center during the early administration of the region by both the friars and soldiers of Spain."

https://en.wikipedia.org/wiki/Santa_Maria_Church

THE BEAUTY OF BLACK & WHITE

A LAKE IN A FOREST Two rubber rafts slowly make their way to a gazebo located in the middle of this lake deep in the heart of a government-protected forest development project in the town of Diadi in the province of Nueva Viscaya. Aside from this lake where one can also go fishing, there are concrete lodging houses and picnic areas in the forest enclave.

THE PAOAY LAKE This lake is one of the largest inland bodies of water in the Philippines located at the towns of Paoay and Batac in Ilocos Norte. It was here in the 1920s when former President Ferdinand Marcos went hunting for wildlife as a budding teenager. During his term as president, I was lucky to have been commissioned by the then Ministry of Agriculture to document in slide transparencies the full-scale development of the lake that included the following: Manufacturing of a million bricks from local clay that supplied the entire requirements of the Fort Ilocandia international hotel; Dendro-thermal (Ipil-Ipil) project to supply firewood to the scores of local kilns engaged in the production of bricks; Bullfrog growing project; Poultry raising and dressing project; Water Impounding project; Tilapia Fish culture; Tree Plantation project (gmelina and mahogany).

It was also along the banks of the lake that Marcos built the "Malacañang Palace of the North" which became a popular tourist destination, thanks to his son Ferdinand Marcos, Jr. and daughter Imee Marcos who both became governors of the province. (Imee Marcos is the incumbent governor of the province as of date, February 2017.)

THE BEAUTY OF BLACK & WHITE

A FOGGY AFTERNOON in the upland city of Baguio finds this family seemingly looking for some of their companions. I shot this photo in May of 2014 at about 3 o'clock in the afternoon at the front yard of the Baguio City Cathedral. The city was founded by the Americans in the early 1900 and converted it into the summer capital of the then US Commonwealth government in the Philippines. Today, the metropolitan city is apparently choking itself owing to a huge population that grows big---albeit temporarily---at summer time when people from the lowlands seek, and find, refuge in its cool climate.

THE BEAUTY OF BLACK & WHITE

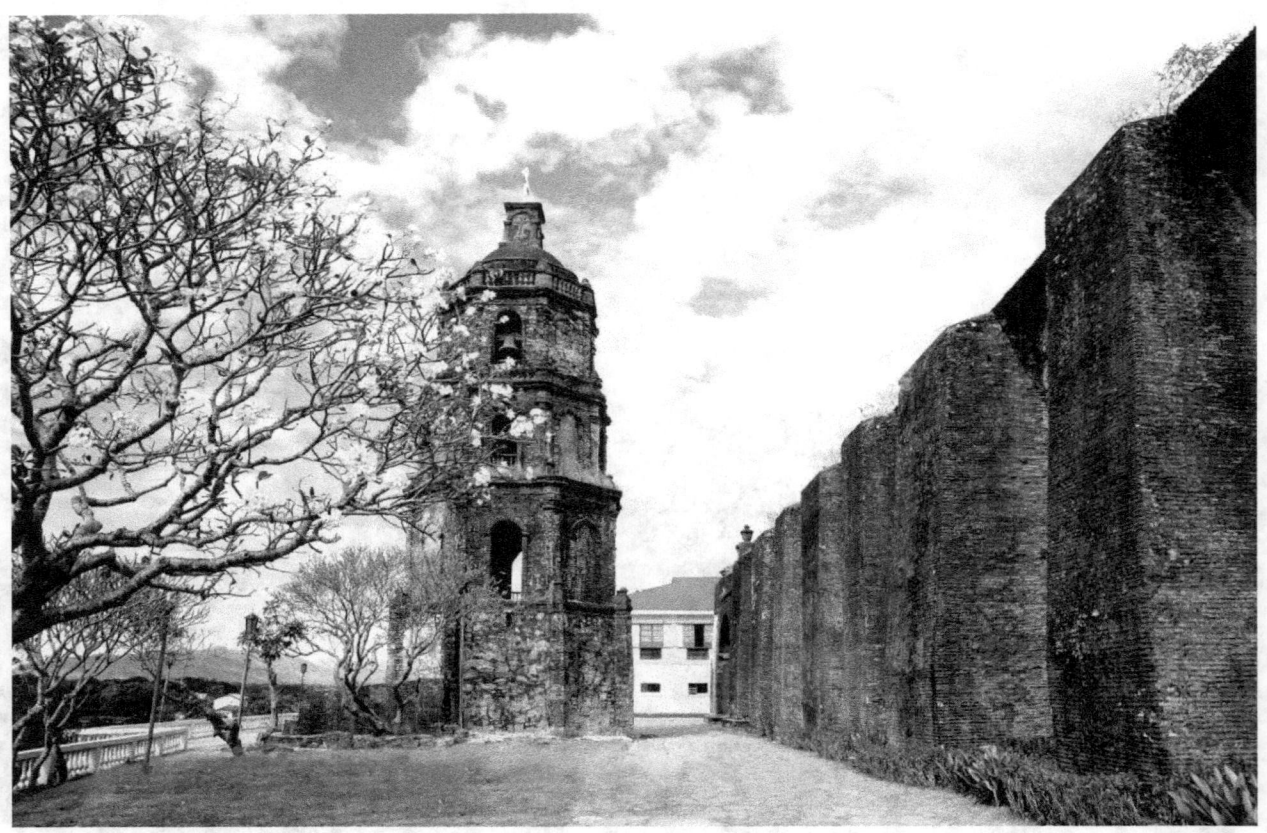

A FOUR-STOREY BELFRY stands by itself beside the Church of Our Lady of Assumption, in the town of Santa Maria in Ilocos Sur, Philippines. Notice the thick buttresses at right that support the thick brick walls of this centuries-old Christian house of worship. For more details, please see earlier photo of the same church on Page 122.

THE BEAUTY OF BLACK & WHITE

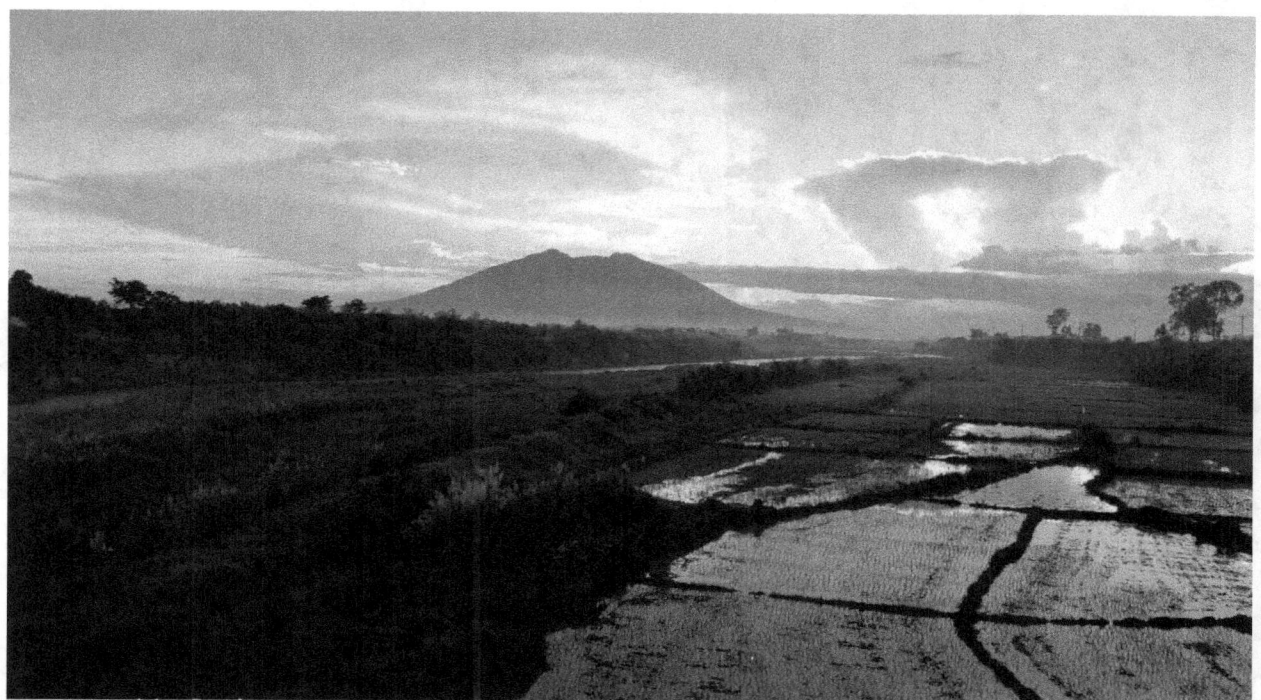

SUNRISE OVER THE EXPRESSWAY My driver and I were coming home to the northern province of Pangasinan from Metro Manila when I chanced upon this view along the North Luzon Expressway (Nlex) in Pampamga. The long stretch of the highway, from Nlex to the Tarlac-Pangasinan Expressway, or Tplex (stretching for about 300 kilometers), always offers a scenic view of sunrises in varying landscapes.

THE BEAUTY OF BLACK & WHITE

THE KING OF THEM ALL I call this rooster "Ama" as it had fathered no less than a hundred chicks between 2012 and 2015 the year when more than 75 per cent of the population of fowl at the farm was wiped out by a large flood, including this rooster. (See similar caption on Page 117) I had to stalk this one from place to place at the farm until I was able to nail him in this pose.

THE BEAUTY OF BLACK & WHITE

EBB TIDE I woke up to a cold morning in January of 2014 when the scent of that distinct fresh sea air wafted and filled my lungs. I walked out to the balcony of my one-storey rented room. The tide had receded exceedingly low and this view presented itself as I wandered further down the beach front with my camera strap slung around my neck. I am not one to miss this view. And so I clicked here and there and gingerly hopped along the exposed but slippery corals. At Casa Teresita Resort in Pagodpod town in Ilocos Norte, the Philippines.

THE BEAUTY OF BLACK & WHITE

TRANQUILITY It was 7 o" clock in the morning and the windmills were not spinning. No one was on the scene, not even a stray dog or a hawker with the usual souvenir items. It was so tranquil and quiet and the tourists had not arrived. Before unwanted obstructions and subjects could clutter my view, I took aim and shot with my cam. Soon after, two cars arrived and unloaded eager-beaver passengers. Then a big bus wheeled in with more tourists. And so, I hopped into a nearby restaurant to join my family for early morning breakfast.

THE BEAUTY OF BLACK & WHITE

A CERTAIN SMILE This is a variant of my picture of the former Miss Patricia Gorospe (now Mrs. Zerjo Albano) during a "photo session" for a sales marketing kit for my friend, the late Deomedes Lorenzo who successfully sold his resort using the marketing kit that I prepared for him. Unfortunately, my friend died a few months later not enjoying the "windfall" from the sale.

This picture made it on my list because of the seemingly lonesome view in the background as contrasted by the smile on the face of our subject, and the long shadow created by the banking sun. In the very far distance could be seen the windmills of Burgos town some 20 kilometers away.

FISHCAGES Fortunately for them, local villagers got the go-ahead signal to construct these fish pens and cages along a public waterway in Caoayan town at the outskirts of Vigan City in Ilocos Sur. Near this place are three top tourist attractions, which are: A local resort-museum owned by a former governor of the province; a garden-resort; and the heritage city of Vigan itself.

THE BEAUTY OF BLACK & WHITE

SOMEWHERE BEYOND THE SEA "Compose and frame the picture in your mind first." That was the best and most lasting advice that my father, Marcial S. Valenzuela, implanted in my mind and it would be put to good use in all the pictures that I shot. First, I would scan and frame the view as presented before me, take aim and compose right in the frame, and then click away. What would this picture be without the two coconut trees to the left?

THE BEAUTY OF BLACK & WHITE

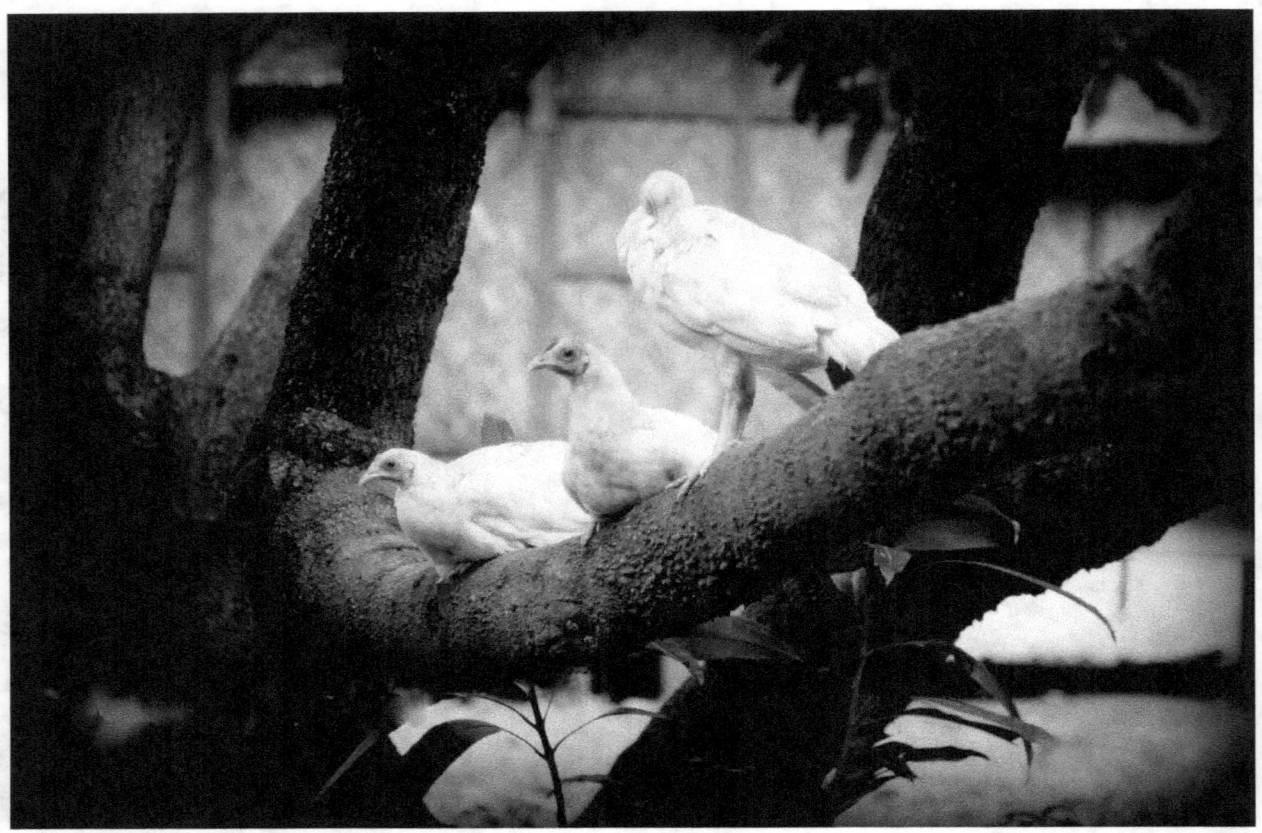

PETER, PAUL and MARY were picking their feathers and cleaning themselves one gray afternoon at the farm when I chanced upon them. I zoomed in on them, aware that I would most certainly scare them away if I approached closely. This photo is as mundane as it could get.

THE BEAUTY OF BLACK & WHITE

HIGH CHAIRS BY THE WINDOW As my final picture in this section, let me present this one: Two deserted, or unoccupied, high chairs set by the window of an old house. This is symbolic of myself who always look out for the best opportunities, scenic places and views that come across my way in my many travels, mostly "in my own backyard"----- in my country that offers a lot of historic and beautiful sceneries to capture on the camera.

Epilogue

I shall always pursue photography with great passion "following in the footsteps" of my father, Marcial S. Valenzuela, the Dean of Press Photographers of the Philippines. He had long gone to the Great Beyond but he left behind hundreds of photographs, all of them in beautiful black and white, as well as an equal amount of negatives some of them dating back to the 1930s. Yes, I still have them in very good condition.

Someday, too, I shall make my final exit and join him. It is my wish that I could finish the tedious work of cataloguing all the moments in each of the negative and print that my father had left behind. The story and caption behind each of the photos in Part I of this book are still fresh in the data bank of my mind based on the many conversations that we had when he was still around.

In the next volume of this book, I hope there would be one, I shall feature more of the great works of my father and this time highlight the talents of his grandchildren, namely: Nestor Valenzuela, Karl Valenzuela and Eddxer Valenzuela, who are among the best digital photographers in the 4th generation of the Valenzuelas (down the line from my grandfather, Vicente). Add to them the great photos of my son-in-law Arthur R. Pitargue, M.D.

And to the Dean, I salute you. You shall and always will be our inspiration and role model. And so, until the next volume, happy shooting everyone.